Speedlights & Speedlites

Second Edition

Speedlights & Speedlites

Creative Flash Photography at Lightspeed

Second Edition

Lou Jones, Bob Keenan, Steve Ostrowski

Focal Press
Taylor & Francis Group

NEW YORK AND LONDON

* For Nikon Speedlight and Canon Speedlite users only

First published 2009 by Focal Press

This edition published 2014 by Focal Press
70 Blanchard Road, Suite 402, Burlington, MA 01803

Simultaneously published in the UK
by Focal Press
2 Park Square, Milton Park, Abingdon, Oxon OX14 4RN

Focal Press is an imprint of the Taylor & Francis Group, an informa business

© 2014 Taylor & Francis

Notices
Knowledge and best practice in this field are constantly changing.
As new research and experience broaden our understanding, changes
in research methods, professional practices, or medical treatment may
become necessary.

Practitioners and researchers must always rely on their own experience
and knowledge in evaluating and using any information, methods, compounds,
or experiments described herein. In using such information or methods they
should be mindful of their own safety and the safety of others, including
parties for whom they have a professional responsibility.

Product or corporate names may be trademarks or registered trademarks,
and are used only for identification and explanation without intent to infringe.

Library of Congress Cataloging in Publication Data
Jones, Lou, 1945–
 Speedlights & Speedlites : Creative Flash Photography at Lightspeed /
 Lou Jones, Bob Keenan, Steve Ostrowski. — First edition.
 pages cm
 Includes index.
 ISBN 978-0-240-82144-3 (pbk.)
 1. Electronic flash photography. 2. Photography—Digital techniques.
 3. Canon digital cameras—Equipment and supplies.
 4. Nikon digital cameras—Equipment and supplies. I. Keenan, Bob.
 II. Ostrowski, Steve. III. Title. IV. Title: Speedlights and speedlites.
 TR605.J66 2013
 778.7'2—dc23 2012047630

ISBN: [9780240821443] (pbk)
ISBN: [9780240823591] (ebk)

Typeset in Utopia
By Keystroke, Station Road, Codsall, Wolverhampton

Printed and bound in China by C&C Offset Printing Co., Ltd

Bound to Create

You are a creator.

Whatever your form of expression — photography, filmmaking, animation, games, audio, media communication, web design, or theatre — you simply want to create without limitation. Bound by nothing except your own creativity and determination.

Focal Press can help.

For over 75 years Focal has published books that support your creative goals. Our founder, Andor Kraszna-Krausz, established Focal in 1938 so you could have access to leading-edge expert knowledge, techniques, and tools that allow you to create without constraint. We strive to create exceptional, engaging, and practical content that helps you master your passion.

Focal Press and you.

Bound to create.

We'd love to hear how we've helped you create. Share your experience: **www.focalpress.com/boundtocreate**

TENETS OF TTL SPEEDLIGHTS

1. **Separate. Get those Speedlights off camera.**

2. **Bounce. If you can't separate, bounce it. Bounce it anyway.**

3. **Resist using Speedlights strictly on manual. The computer can outthink you.**

4. **In any camera exposure mode, when correctly exposing for existing light, the camera computer will automatically reduce TTL flash to a fill light.**

5. **LCD = aesthetic; histogram = exposure. Use them both.**

6. **Exposure Compensation is used to change the TTL ambient exposure and Flash Exposure Compensation is used to correct the flash exposure on the subject.**

7. **Expose to the right (on histogram). Underexposure provides no benefit.**

8. **Most real problems with Speedlights can be traced to battery failure.**

9. **Take your camera seriously, don't abuse postproduction.**

10. **No Fear. Just do it.**

11. **The elegant solution is often the simplest solution.**

SKYLINE

This image was done to advertise workshops. It was a race against time. At this latitude, the light in the sky only lasts for approximately 45 minutes after sunset. I needed a longer exposure to capture the fading sunset, so I used the shutter priority mode. The light on the model was automatic.

After several attempts, the softbox was aimed up so it would falloff, lighting only the upper torso. The backlight illuminated the scarf and gave an edgelight to the model. CineFoil® acted as a gobo to prevent light from spilling into the lens (see Gobo). We used a leaf-blower to create the windblown effect. All the elements, including the city lights, positioning of hair, and clothing, worked in concert for maximum aesthetic effect.

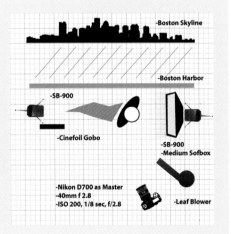

-Boston Skyline
-Boston Harbor
-SB-900
-Cinefoil Gobo
-SB-900
-Medium Sofbox
-Nikon D700 as Master
-40mm f 2.8
-ISO 200, 1/8 sec, f/2.8
-Leaf Blower

Acknowledgements

A special thank you to:

Leah Cornwell Raymond, Studio Manager at Lou Jones Studio, for her dedication to producing new content which required persistence and vision, for keeping the studio organized and focused, and for the many hours spent on copy and technical editing.

Michael DeStefano, Digital Technician at Lou Jones Studio, for his efforts to make sure the images and content were modern and attractive, for the postproduction of photographs, and for tirelessly designing and illustrating the photo-shoot diagrams.

And to all the friends, relatives, clients, and models who are included in the book.

Contents

Illustrations

Tables

Color Coding Key

Brand-specific information is indicated by the following colors:

Green: Canon Speedlites 600EX-RT/600EX, 550EX/ 580EX/550 EX MK II/580EX MkII flashes, used with compatible Canon EOS cameras.

Purple: Nikon Speedlight SB900/910/SB800, Nikon Speedlight Commander SU-800, used with compatible Nikon cameras.

Some of the information in the book has been categorized in an effort to increase accessibility. Five aspects are differentiated with the following background colors:

Solutions: Olive green

Warning: Red

Example: Orange

Products: Tan

Textbook: Gray

Introduction

It may be hubris, but what did the first artist look like? Art stirs primal urges so what circumstances turned an act of survival into an act of passion? Whereas most two-dimensional art began organically—splashing pigment on cave rock, drawing lines in the sand, penning ink on paper—its origins most certainly were simple.

More recent to the scene, photography has always been the "red-headed stepchild" because of its dependency on technology—state-of-the-art technology—the most advanced engineering at any point in its evolution. Newer and newer cameras, film, lenses, and sensors have continually pushed the envelope of science. Since the earliest days where practitioners reveled in grinding their own glass for lenses, mixing their own chemicals, measuring the Inverse Square Laws, they have been on a quest to make the processes easier for each new generation.

The inventors and innovators at the infancy of photography were all scientists, engineers, and do-it-yourself hobbyists. So complicated is the balancing act of taking pictures that the pleasures of making photographs remained out of the realm of many creative people because of mastering optics, chemistry, and logistics and also the expense. But photography was so amazing that its persistent popularity easily proved to savvy manufacturers that there was a gap—a market—to exploit.

Ironically the last hundred plus years have been spent trying to make the process no more difficult than drawing in a sketchbook. The implements have gotten smaller and lighter. The physics and chemistry has been reduced—eliminated. Autofocus, automatic exposure, motordrives, software have made each skill ergonomic and mindless. Armed with high-tech but less costly cameras, rank amateurs can make rather credible reproductions of their friends and relatives. Echoing George Eastman's motto found in early KODAK marketing, "You push the button, we do the rest," today's photography requires that you only supply the elusive imagination.

We have survived arguably the most cataclysmic revolution in any artform in recorded history with the implementation of computers and digital photography. Painful in the onset, it has become more accessible for a myriad of new enthusiasts. Since computers have been introduced into our daily lives using them is second nature.

However, in a parallel universe, the last holdout in the "equation" has been lighting. Amateurs and professionals alike have shirked the duty of learning "artificial" lighting. Even today, with bravado, many still proudly proclaim "I *only* use *natural* light." In the right hands that craft has gifted the world with luscious black/white and soft pastel photographs that need no excuse. But in the worst case there remains a blind spot.

There is nothing photographers love more than their gadgets and rituals. For decades, I dragged along ancillary cameras that shot instant films, light meters, and huge, quirky Polaroid film in order to pre-visualize and ensure I got a proper picture. Over the years, light became a little more streamlined and fashionable, but it remained complicated, heavy, costly, and cumbersome. With the equipment mentioned above, by the time you made a proper exposure measurement, the scene had often changed irrevocably.

Fortunately Speedlights have changed all that. By putting computers into the cameras AND the flashes, and programming them to communicate with each other, the onerous task of coordinating artificial and available light is manageable. Tremendous ingenuity has been employed to manufacture flashes smarter than you. They are faster, cheaper, and more intuitive.

It is uncanny that the camera companies do not fathom what they have wrought. And most people use Speedlights exactly as they have utilized flashes

for decades, not trusting their potential. This is perfectly understandable, but Speedlights are designed to work alone and make exposure nearly foolproof. They are anything but normal flashes. All we have learned about lighting in the past has changed. There is no reason to leave so much capability on the table. Mount a Speedlight on top of your camera and improve the simplest fill lighting techniques or fill a cathedral with the visible spectrum—automatically.

If that is all it did we should be grateful. However, its shepherding of multiple light sources is miraculous. You can throw a handful of Speedlights in every direction around a room and coordinate them all effortlessly. Although this alters the way we have lit in the past, the new effort is well worth the journey. Shedding old habits is unsettling, but new freedom is gained in creativity, speed, flexibility, and economy. On sequential frames in your camera, you can produce a traditional lighting scheme and then shoot with unorthodox lighting by flipping a switch, just to see how it looks. The opportunity to experiment without reevaluating each alteration increases your value as an artist.

Here we are making very ambitious claims about how a single piece of equipment can improve your photography. Nothing worthwhile comes easy. If it did, anybody would do it. You cannot afford to be intimidated by the terrible instruction books, complicated menus, and myth. We wrote *Speedlights and Speedlites: Creative Flash Photography at Lightspeed* to help you. And now we have been commissioned to write an updated, new version. We learned a lot since writing the first. So stay tuned.

In addition, you can follow my blog:

fotojonesblog.blogspot.com.

Sign up for updates to download a FREE copy of the ebook: *Speedlights*. If you want to observe the flashes in action, visit youtube.com/user/loujones2008 and vimeo.com/loujones to watch videos my studio has produced. More work with Speedlites can be seen at www.facebook.com/StephenOstrwskiPhotography. For information regarding workshops on Speedlites with Stephen Ostrowski in Boston, Massachusetts, visit www.NESoP.com.

With a little practice soon you will realize you are like gods, because only gods can move the sun.

Why Speedlights?

With today's advanced digital cameras and their hypersensitivity to light, it is a wonder we need any artificial light at all. But even the most dedicated purist will concede that there are situations that beg for supplemental lighting, like when nature can should be enhanced for optimum clarity.

The fundamental question is "Why Speedlights?" Photographers have been lighting with flashes for decades. Why change? We have perfectly good hot lights that allow us to see exactly what we are photographing, powerful studio strobes that have been more than adequate for generations, and third and fourth generation flashes that have paved the way for portability and ease of use.

The above rationales are correct. There is no need to change your practices until you reach an impasse or you have a new problem to solve. The old ways will continue to serve you. As long as there is photography there will be available light or vice versa.

Electronic flash is scary to a lot of beginners. They respond by swearing by available light and avoiding the complexities of strobes. Flash is just another tool. Albeit a little more complex than the basic cameras, learning flash is not an insurmountable challenge. Current lighting methods are advanced and mature. Just as computers and digital have revolutionized photographic capture, the same technology has changed lighting.

There are a number of areas in which Speedlights can match "old school" techniques and many where they are far superior.

SIZE

Let us start with the most obvious. *Size* is a major factor for exploring Speedlights. I used to carry several large cases of equipment to be able to handle the requirements of commercial/industrial photography for my clients. Weight should not be overlooked either. You pay for weight in multiple ways in photography: fatigue, overweight charges on airlines, and more luggage to contain them. Now everything in my kit fits in the overhead compartments on airplanes.

Although each Speedlight unit is small and compact, its size belies its power. The design engineers packed a lot more energy into each individual Speedlight. Because they are so small (and wireless) they can be placed in locations and spaces inaccessible to their larger, traditional counterparts.

WIRELESS

Now you must admit that the elimination of wires makes the use of artificial lights a *lot* easier. Not only do you not have to carry dozens of feet of extension cords to link each light to another or back to the powerpack, no cords make the unit even smaller. In addition, you do not have to hide cords, so you do not see them in the final photograph. But mostly the labor-intensive onus of hardwiring is gone.

Speedlights also need no power cords . . . no auxiliary electricity. You are not dependent on an external power source.

ECONOMICAL

The manufacturers' *dedicated* Speedlights are not inexpensive but they are nowhere near as costly as a generic studio strobe. When price is a factor you can afford several Speedlight units for just one strobe and powerpack.

SPEED

With traditional strobes, once you construct the lighting scheme it can be hard to break down and rearrange meticulous lighting. Because of size and convenience of Speedlights, the consummate photographer can set up, use, and break down many

lights in very short order. You can do more shots with Speedlights which allows you to experiment and try more ideas. This alone is worth consideration.

SMART

Heretofore the most controversial aspect of using Speedlights is the ability to use them on *automatic*. Many photographers refuse to explore those possibilities and insist everything be done manually, ignoring the tremendous technology imbedded in Speedlights. There is no reason to own an expensive Speedlight if you do not at least engage one or more of the "automatic" settings when appropriate.

Photographers have adopted motordrives, autofocus, autoexposure, etc. when necessary. The fact that a state-of-the-art computer is inside every Speedlight has transformed lighting just as much as computers placed in dSLRs.

If you are using just one light mounted on the hotshoe of your TTL camera, automatic exposure can "outthink" most of the dynamic situations of today's photographer. When using multiple lights there is no contest, automatic exposure is superior.

You relinquish no control "on automatic." You can change the effect of each light but the computer coordinates the contribution of each individual source and makes sense of it. If it is not what you had in mind you can alter it but it provides a great starting point.

VERSATILITY

It took me a lot longer to come to the realization that after a career shooting with studio strobes all over the world I had become complacent. I knew what they would do in most situations. But converting to Speedlights out of necessity I realized their biggest asset was *versatility*. Speedlights have often been appreciated because of their portability and they are especially suited when the shot is dynamic and the subject moves a lot but the versatility makes them suitable for more standard jobs: portraits, still life, etc. Despite their size, cost, and convenience (or rather because of it) they could do almost everything my "big lights" could and many things my "regular" strobes could not. They became invaluable to a new cheaper, faster, more adventurous style and opened an entirely new chapter to lighting. I had learned the rules of lighting "old school." The laws of physics had not changed but my imagination and potential had.

Speedlights are still an elusive element in the embryonic stages of Digital Lighting. This new edition proposes to help you harness it.

Chapter 1 One Light

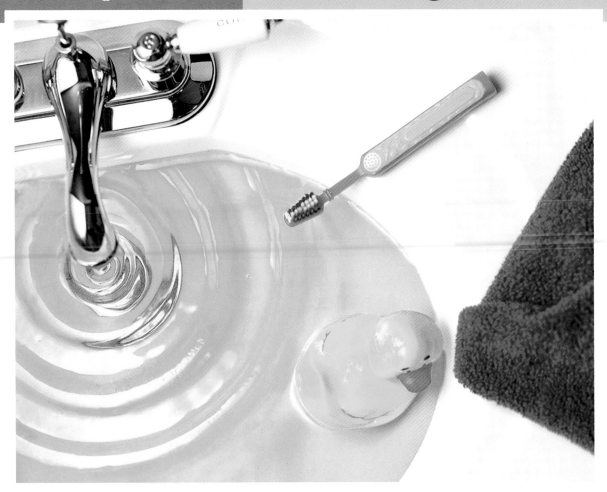

Photography is light. And to move out of the darkness, you only need one light. Diffused, bounced, as fill, that one light changes shapes, becomes diverse and more talented. There are not enough terms to describe all the ways that one light can be reconfigured to make a photograph more useful.

Not enough trade names for the modifiers used to reshape light. Real artists continue to master using just one light source. The prototypical Weegee[1] character is no longer with us but his skill set informs modern shutterbugs and road warriors alike. Wherever quick light is needed we revert back to classic "old school" ways: straight, unadorned, contrasted, and flat light which is not realistic.

Weddings, events, photojournalism, art. One light. Portable. Efficient. One light is not much but in the hands of an expert it is all that is necessary.

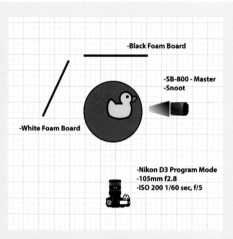

RUBBER DUCKY

The idea for this photograph came to me while I was brushing my teeth. Years ago I commissioned a model maker to fabricate a plastic water ripple for a photograph. He did such a good job that I put it away for future use. It took years to find the perfect client.

Even though it was tight quarters, we shot the job in the new studio sink from the top of a ladder. We cropped the composition tightly because the Plexiglas ripple was only a quarter of a circle. To add contrast to the white-on-white shot, we tinted the water with food coloring. My assistant took great care to suspend the plastic on top of the water surface. We used a couple of large black "show cards" along the walls to reflect contrast in one side of the ripple. The only light source in the image was a Speedlight with a snoot (see *Snoot* on page 119) bounced into a white "show card." We moved all the elements around until we got something we liked. A fair amount of postproduction was done to smooth out sharp edges in the water, but nothing else was modified.

ONE TTL FLASH

Electronic Flash: Definition

A flash is a device that produces a brief burst of artificial light at a color temperature of approximately 5,500 Kelvin. Flashes can freeze motion in quickly moving objects, help provide smaller f/stops for greater depth of field, correct color temperature of the available light, but are mostly used to illuminate scenes that do not have adequate lighting to properly expose a photograph.

Speedlight/Speedlite:[2] Definition

Speedlight has become a generic term. It is interchangeable with flash, strobe, etc. For the purposes of this book, its definition is very specific. All of the pictures were made using Nikon or Canon shoe-mountable flash heads. These flash units work with their respective manufacturer's digital cameras in new and exciting ways. While most of the processes can be done easily and automatically, certain features allow for an unprecedented array of possibilities and creative control. Since there will always be newer and more advanced cameras and flash units arriving on the market, we want to state what makes the current products distinct and revolutionary.

There are two key attributes to the current state-of-the-art Speedlight:

The Speedlight can be wireless. Communication between compatible lights is accomplished with light pulses. No wires or external devices are needed to fire off camera lights. Although there is usually a Master Speedlight mounted on the camera, even a single Speedlight can be separated from some cameras by using the pop-up flash as a Commander.

[1] Weegee—Arthur Fellig (1899-1968) Newspaper photographer of legend

[2] Speedlight™ (Nikon) and Speedlite™ (Canon) are trademarked names for their products. In general, we will use the generic spelling ie. Speedlight, except in the description and lighting diagrams of photos made with the Canon Speedlite.

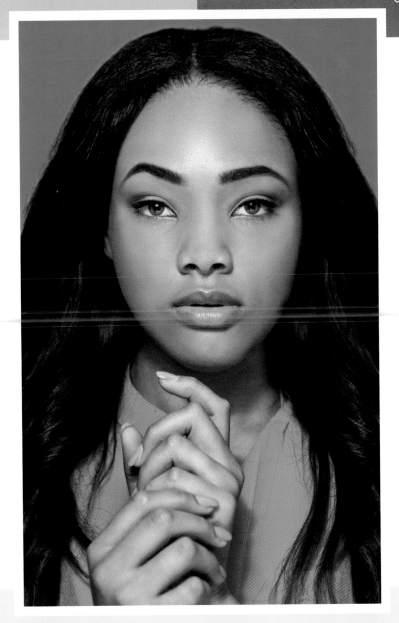

BEAUTY SHOT

At some point in every photographer's career, he/she has to tackle the beauty shot. What seems like a simple portrait can be a lot more complicated. These straight-on shots emphasize all sorts of "defects," like unsymmetrical faces, blemishes, proportions, etc. Since it is intended to show off a model to her agency or to potential clients, the lighting has to have a lot of punch to show off the best in a model's face, but it has to be soft enough not to create its own set of problems.

Recently, beauty dishes have become more prevalent than umbrellas or softboxes when doing beauty shots (see *Beauty Dish* on page 120). They produce a slightly "harder" light than bank lights so they must be used with caution.

This shot required only one light which shows how effective just one Speedlight can be. However, there is a large mirror propped up below the model's face and two large white reflectors on each side. The aggregate effect is a very flat lighting with "bite" and an interesting catch light in the eyes. Mastery of minimum equipment is essential to the building of your lighting skills.

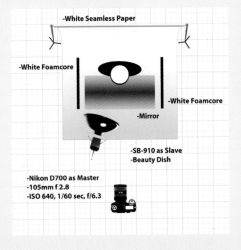

-White Seamless Paper
-White Foamcore
-White Foamcore
-Mirror
-SB-910 as Slave
-Beauty Dish
-Nikon D700 as Master
-105mm f 2.8
-ISO 640, 1/60 sec, f/6.3

Multiple Speedlight units can be used and controlled wirelessly by a master flash from your camera position. The master flash can also control multiple groups comprised of more than one Speedlight.

While all of these features may evolve, and other companies may eventually add these capabilities to their camera and flash units, we believe this step in technology is significant and well worth the effort to master, no matter what your level of photography.

Several independent manufacturers produce flash units that interface to varying degrees with the TTL flash metering systems of the Canon and Nikon digital cameras. A few are fully compatible and we will deal with them in later chapters. This book however deals specifically with the Canon 580EX-RT, 550EX, 580EX, 580EX MkII, 600EX, and 600EX-RT; and the Nikon SB800, SB900, and SB910 TTL professional Speedlights.

All future references to Speedlights, flash, or strobes pertain to this narrow definition, unless otherwise indicated.

A flash with a guide number of 160 (for ISO 100, and 50mm zoom head setting) makes a versatile lighting tool capable of actually overpowering sunlight. A flash with a guide number of 160 provides f/16 worth of flash at a ten foot flash-to-subject distance, i.e. 160/10=f/16. A standard ISO 100 sunlight exposure (based on "sunny 16" exposure guidelines) is 1/60 sec. at f/16. With most current digital cameras, flash can be used up to 1/250 sec. The flash exposure can be made at 1/250 sec. at f/16, underexposing the sunlight by two stops, and making the flash the predominant light source.

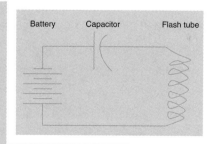

FIGURE 1.1 FLASH SCHEMATIC

GUIDE NUMBER

Manufacturers express the light output of their flashes as **guide number**. Guide number defines the maximum intrinsic **aperture value** worth of flash available from a flash unit at any given flash-to-subject distance, giving the photographer a realistic expectation of the capabilities and maximum power of the flash. A guide number may be expressed in feet or meters, and is dependent on ISO, flash reflector efficiency, zoom head setting, and flash power. Guide numbers are useful and meaningful when applied in a simple traditional equation:

$$\frac{\text{guide number}}{\text{Flash-to-subject distance}} = \frac{\text{aperture value of light}}{\text{falling on the subject}}$$

(guide number divided by the flash-to-subject distance = aperture value etc.)

This equation can also be expressed as:

guide number = Aperture \times Distance

FUNDAMENTALS OF ELECTRONIC FLASH

To effectively use electronic flash, it is useful to know how it works.

Electronic flash has a hollow glass flashtube filled with the rare gas **xenon**.[3] Xenon (notice the similarity to the word neon) produces blue light when exposed to electric current. Electronic flash stores voltage from the batteries or AC current source in a capacitor. The capacitor discharges electricity into the flashtube. The amount of electricity discharged, the "flash power," determines how long the flashtube is lit, i.e. the flash duration. The brightness of the flashtube remains constant. The flashtube only "turns on" for longer or shorter periods of time.

The flash duration of TTL electronic flash is very brief, 1.2 milliseconds or less. Therefore, if the shutter is open longer than the flashtube is illuminated, **the shutter speed itself will have no effect on the amount of flash** in the photograph.

The quantity of flash recorded by the camera is a function of the flash duration, the flash-to-subject distance, the ISO, and the aperture. Electronic flash is always expressed as an **aperture value** worth of light. At any given shutter speed, "f/16 worth of light" falling on the subject is more light than "f/8 worth of light."

[3] Xenon (Xe, atomic number 54), noble or inert gas, of the family Helium, Krypton, Argon, and Radon

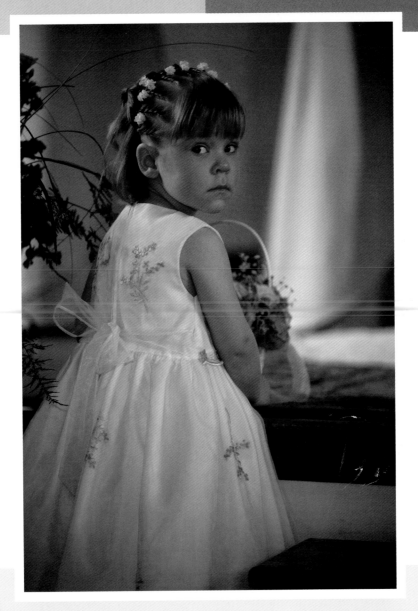

FLOWER GIRL

She kept looking over her shoulder at all the people. Kneeling in the center aisle gave me the perfect vantage point at her eye level. My knee served as a brace for the long lens. The 80-200 zoom gave the intimate perspective and isolated her from the surroundings. The existing light was soft, wonderful, and warm. A touch of flash from a Speedlite mounted on a flash bracket idealized the contrast and cleaned up the color (see *Flash Brackets* on page 126).

Flash photography is no longer formulaic and uncertain. I did not want too much flash here. It was important to maintain the feel, the mood, and the moment. With film, I would have to run calculations in my head, figure, guess, not until days later see if my decisions were sound. Digital allows me to respond visually, emotionally, technically, and immediately. In seconds, I was able to make and evaluate several test images, perfecting existing light and flash to my satisfaction.

I'm living proof you can teach an old dog new tricks. I get digital. I know when I get the shot.

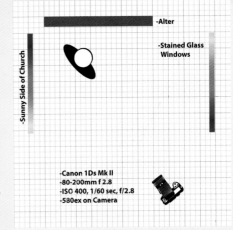

-Alter

-Stained Glass
 Windows

-Sunny Side of Church

-Canon 1Ds Mk II
-80-200mm f 2.8
-ISO 400, 1/60 sec, f/2.8
-580ex on Camera

COMPREHENDING FLASH EXPOSURE

Electronic flash can be directly compared to continuous light sources. The physical behavior of light remains the same regardless of whether it is constant or intermittent. **Light is light, is light, is light.**

A fluorescent light is a glass tube filled with gas producing light continuously when exposed to electric current in the same way as a flashtube. Imagine a camera in a completely dark room. The shutter is opened for one hour. During that hour, the fluorescent light is turned on for five seconds. Five seconds of light are recorded. Another one-hour exposure is made with the fluorescent light turned on for five minutes. Five minutes of light are recorded. In both examples, the brightness of the light remains constant. In both examples, the quantity of light recorded by the camera is not dependent on the shutter speed.

The similarities and the differences in exposure for continuous light sources and for electronic flash can be expressed in the following manner:

Continuous Light Exposure → ISO
+ Time Value (shutter speed)
+ aperture value (f/stop set on the camera)
+ Quantity of Continuous Light falling on the Subject

Flash Exposure → ISO
+ Time Value (flash duration)
+ aperture value (f/stop set on the camera)
+ Quantity of flash falling on the Subject*

* Where the quantity of flash falling on the subject depends on the guide number and the flash-to-subject distance.

TTL Flash and Exposure: A Primer

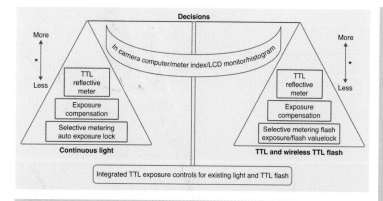

FIGURE 1.2 TTL EXPOSURE CONTROLS
TTL flash is based upon through-the-lens reflective flash metering. The exposure strategies are similar to reflective meter continuous light exposure strategies:
A. All reflective meters provide an exposure value based on exposure for a middle tonal value.[4]
i) If the reflective meter sees predominantly white or light tonal values, more exposure than the meter indicates may be required.
ii) If the reflective meter sees predominantly dark tonal values, less exposure than the meter indicates may be required.
B. Exposure Compensation is used to change the metered exposure for correct recording of different tonal values.
C. Flash Exposure Compensation is used to correct the flash exposure for subject reflectance, or whenever more or less flash is desired.

* Flash Exposure Compensation "+" may be required for light-toned subjects. Flash Exposure Compensation "–" may be required for dark-toned subjects.

[4] This is analogous to the 18% gray that is prevalent in film photography, where the average meter reading is when 18% of the light is reflected from an object.

TTL Electronic Flash: Definition

TTL Electronic Flash is a proprietary, integrated, computerized, automatic flash exposure system. A Through-The-Lens (TTL), in-camera flash meter works with brand-specific flash units. The lens, camera, and flash all communicate through a series of connections between camera and lens and a five-pin hot shoe between camera and flash. The flash's meter reads the amount of flash entering the camera and the camera's computer automatically adjusts the flash duration to provide a "standard" or "balanced" flash exposure. The flash meter evaluates the same scene the photographer sees in the viewfinder. The flash automatically responds to changes in focal length, aperture, ISO, flash-to-subject distance, subject reflectance, filters, and close-up accessories. The camera's computer automatically alters the flash exposure instantaneously in order to balance flash and ambient light in response to changes in the existing light exposure. TTL electronic flash is the most technologically sophisticated automatic flash system in the history of photography. I TTL, E TTL, E TTL II, etc. are all proprietary versions of TTL Electronic Flash.

There has been a paradigm shift with the introduction of computers making such a vast array of choices for us. No longer is linear thinking applicable. With parallel metering systems at play, one for available light, one for flash, there is a similar but different logic.

In manual mode, f/stops and shutter speeds perform pretty much as they always have. In the many versions of automatic, the camera's computer integrates many more parameters. To take advantage of all the benefits this new logic affords, it may make more sense if the photographer understands these automatic systems and the camera's logic.

TTL Exposure System

As stated before, the current Digital Single-Lens Reflex (dSLR) camera has two integrated metering systems: a TTL reflected light meter for continuous existing ambient light and a TTL reflected flash meter for compatible flash units. The camera computer reads, and/or balances existing light and flash based on input from the photographer and reflectance of the scene. These two metering systems provide separate, yet similar, controls for existing light and flash. When in an automatic exposure mode (S/Tv, A/Av or P), the dSLR makes it simple to control exposure because the LCD monitor and the histogram provide instant feedback. "Take a picture, take a look." Adjust accordingly by selecting + or – for more or less.

INVERSE SQUARE LAW
Why is "Distance" important?
The Inverse Square Law in physics explains that all light becomes less intense over distance.

$$\text{Intensity} = \frac{1}{\text{Distance}^2}$$

When the light-to-subject distance is doubled, only one-quarter of the quantity of light (two stops less) reaches the subject:

$$\text{Intensity} = \frac{1}{2^2} = \frac{1}{4}$$

When the light-to-subject distance is halved, four times the quantity of light (2 stops more) reaches the subject:

$$\text{Intensity} = \frac{1}{\left(\frac{1}{2}\right)^2} = 4$$

The quantity of light illuminating a subject is always dependent on light-to-subject distance.
TTL Flash will automatically respond to changes in flash-to-subject distance, within the "usable distance range" displayed on the flash LCD panel.

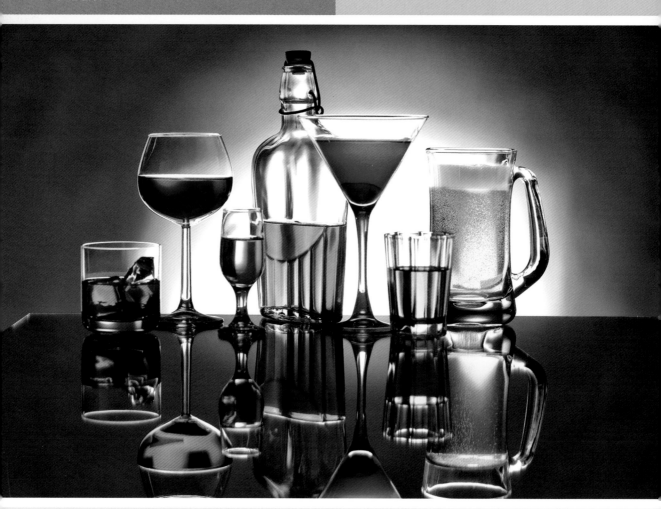

LIQUOR

Metal, glassware and shiny objects are especially taxing to photograph. Any light that you shine on them is reflected in the object. Hot spots are distracting and annoying. Banklights, striplights being a perfect example, have been designed so that when they show up in the picture they look "natural."

The color of the liquid is highly important with certain drinks. Glass allows the drinker to observe and admire the beautiful hue, and it is a selling point for the manufacturer, so photographers have been lighting these products from behind. Once you see how effective it is, you will attempt to light everything that way. It is a lot harder than it looks.

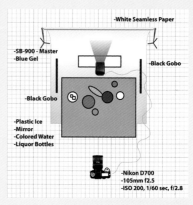

-White Seamless Paper

-SB-900 - Master
-Blue Gel

-Black Gobo

-Black Gobo

-Plastic Ice
-Mirror
-Colored Water
-Liquor Bottles

-Nikon D700
-105mm f2.5
-ISO 200, 1/60 sec, f/2.8

TTL Flash and Aperture

The aperture value set on the camera is communicated to the TTL flash by the camera's computer. With manual flash, or non-TTL automatic flash, changing the f/stop can change the relative amount of flash illumination in the picture. But TTL flash automatically changes flash power in response to changes in f/stop. The camera's computer adjusts the flash duration to maintain a constant relative flash exposure even at different f/stops. When no existing light is being used, making the same TTL flash picture at different f/stops will produce virtually the same histogram.

TTL Flash and Distance

Speedlights are small and compact, therefore power is limited. TTL flash displays a usable distance range on the LCD panel of the flash. The distance range shows the near and far limits of the flash's ability to provide a "standard" flash exposure and represents the minimum and maximum amounts of light the TTL flash can produce. The usable distance range is dependent upon ISO, aperture, and focal length. Stay within the limits of the distance range displayed on the flash. If you change f/stop, ISO, and/or focal length, check the distance range display on the flash.

TTL Flash and Subject Size

If the flash subject is very small in the picture, or if only a small portion of the picture is being illuminated with TTL flash, the flash may overcompensate. This is because the metering sensors cover the entire area and are making a "best estimate" for what is most important in the frame. Depending on meter pattern, the flash meter is looking to see a certain quantity of flash across the frame. It is logical for the flash to provide lots of flash to a subject that is taking up only a small portion of the frame.

Use Flash Exposure Compensation to ensure satisfactory flash exposure.

TTL Flash and Shutter Speed: Synchronization

The flash needs to fire while the shutter is open. This is called synchronization. Flash synchronizes with the shutter over a wide range of shutter speeds, from the longest shutter speed up to a faster shutter speed traditionally referred to as "X". With advances in shutter materials and designs, depending on the size of the digital sensor, many dSLR cameras can now synchronize with flash as fast as 1/250 or 1/500 sec. Refer to your camera instruction manual to find X for your particular camera. In older cameras, if you use a shutter speed faster than X, the flash will fire while the shutter blades are closing, resulting in a partially unlit image. With vertical-operating shutters, the top portion of the picture will show a flash lit image, the bottom part will be darker. Normal flash synchronization fires the flash at the beginning of the exposure. Other flash synchronization options, such as Slow Speed Synchronization, High Speed Synchronization/FP Focal Plane Flash, and Rear Curtain Sync/Second Curtain Synchronization are listed in Speedlight Components on page 11.

"X" is not "the" shutter speed to use with flash. X represents the fastest shutter speed usable with flash (except in Canon's High Speed Sync and Nikon's Auto FP Flash). Any and all shutter speeds from 30 to X may be used for regular flash photography. Explore different shutter speeds to change the amount of ambient light in your flash pictures.

> Most current dSLRs will not allow shutter speeds faster than X when the flash is turned on. The computer ensures that the flash and shutter are not accidentally "out of sync." To see this on your camera, set the camera to Manual and set a shutter speed faster than X, such as 1/2000 sec. Attach and turn on the flash. The shutter speed should now drop to 1/250, 1/200, or whatever X is for that camera. If the shutter speed does not drop to X, your Canon flash may be set to High Speed Sync or your Nikon camera may be set to "Auto FP Flash."

TTL Flash: Flash Anatomy and Features

The TTL flash offers many traditional functions and some unique features not found on other types of flash. These features and functions make the TTL flash a versatile problem-solving tool.

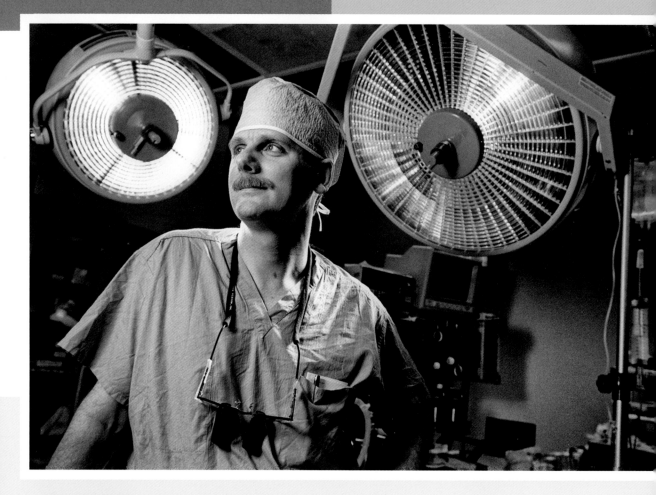

OPERATING ROOM

An editorial assignment from a national magazine allowed me to test the limits of a single Speedlight. I had to shoot a photo-essay about the ethics committee of a local hospital. The logistics were cumbersome. Doctors, nurses, ministers, and administrators are busy people.

We made appointments with each subject and did photographs in Neonatal Intensive Care Units (NICUs), libraries, boardrooms, X-ray rooms, etc. I wanted maximum flexibility because I intended to light everything. The amount of time we spent with each person varied enormously but the surgeon evaded us continuously.

The whole project was done with one Speedlight. Most of the images that were used in the story were done with a small softbox handheld by an assistant who followed the subjects in their daily routines. We finally got the surgeon who operates on fetuses in utero to agree to pose. I pushed him to let us photograph in an operating room. We scrubbed in and put on sterile surgical caps and gowns. One Speedlight on a custom-made TTL cord allowed my assistant to get as close as possible to the doctor. We just turned on all the operating theater lights and made them part of the image and used Program Mode to balance the available light.

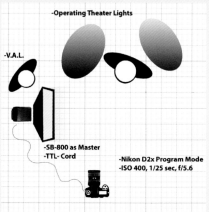

-Operating Theater Lights
-V.A.L.
-SB-800 as Master
-TTL- Cord
-Nikon D2x Program Mode
-ISO 400, 1/25 sec, f/5.6

Speedlight Components

1. Pilot Lamp or Ready Light

Illuminates when the flash is ready to fire. The pilot lamp/ready light displays on the back of the flash and in the camera viewfinder. The time it takes for the flash to be ready to fire is called the **recycling time**. Refer to the flash instruction manual for typical recycling times.

Nikon: Accessory battery holder SD800 adds a fifth AA battery to the SB800, giving 20% faster recycling times.

Canon: The 580EX MkII gives faster recycling time than the 580EX. The 580EX gives faster recycling times than the 550EX.

(See also, *Batteries*, page 135).

2. Flash Exposure Confirmation

Indicates the flash meter has detected a sufficient quantity of flash entering the camera.

Nikon: the Ready Light glows steady to confirm the flash exposure. The Ready Light blinks rapidly to indicate insufficient flash exposure.

Canon: small indicator light near the pilot lamp on the flash glows green to confirm sufficient flash exposure. It does not illuminate if the flash exposure is insufficient.

> If insufficient flash exposure is indicated, try one of the following: use a higher ISO, use a larger aperture, or move closer.

3. Bounce and Swivel Head

Rotates 360° and tilts up and down allowing the light to be pointed in different directions.

A downward tilt below horizontal is used for close subjects, to avoid a dark band at the bottom of the picture. Refer to the flash instruction manual for distance recommendations regarding the down tilt.

> In Remote/Slave flash operation, use the bounce and swivel feature to position the Wireless TTL Remote/Slave receiver toward the Master flash while at the same time pointing the Remote/Slave flash head toward the subject. (See *Wireless TTL Flash* on page 55.)

4. Built-in Wide Panel or Built-in Wide Flash Adapter

A Fresnel plastic covering that pulls out and flips down over the front of the flash. The wide panel changes the angle of illumination to provide even flash coverage for extreme wide-angle lenses. Refer to the flash instruction manual for focal lengths requiring the wide panel.

> The wide panel is not a diffuser. It does not make the light softer.

5. Catchlight Panel or Built-in Bounce Card

Pulls out with the wide panel. Retract the wide panel to use the bounce card. The primary purpose of the bounce card is to create catchlights in the eyes

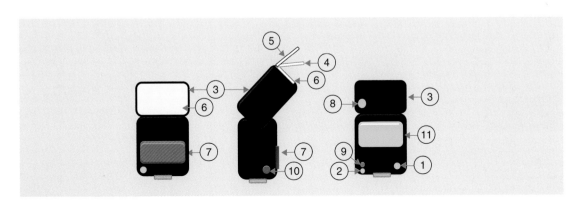

FIGURE 1.3 SPEEDLIGHT COMPONENTS

in outdoor portraits. The bounce card can also provide fill light in the eyes when bouncing the flash from a ceiling. Refer to the flash instruction manual for details about using the bounce card.

Nikon: the bounce card has a Control Button Quick Reference guide for setting the flash to Remote.

> Pull out the wide panel carefully. Excessive force can damage the flash.

6. Zoom Head

Internal mechanism that automatically changes the angle of illumination to match the angle of view of the lens. The zoom head can also be manually adjusted to change the angle of illumination as needed.

7. AF Assist Beam Emitter or Wide Area AF Assist Illuminator

The red panel on the front of the flash emits a striped, high contrast pattern onto the subject, allowing the camera autofocus system to operate in low light.

> Longer focal length settings are especially valuable to obtain a narrow angle of light. This creates a "spotlight" effect, useful when taking pictures down a hallway or aisle, or when edge falloff and vignetting is desired. Turn the flash head horizontally or vertically to shape the light to match the subject. Use the zoom head in conjunction with the bounce and swivel head to precisely place light.

Canon: on some camera models, the AF Assist Beam Emitter feature may be enabled or disabled through a camera Custom Function. Refer to the camera and the flash instruction manuals. When the flash is used as a Wireless TTL Slave, the red panel on the front of the flash blinks to indicate the flash is recycled and ready to fire.

8. Modeling Flash or Modeling Illuminator Button

The flash fires repeatedly for approximately one second, giving a visual preview of the effect of the flash on the subject. This "modeling light" can also be activated by pressing the depth of field preview button on the camera.

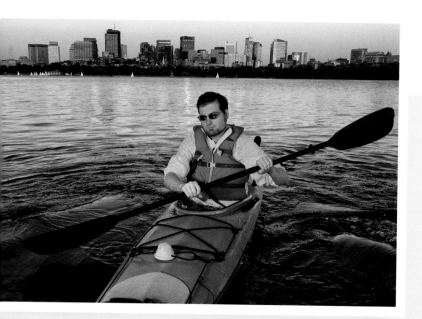

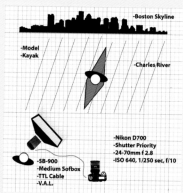

KAYAK

This shot of kayaking took several months to develop. I scouted a large expanse of the river to find a location where we could get the skyline large enough in the background. Once we found the launch site and a model who owned his own boat, we scheduled the shoot at sunset to take advantage of the sun lighting the face of the city. We hardwired the Speedlight to the camera using a TTL cord (see *TTL Cords* on page 130). My studio manager acted as VAL (see *VAL* on page 107) and aimed the softbox while I chased around to frame the shot.

Excessive use of modeling flash may cause overheating, damaging the flash. Refer to the flash instruction manual.

Nikon: there is a dedicated Modeling Illuminator button on some Nikon models.

9. Flash button

Press to test fire the flash.

10. Light sensor window for wireless remote flash

This sensor comes into play when triggering remote flashes with line-of-sight. (See *Wireless TTL Communication: Line-of-Sight* on page 61.)

It is important to identify this sensor because it needs to be clear when using wireless TTL flash. The sensor is on the side of Nikon Speedlights and on the front of Canon Speedlites.

11. LCD panel

See *The LCD* on page 16.

Features controlled through menus displayed on LCD:

a. Flash Exposure Compensation

Changes the quantity of flash in the picture without changing the aperture or the shutter speed. Compensates the flash exposure up to +/– three stops. Corrects the flash exposure for subject reflectance, fill flash, or whenever more or less flash exposure is desired. Flash Exposure Compensation can be set on the flash, or through the camera body. Refer to the camera and flash instruction manuals for details of setting Flash Exposure Compensation.

If Flash Exposure Compensation of more than +/– three stops is required, change the flash mode to "M" Manual.

Nikon: if the flash is already firing at maximum or minimum power, Flash Exposure Compensation settings will be limited.

Canon: if the flash is already firing at maximum or minimum power, Flash Exposure Compensation may have no effect on the flash exposure.

b. Flash Exposure Bracketing

Canon: allows a sequence of three pictures, each with a different quantity of preset flash. Refer to the flash instruction manual for details of flash exposure bracketing.

Nikon: not applicable.

c. Flash Exposure Lock or Flash Value Lock

Measures and locks the flash exposure for a selected area of a scene or subject, utilizing the partial or spot metering circle in the viewfinder. Use this feature when the subject is in front of a contrasting or reflective background, to freeze the metering on a select area while moving the framing for better composition, or when the flash subject is small in the picture. Refer to the camera and flash instruction manuals.

Canon: the AE Lock (*) button becomes the Flash Exposure Lock button when used with flash. Professional camera models have a separate FEL button.

Nikon: access the Flash Value Lock through the camera menu or program the function button on some cameras.

d. Slow Speed Synchronization/Flash Shutter Speed

Nikon: allows the use of shutter speeds slower than 1/60 sec. with flash in order to obtain the correct exposure in low-light conditions. Refer to the camera instruction manual.

Canon: not applicable.

e. High Speed Sync (FP Flash) or Auto FP (Focal Plane) Flash

This feature allows the use of flash with shutter speeds faster than 1/250th. The flash fires repeatedly until the shutter has traveled completely across the digital sensor. The effective flash-to-subject distance range is reduced with increases in shutter speed. Primarily used for outdoor fill flash in bright sunlight, if large apertures are desired to blur the background and can be applied to other situations. Not for use in regular, general flash photography.

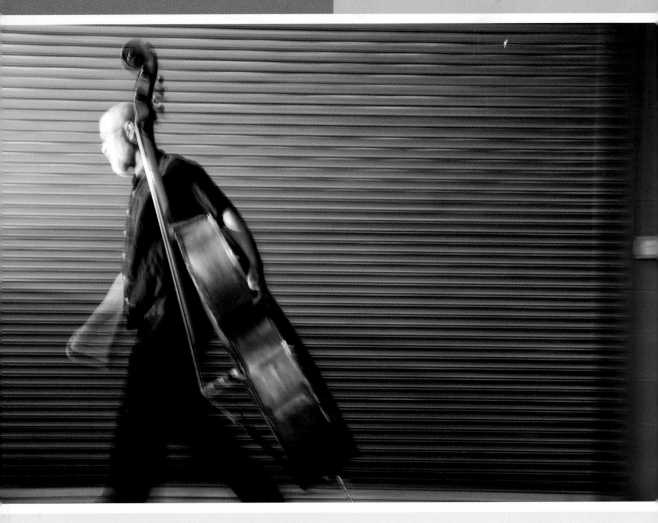

BASS

This image was chosen for the music CD for this artist. Before Rear Curtain Sync/Second Curtain Synchronization, this type of image was nearly impossible. But Speedlights on automatic make it almost child's play.

In my studio, I set the single Speedlight up just out of frame on the left. It was gobo-ed (see *Light Modifiers* on page 111) to prevent light from spilling into the lens. With the Nikon D2x on a tripod, I was able to smoothly pan with the jazz musician as he walked toward the flash. The flash's internal computer calculated the quickly changing distance between the subject and Speedlight. It was simply a matter of capturing the best body language. We could judge aesthetics after every exposure by checking the LCD and histogram.

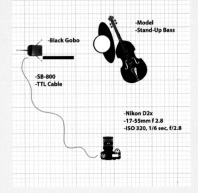

-Black Gobo

-Model
-Stand-Up Bass

-SB-800
-TTL Cable

-Nikon D2x
-17-55mm f 2.8
-ISO 320, 1/6 sec, f/2.8

Refer to both the camera and flash instruction manuals. This flash feature may be selected on the flash or through the camera menu, depending on camera model.

f. Rear Curtain Sync or Second Curtain Synchronization

Normal flash synchronization fires the flash immediately after the shutter opens. Rear/Second Curtain Sync fires the flash at the end of the exposure, just before the shutter closes. This technique ensures that in flash pictures of a moving subject the blurring trails behind the subject's movement, rather than in front, creating a more realistic sense of movement in still photographs. This function is unique to TTL flash and compatible cameras with electronic focal plane shutters.

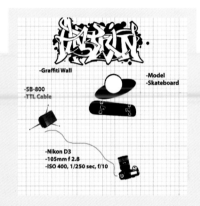

SKATEBOARD

Finding all the elements of this photograph took time. I scouted several walls covered with graffiti. We interviewed a number of potential models with sufficient tattoos that my studio manager found using Craigslist.com. Even the skateboard adorned with manufacturer decals gave us difficulty.

As abstract as the image needed to be, all we needed was a small amount of fill light from the off-camera flash. It was freezing on the day of the shoot. The model was a real trooper to pose only in a t-shirt.

Refer to both the camera and flash instruction manuals. Depending on camera model, this flash feature might be selected on the flash or through the camera menu.

g. Multi Stroboscopic Flash or Repeating Flash
The flash will fire multiple times in rapid succession during a single exposure, creating multiple exposures of an object or a sequence of a moving object in one image. Best results are obtained with light-toned subjects against dark-toned backgrounds.

> Rear/Second Curtain Sync is most effective at slower shutter speeds, such as 1/15 and 1/8 sec. and works best with light-toned subjects against dark-toned backgrounds. Underexpose the existing light. Holding the camera still will record motion trails behind a moving subject. Panning the camera with the moving subject will record a relatively sharp subject with the background showing motion blur.

> Excessive use of multi/repeating flash may cause overheating, damaging the flash. Refer to the flash instruction manual for operation and exposure calculations.

h. Manual Flash Mode
Manual Flash Mode can be selected in both automatic exposure and manual exposure camera modes. Flash power is selected manually by the photographer. Satisfactory flash exposure can be obtained by referring to the LCD panel, calculation using the guide number, using a handheld flash meter, or by studying the histogram. Refer to the flash instruction manual and the Manual Flash section on page 67.

Some Canon camera models offer in-camera metering of Manual flash.

The LCD

> The Liquid Crystal Display (LCD) is the viewing screen on the back of most digital cameras. The LCD monitor displays the results after an exposure. The LCD image is used to judge composition, framing, expression, gesture, moment. The LCD shows basic visual elements and the relative brightness values between these elements. It is also possible to make approximations concerning color temperature and white. On some dSLRs, the LCD can be used as a live viewfinder to compose images. It can also be used for paging through and editing images and on most models this is where the menus for camera functions can be accessed.

> The LCD uses a great deal of battery power. Excessive or lengthy use of the monitor can quickly drain batteries.

> The LCD is a backlit display, just like a computer monitor. While a print transmits reflected light and reflected colors to our eyes, a backlit display transmits "direct color" to our eyes. An image that looks "perfect" and rich to our eyes on a calibrated computer monitor will often produce a dark muddy print; an LCD image that looks "perfect" and rich is generally 1 or 2 stops underexposed in the file. To better train your eyes to using the camera LCD, select a well-exposed file with a correct highlight point and good contrast. Display the image on both the camera LCD and on a correctly calibrated computer monitor. Compare the two images and note the differences. By necessity, we must understand the LCD image will often look too light to our eyes. The viewing environment also affects our judgment of the LCD image. There are various aftermarket folding and rigid hoods and magnifiers that can shade the LCD in bright sunlight. Be aware the LCD image may look even brighter when viewed in low light. Training the eyes is the best way to utilize the LCD.
> The LCD is an important tool for judging relative exposure values. Example: a picture of a person lit with flash in the foreground and with bright sunlight in the background. The histogram highlight point will indicate if the background highlights have detail. The shadow point will indicate the detail levels of the dark values. But what about the skin tone? There is no way of telling exactly where in the graph the skin tone falls. The value of the skin tone exposure in the picture must often be judged visually.
> The Highlight Alert function in the menu activates the "blinkies." When viewing the image on the camera LCD, areas of overexposed pixels lacking detail will blink. "Blinkies" only warn of overexposed pixels.

A great way to judge exposure for skin tone is a look for "blinkies." Example: in a wedding photo, bring the exposure value up until the bride's white dress begins to blink, indicating overexposure. Reduce the exposure value (EV) by a third of a stop to eliminate the "blinkies." That will place the highlight point for the dress correctly as a "white with detail" in the histogram and in the file. If the dress is correctly exposed, the skin tone is correctly exposed as well. Also do this when there are specular highlights on skin, aka "shine." Increase exposure value until "blinkies" just appear in the highlights, and then reduce the EV by one-third of a stop. With the specular highlights holding detail, the rest of the skin tone exposure is maximized in the file.

For proper exposure, it is important to remember the meter, the image preview on the LCD, the Highlight Alert, and the histogram provide different information. All should be utilized in the decision-making process. The LCD preview is based on the rendered gamma-corrected JPEG, even if shooting in RAW-only mode. The feedback on the LCD is only part of the message. It displays a deceptively high level of contrast. A technically correct exposure often produces an ugly LCD image. A rich, vibrant JPEG preview on the LCD can often result in an image file as much as 1½ stops underexposed. Therefore it is necessary for the photographer to comprehend and analyze the data from the meter, the LCD, the blinkies, and the histogram.

Measuring Light

Despite all the rhetoric differentiating digital from film, there has been a paradigm shift in technology. It has altered the way we should think about taking quality pictures. The vocabulary, as well as function, has changed. Workflow versus processing, archiving instead of editing, and, because computers are making most of the decisions, even exposing an image has been affected.

In the past, to make the ideal black and white film negative we were instructed to "expose for the shadows, develop for the highlights." With positive color films, we exposed to hold detail in the highlights, and let the shadows fall where they may. With digital, the object is to place as much data within the RAW/NEF file as possible. However, just getting the

exposure "between the uprights" of the histogram is not enough. And we should not rely on the crutch of postproduction. You must be conscientious about getting a good, original exposure. In linear digital capture, the brightest stop of highlight data contains half of all the information contained in the entire image. The next stop represents half the remaining information and so on. A file has the greatest chance to reproduce detail if the information is justified closest to the highlight side of the RAW/NEF file. The current mantra for the new ideology is **Expose To The Right** (ETTR), placing the highlight point of the histogram by adjusting the camera exposure value to maximize file information. This is especially important with higher ISOs. (See the *Histogram* section on page 23.)

Understanding the Light Meter

Correct exposure in photography is a function of the incident light and the sensitivity to that light. If the light and the ISO remain the same, exposure remains the same, regardless of the color or tonal value of the subject. The only exception is with shiny reflective subjects, such as chrome and steel.

An **incident light** meter is held directly in front of the subject. It has a translucent dome over the meter cell which is pointed toward the light source to be measured. The incident meter measures the quantity of light falling on that subject. In general photography, the incident meter always indicates a correct exposure value.

The dSLR camera has two built-in light metering systems. One meter system measures the amount of continuous ambient light reflecting from the scene. A second system measures the amount of flash from a Speedlight reflecting off a subject. Both built-in meters are **reflective meters**. Reflective meters do not satisfy the correct exposure criteria, as reflective meters measure reflected light values rather than incident light levels. A change in subject reflectance will cause the reflective meter to indicate a change in exposure, even if the light falling on the subject and the ISO remain the same. Therefore, reflective light meters do not always indicate technically correct exposure values.

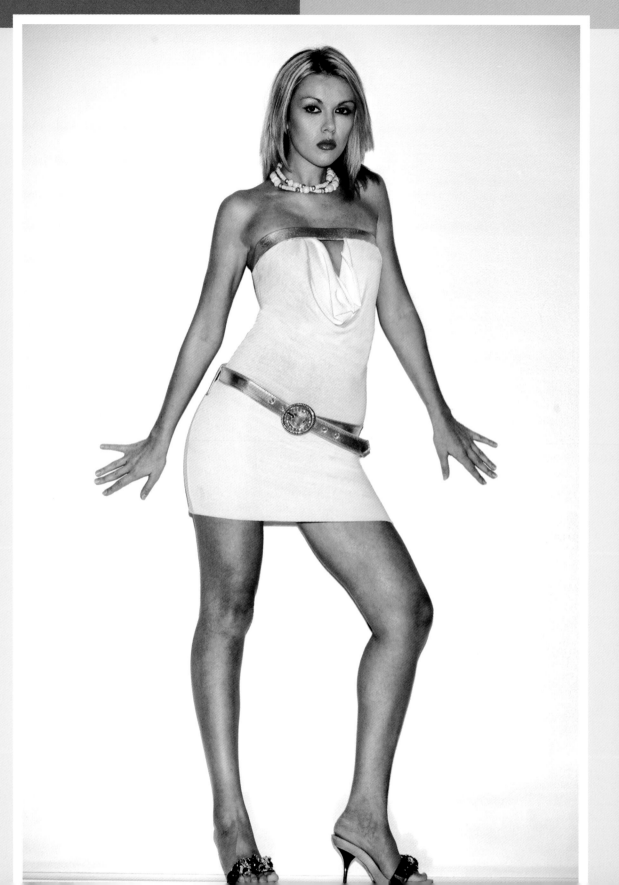

A professional soccer match at midday is an example of when a reflective meter may give a rollercoaster of inconsistent exposure values. If the light falling on the field remains the same, the correct exposure for all the action on the field will remain the same. The camera can be set to one correct exposure value for all pictures. The reflective meter however may see a rapidly changing array of reflectance values, such as a player in a light-colored uniform running in front of a variety of light and dark advertisements along the edge of the field, surrounded by opposing players in dark uniforms. Even though the light remains the same, the reflected meter will indicate different exposure values. Many of these will be incorrect.

The reflective meter is a simple comparative measuring instrument rather than absolute truth. Zero on the reflective meter has been a standard reference point for determining exposure for generations, whether working with older mechanical analog devices or modern backlit electronic displays. Setting the exposure compensation to zero, manually making the meter go to zero in the viewfinder, or rotating a dial on a handheld meter to center a needle will indicate the relative amount of light needed to render the scene as a middle tonal value. A wall photographed with the meter at zero will result in an underexposed image file. The white wall will be recorded as a middle tonal value. A black luggage bag against a black curtain photographed

with the meter at zero will likely be overexposed. The dark tones will be exposed closer to middle tonal values. The amount of this effect will depend on the meter pattern or meter mode on the camera. Evaluative and **Matrix** metering allows the camera's computer to evaluate information and apply exposure compensation for subject reflectance on its own. Any change applied by the photographer is in addition to compensation by the computer. Center Weighted Averaging, Partial, and Spot metering put exposure decisions purely in the hands of the photographer.

Ultimately, it is up to the photographer to tell the meter and the computer what to make the picture look like. If it contains mostly light tones, the photographer instructs the camera to correctly expose this scene by setting the meter to read at +, where light tonal values live on the scale. The more whites, the more +. If the picture is mostly dark, the photographer moves the meter to –, where the dark values are. This remains true regardless of the intensity or dimness of the light. Correctly exposing a light scene still requires + in bright or low light conditions. In general, to consistently achieve maximized exposure values, consider the tonal values in the viewfinder, evaluate the meter setting according to the predominant tonal values, and analyze the resulting values as indicated by the histogram. All of these steps combine to ensure a maximum amount

ANYA IN WHITE
This image was made with one direct, unmodified, Speedlite mounted on a professional flash bracket (see *Flash Brackets* on page 126) on a handheld camera. The center of the Speedlite is located close above the center of the lens, producing a front light. The full length is shot with a 110mm focal length at a distance of 25 feet with the model against the white back wall of the studio. The longer distance creates a narrow angle between the center of the lens and the center of the flash, providing a nearly shadowless light. The shadow is projected almost straight behind the subject. The flash compensation is + 1²/₃ because of the predominance of white and light tones in the scene, adjusted according to the histogram. The overhead lights in the studio were left on to keep the ambient level bright and the pupils closed down, preventing red eye. The shutter speed was high to eliminate the effect of the ambient light 1/250 at f/4.5, ISO 100. Simple and effective.

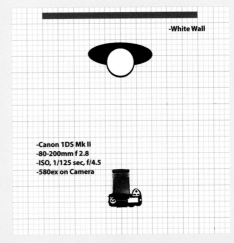

-White Wall

-Canon 1DS Mk II
-80-200mm f 2.8
-ISO, 1/125 sec, f/4.5
-580ex on Camera

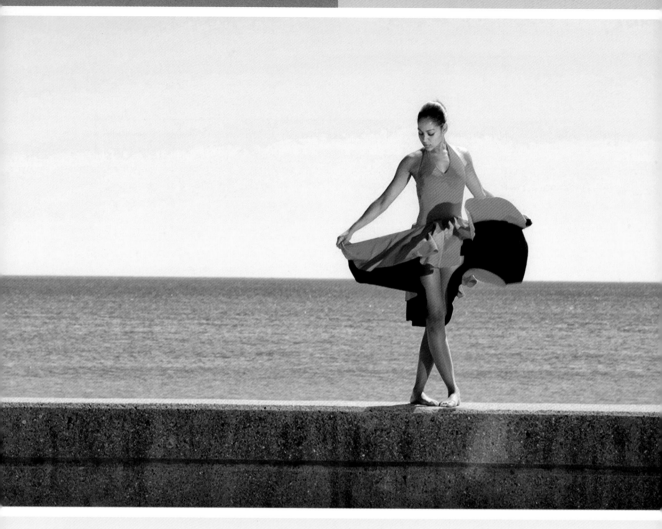

DANCER

This was a cover photograph. We interviewed several Latin dancers to find our model. The art director wanted the ocean on the horizon so she could drop in text. My studio is near a shoreline, so we merely had to find the appropriate setting.

I wanted to use a telephoto. The lens compressed the distance between the water and model but it put the camera quite a distance from the dancer and Speedlight. In bright daylight we were at the limits of line-of-sight. Because communication was intermittent, we decided to use PocketWizards® Plus II's (see *PocketWizards®* on page 125). The dancer was backlit by the sun. We used a fill light on her face and dress to reduce contrast.

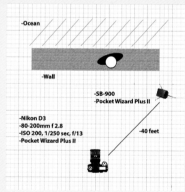

-Ocean

-Wall

-SB-900
-Pocket Wizard Plus II

-Nikon D3
-80-200mm f 2.8
-ISO 200, 1/250 sec, f/13
-Pocket Wizard Plus II

-40 feet

of usable information in the digital image file, i.e. correct exposure.

In summary, for existing continuous ambient light and for flash, the reflective meter provides the following:

1. Measures the amount of light reflecting off the subject.
2. Provides the exposure value needed to record the scene as a middle tonal value. The meter reading changes with subject reflectance.
 i. White tones may require more exposure, more light.
 ii. Dark tones may require less exposure, less light.

> Shoot to the histogram. Use exposure compensation to adjust the histogram, to adjust the recorded (captured) tonal values in the file.

Stops, F/Stops, Exposure Value

> Photographers must learn both a visual language and a technical language. The definitions and terms in photography allow photographers to quantify light and to communicate with each other.
>
> Open one stop. Overexpose one stop. Give one stop more flash. These three statements use a common term: **stop**. Yet each statement denotes distinctly different decisions and actions, triggering chains of events with differing end results.
>
> Literally, the word stop refers to the mechanism of the iris diaphragm. A stop is a physical barrier in the lens that regulates the amount of light passing through the lens. In practice, the word stop represents distinct changes in quantities of light entering the camera, on a subject, or being emitted by a light source. When any quantity of light is doubled, that quantity of light is termed one stop more light. When the quantity of light is halved the result is one stop less.
>
> Plus one stop or minus one stop does not automatically mean changing just the aperture. Depending on the desired visual effect, a one-stop change can be accomplished by changing shutter speed, changing f/stop number, or a combination of the two. Changing the amount of light with shutter speed will shift the histogram and alter the recording of motion. Changing with f/stop will shift the histogram and change depth of field. To say "open one stop" or "close one stop" specifically refers to changing the f/stop number, opening or closing the aperture diameter.

ISO is compared in stops. When ISO is doubled, the sensitivity to light is doubled. ISO 200 is one stop more sensitive than ISO 100 and only requires half the light to obtain correct exposure. Changing the ISO will shift the histogram without changing shutter speed or f/stop number.

The quantity of light falling on the subject and the quantity of light being provided by a flash are also measured or expressed in stops. If the light falling on a subject is doubled, that quantity is said to have increased by one stop. With flash, if the flash duration is halved, the flash will be reduced by a stop. In both cases, by changing the quantity of light, the histogram is shifted without changing shutter speed, aperture, or ISO settings. Comprehending exposure expands the aesthetic possibilities.

The term f/stop causes much confusion and conflict. For the lens, f/stop defines a specific quantity of light entering the camera and relates directly to the diameter of the aperture. F/2.8 is a larger diameter opening, so f/2.8 is a large aperture. F/22 is a small diameter opening, so f/22 is a small aperture. F/stop is one element of depth of field. F/stop is used as a word, is labeled by a number, and actually expresses an equation.

$$\frac{\text{Focal length}}{\text{Diameter of the aperture}} = \left\{ \begin{array}{l} 1.4 \\ 2 \\ 2.8 \\ 4 \\ 5.6 \\ 8 \\ 11 \\ 16 \\ 22 \end{array} \right.$$

This equation explains why a tiny opening on a wide-angle lens lets in the same amount of light as a much larger opening on a long telephoto.

F/8 worth of light through the lens is the same for all lenses set to f/8. If the lens designer has succeeded, the photographer can trust that f/stop number is a constant. Consumer grade zoom lenses are often variable aperture lens, where the f/stop number changes as the focal length is changed. Actually, with these lenses, the aperture diameter remains the same as the focal length changes. These lenses may be f/3.5 at a wide focal length, yet only let in f/5.6 at a long focal length at the same maximum aperture diameter.

A constant aperture lens has a complex mechanism that precisely adjusts the aperture diameter as the focal length is changed, resulting in a constant maximum f/stop number at all focal lengths.

Since f/stop defines a specific quantity of light, f/stop is an aperture value worth of light entering the camera, on the subject, or being emitted from a light source. Aperture value can be used to quantify light in almost any context. A flash may provide f/5.6 worth of flash. If the flash is doubled, it will provide f/8 worth of flash, which is one stop greater than f/5.6.

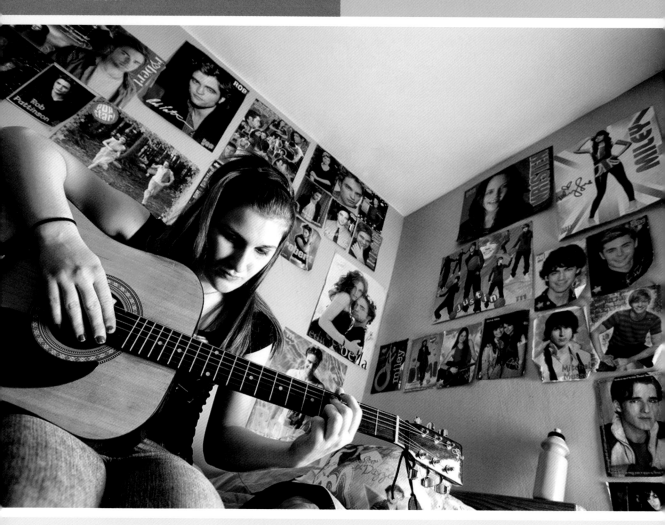

GUITAR

We were commissioned to do a multimedia program inside an adolescent, head trauma facility. We had to be in tune with these wonderful kids, and sensitive to their moods and abilities. Since we were not sure that every person could accommodate what we were doing, I utilized a "flying" technique that I devised years ago. By using hand signals to direct my assistant VAL (see *VAL* on page 107) I can follow people in their normal lives with minimum interference. One light and this method was all that was necessary to achieve the documentary effect I was after, while getting the studio-like quality for the final image/sound/graphics production.

I spent weeks following the kids in their school and in their daily lives. Eventually they all got used to me. A Speedlight on Programmed Mode let me take frame after frame with correct exposure. There was no chance to repeat anything, so every moment and expression was important. Documenting the children's maneuvers through life was an experience I will never forget. It was the assignment of a lifetime.

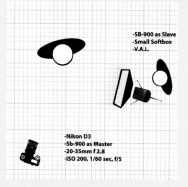

-SB-900 as Slave
-Small Softbox
-V.A.L.

-Nikon D3
-Sb-900 as Master
-20-35mm f 2.8
-ISO 200, 1/60 sec, f/5

EXPOSURE VALUE, OR EV

Exposure value, or EV, is another common photographic term requiring clarification. It denotes all combinations of shutter speed and relative aperture that give the same exposure.

Many light meters and camera systems are calibrated to operate using the EV system. EV 0 is 1 second at f/1.0. Interpolating shutter speed and aperture values: EV 0 is also 8 seconds at f/2.8, EV 1 is 4 seconds at f/2.8, EV 2 is 2 seconds at f/2.8, EV 3 is 1 second at f/2.8, EV 4 is 0.5 seconds at f/2.8, etc. Since EV indicates a specific quantity of light, different combinations of shutter speed and aperture will produce that same EV, and are called **Equivalent Exposures**. Equivalent Exposures maintain the same quantity of light while giving the photographer creative choices in the recording of motion and depth of field, and allow flexibility in responding to individual situations.

Example:

EV 12 =
- 1/4000 second at f/1.0
- 1/2000 second at f/1.4
- 1/1000 second at f/2
- 1/500 second at f/2.8
- 1/250 second at f/4
- 1/125 second at f/5.6
- 1/60 second at f/8
- 1/30 second at f/11
- 1/15 second at f/16
- 1/8 second at f/22
- 1/4 second at f/32

In some cases, the desired visual effect determines the need for a particular EV. The photographer may be faced with an image where stopping motion, great depth of field, and low light are all necessary. In this case, a high ISO may be required to successfully achieve an EV with a fast shutter and a small aperture that also gives a technically correct quantity of light.

A change in one EV results in a change of one stop. + 1 EV is equivalent to plus one stop, - 1 EV to minus one stop. Once again, this does not automatically mean to change just the f/stop number.

In review, "plus one stop" can be accomplished with shutter speed, aperture, ISO, and/or light. "Open one stop" means a larger f/stop number. "One stop more flash" requires changing the flash exposure compensation. To obtain a one-stop faster shutter speed with the lens aperture wide open, double the ISO. The photographer must become more precise in comprehension and retention of vocabulary and pay close attention to context. Inaccuracies lead to unsatisfactory results. Precise photographic vocabulary results in more fluid problem-solving.

Canon: Aperture Priority exposure mode is Av, in which the photographer selects the aperture value of the exposure. Shutter Priority exposure mode is Tv, in which the photographer selects the time value of the exposure.

Nikon: Aperture Priority mode is A and Shutter Priority is S.

Histogram

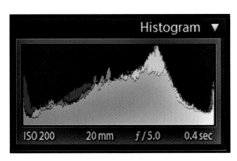

The camera LCD monitor is a great place to make decisions regarding cropping, composition, expression, gesture, and sharpness and to evaluate lighting. But the appearance of the digital image on the camera LCD monitor is not an accurate depiction of the actual digital image file exposure. In most cases, if an image looks "perfectly" exposed on the camera LCD monitor, it is more than likely suffering one or more stops of underexposure. A better way of making exposure decisions is to use the histogram. The histogram is one of the most powerful exposure instruments provided to photographers. The histogram far surpasses the Polaroid as a testing tool and is instantly available for *every* image as we shoot. Resist the temptation of relying solely on the LCD for previewing.

In general, there is no universal or ideal histogram. A good histogram is one that accurately

The Luminosity or Bright **histogram** is a true graphic representation of tonal values as recorded in the digital image file. The **histogram** is a graph: brightness on the horizontal axis (x-axis) and number of pixels at each brightness level on the vertical axis (y-axis). This mapping of the tonal values in an image allows the photographer to see the accuracy and spread of the exposure over the camera's dynamic range. The left and right edges of the histogram represent the limits of the digital sensor's capability to hold shadow and highlight details. The extremes of the histogram display represent the dynamic range of the sensor. Pixels piled up against or touching the right edge of the histogram represent pixels overexposed with no detail. These are pixels recorded as "pure paper white," since no ink will be deposited in these areas when printed. Pixels touching the left side of the histogram represent pixels exposed as pure black with no detail. Besides the full histogram, the LCD often displays three distinct graphs, representing the three color channels, red, green, and blue. The height of the spikes represents the number of pixels exposed at any one tonal value. High spikes represent large numbers of pixels exposed at that tonal value, low spikes represent few pixels exposed.

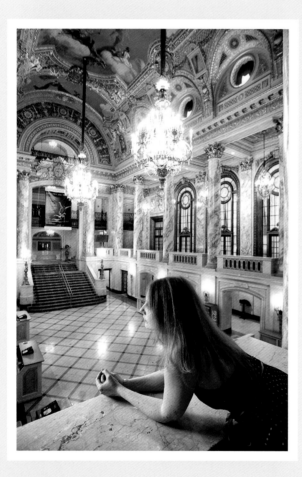

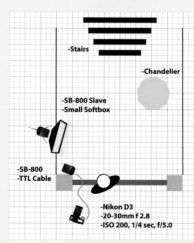

-Stairs

-Chandelier

-SB-800 Slave
-Small Softbox

-SB-800
-TTL Cable

-Nikon D3
-20-30mm f 2.8
-ISO 200, 1/4 sec, f/5.0

THEATER

A lot of commercial photography has little to do with taking pictures. Shooting the opulent lobby of this venerable theater required calling in a lot of favors. We had to get permissions from the theater company; the unions, who had to be on site to "help" with the production even though they were not needed; and the manager, who gave us a lot of administrative trouble but was very helpful once we were on location.

I had three assistants for efficiency. One of them brought a dress so we could also use her as model. Because we did not have time to light the entire space, this was a perfect opportunity to employ the amazing Rear Curtain Sync/Second Curtain Synchronization (see *Speedlight Components* on page 11). The light contribution of the Speedlight/softbox was balanced automatically. Since the available light was tungsten, the strobe matched the prevailing color balance in the room so you barely notice the daylight coming in through the windows has shifted very blue, allowing the huge lobby to bask in all its historical glory. (See *Balancing TTL Flash and Available Light: Colors of Light* on page 48.)

Each section of the histogram represents approximately one stop of tonal value. Determine the number of stops to change on the camera exposure by counting the number of sections the highlight point needs to be moved on the histogram.

represents the tonal values as existing in the scene, or more specifically, represents the photographer's vision.

The following diagram shows the correlation between the sections, or "bars," of the histogram, and the tonal values they represent as recorded in the image file.

Canon cameras display a five-section histogram. Nikon cameras may display a four- or a five-section histogram depending on sensor.

Because digital is a direct positive image capture, similar to color transparency film and Polaroid prints, the concern with most images is to hold highlight detail. The brightest highlight value in the scene is represented by the **highlight point**. A highlight point that touches or piles up against the right edge of the histogram indicates overexposed highlights. The highlight point is used to judge exposure. It is the brightest tone in the picture. To shift the highlight point to the right, allow more light into the camera. To shift the highlight point to the left, allow

less light. The entire histogram moves as the highlight point is moved.

Once the highlight point is placed to the photographer's satisfaction, the **shadow point** now defines the contrast level of the scene or lighting. The width of the histogram indicates the contrast range of the scene. With a satisfactory highlight point, a shadow point touching or piling up on the left indicates high contrast with loss of shadow detail. (For suggestions regarding controlling contrast, see *Characteristics of Light: Analysis and Decisions*; Contrast on page 34 and 39.) Looking at the diagram, consider the following examples:

1. A "polar bear in a snow storm," correctly exposed, should display a histogram with the majority of the tonal values in the "white with detail" section. To ensure detail in all the white values, no pixels should touch the extreme right edge. A small "bump" may appear in the "black with detail" section, representing the bear's black nose and claws.
2. A group of groomsmen in black tuxedos against a dark toned background, correctly exposed, should show the majority of tonal values in the "black with detail" and "dark tones" sections. Depending on skin tone, the faces may display in the "middle light" or "white with detail" sections. White shirts would also display in these sections. To ensure detail in all the white values, no pixels should touch the extreme right edge. To ensure full shadow and tuxedo details, no pixels should touch the extreme left edge.
3. A scene containing green grass, red brick, and blue sky, correctly exposed, would display the majority of tonal values in the middle, as these are all middle tonal values of these colors.

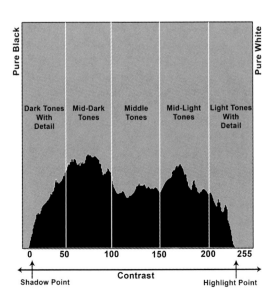

FIGURE 1.4 HISTOGRAM SECTIONS AND TONAL VALUES

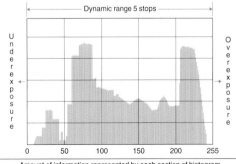

FIGURE 1.5 HISTOGRAM DYNAMIC RANGE

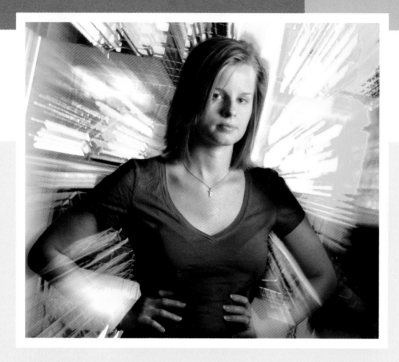

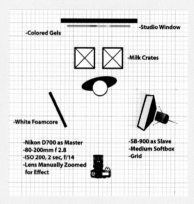

ZOOMING LIGHTS

To accomplish this kind of photograph I needed a continuous, even light source in the background. In this case I used a studio window. My assistants put different colored gels in a patchwork on the windowpane. To control exposure, shutter priority was the obvious choice. With a bit of experimentation I settled on one second. It gave me enough time to turn the zooming collar manually. We had to overexpose the foreground because the window was such a powerful source. I zoomed from short focal length to long focal length. This froze the portrait and blurred the colorful "lines" in the latter part of the extended time. I tried using rear curtain and zoomed in the opposite direction too. The idea was to get the flash at the end of the second. They appeared fairly similar.

> **Underexposure provides no benefit.**
> Underexposure causes excessive noise in shadows at all ISO settings.

In linear data capture a typical 12-bit image can record 4,096 distinct levels of intensity for each pixel. The dynamic range of most dSLRs is about five stops. Half of the levels (2,048) are represented by the right fifth of the histogram. Half of the remaining levels (1,024) are contained in the next brightest stop. The third stop holds half again as much information (512). The darkest stop or the far left fifth, has only 128 levels of capture data.

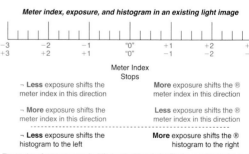

FIGURE 1.6 EXPOSURE METER VERSUS HISTOGRAM

RGB Histogram

The **RGB histogram** shows the exposure levels for each of the three color channels making up the digital image file: red, green, and blue. The RGB

histogram is used to ensure visible detail in all color channels. There may be images where the Bright or Luminosity histogram shows no overexposed pixels, yet the "blinkies" indicate loss of detail. This may be a case where highlight tonal value, or color, is being held, but those areas have no visible detail. For these situations, view the RGB histogram to determine if one of the color channels is touching the right edge, indicating overexposure. Reduce the camera exposure to ensure highlight detail in all channels.

With the combination of the LCD and the histogram, the modern photographer has a frame-by-frame accounting and metering system of unprecedented capabilities. Learning to interpret the data is essential for Speedlight usage.

Exposure: Film vs. Digital

All the fundamental principles of physics remain the same. But with a new medium of storage, scientists, engineers, and practitioners have found that we can achieve better results with some reevaluation.

As with film, there is a finite capability. Digital may have an extended five-stop range, more than E-6 or C-41 color films, but not as wide as black/white film. Digital is still not capable of recording

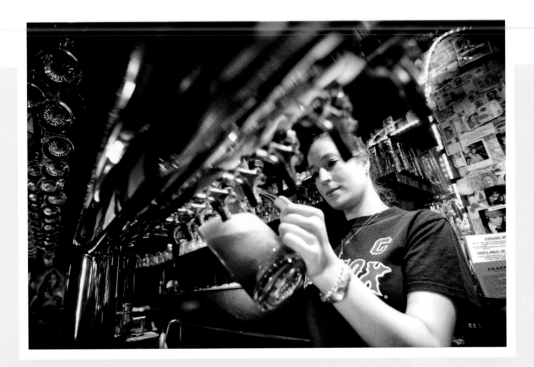

BARTENDER
We were commissioned to shoot this famous bar. I corralled several patrons into different areas around the room to show off the environment. But the glassware behind the bar caught my eye. The female bartender kept going back to pour beer and each time I had my assistant VAL chase her when she returned to this spot (see *VAL* on page 107). He held the small softbox just outside the frame and I pressed my wide-angle lens as close to the glasses as possible (see *Softboxes* on page 113). The extreme angle and the colors of the lights reflecting off glass and metal made the whole shot work.

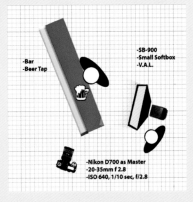

-SB-900
-Small Softbox
-V.A.L.

-Bar
-Beer Tap

-Nikon D700 as Master
-20-35mm f 2.8
-ISO 640, 1/10 sec, f/2.8

all the tones, values, and details seen by the human eye.

Exposure decisions are based upon holding detail in the highlights, similar to metering and exposing color transparency film. Except for special effect, never overexpose highlights, even though in high contrast scenes, shadow values fall where they may. Different from using a light meter, which does not inform you of as many details, you should be paying close attention to the histogram. If you comprehend the commonalities of digital versus analog, it is easier to take advantage of the differences.

Middle Tonal Value

To continue the analogy, in digital photography, Exposure Value (EV) is the combination of shutter speed and aperture that defines the quantity of light entering the camera. The reflective meter indicates what tonal value the image will be at that EV. The "standard exposure value" is when the meter index is aligned with "0" and this, through a complicated set of algorithms, renders the predominant tones in the viewfinder as **middle tonal value** in the digital file. Examples of middle tonal values in color, i.e. the 18% gray of analog photography, are green grass, red brick, and clear blue sky. The "gray" is not important, and is abstract for color photography; the key is the 18% reflectance. Colors that reflect 18% of the light are middle tonal values, also known as "zero." Colors that reflect less than 18% of the light are dark tonal values, or "minus", or "darker than zero." Colors that reflect more than 18% are light tonal values, also known as "plus" and "lighter than zero." A correct EV is when the meter is set to the correct tonal value of the scene.

Like hidden detail in the film negative, if information is contained "between the uprights" of the histogram, we can access that detail using software to enhance the final print. Adjustments levels can bring out buried shadow detail by redistributing dark pixels into lighter tonal values. A proper digital workflow maximizes the highlight information in capture, then works on maximizing the shadow detail in post. This is analogous to latitude in film.

> The standard metered (EV) i.e. the meter at 0, may not be the "correct" exposure value for the picture you are making.

Exposure Compensation

With old manual film cameras, the shutter speed and aperture were the sole devices to alter exposure. There is a new sheriff in town. Digital technology has introduced a new method. To maximize the amount of information in the digital file, use Exposure Compensation to shift the histogram, placing highlight values in the scene as high as you can on the histogram, without overexposing the highlights, i.e. Expose To The Right (ETTR).

The camera makes different decisions depending upon what mode you are in. If you change the EV in Aperture Priority or Shutter Priority, the camera has only one variable to adjust. In Program Mode, changing the EV can change both aperture and shutter according to various factors.

> Aperture of f/8 and a shutter speed of 1/125 of a second at ISO 100 is 13 EV.

> If you need to shift the histogram more than Exposure Compensation allows, go to Manual Exposure Mode.

> The reflected meter reading can be adversely affected by many common scenes. Use EV compensation to correct the reflected meter reading in the following scenarios:
> Predominantly white or light toned scenes such as snow, sand, or a white dress may require Exposure Compensation of +1 EV to +2 EV.
> Predominantly dark toned scenes such as tuxedoes or spotlit theater stages might need Exposure Compensation of -1 EV to -2 EV.
> Backlit, top-lit, and side-lit subjects can use Exposure Compensation of -1 EV to -2 EV.
> Shadowed subjects against brighter backgrounds such as subjects with sunny backgrounds or a subject with a window in the background might need Exposure Compensation of +1 EV to +2 EV.
> Night photos with light sources in the picture such as streetlights, neon signs, or headlights, or when shooting toward the sun could require Exposure Compensation of +1 EV to +2 EV.

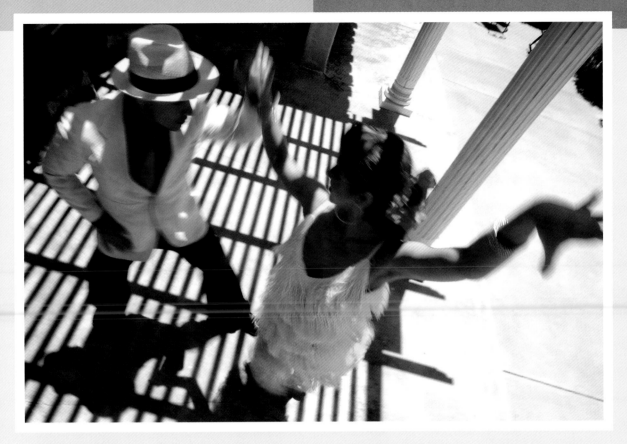

LATIN DANCERS

My assistant and I shot all day inside a dance studio. I learned more about salsa and tango and merengue than I ever cared to know. I called out every style I knew and the dance instructors seamlessly performed for the camera.

We were in southern California and I wanted to take advantage of the beautiful sunlight so we moved the dancers outside. The shadows were as important to the composition as the dancers. Because of the deep contrast difference I added underexposed fill light on the left side (see *Contrast* on page 39). Standing on a ladder, I had my models repeat the same steps over and over. They took charge. I moved with them. We got lots of good images, but the nuances of body language and the delicate hand "falling out of the frame" was chosen by the art director for the final publication.

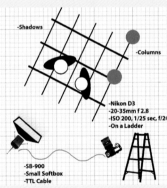

-Shadows
-Columns
-Nikon D3
-20-35mm f 2.8
-ISO 200, 1/25 sec, f/2(
-On a Ladder
-SB-900
-Small Softbox
-TTL Cable

Excessive Contrast

What if all the pixels do not fit within the graph? In some situations, contrast will exceed the ability of the digital sensor to record detail from shadows through highlights. Excessive contrast cannot be corrected through Exposure Compensation alone. The contrast can be changed via the light or by altering tonal values. The only exposure options are: expose for shadow detail and let the highlights "blow out" or expose to retain highlight detail and let shadows go black. (See *Contrast* on page 39.)

Excessive contrast can be corrected in the following ways:

1. Use flash to add light to the subject, bringing illumination and tonal values closer together, thereby reducing contrast, i.e. fill flash. (See *TTL Flash as Fill* on page 45.)

2. Use a reflector to add fill, reduce contrast.

3. Expand or compress the histogram by changing the contrast response of the digital sensor by accessing the following adjustments in the Menu:

Canon: Processing Parameters or Picture Style

Nikon: Image Adjustments

4. Change the available light on the scene.

5. Change the tonal values included in the scene.

6. Use **High Dynamic Range (HDR)** technique: Make a few identical image files varying the exposures, some exposed for the highlights, some exposed for the shadows; combine in Photoshop.

Mastering Distance: Near and Far

The Bounce and Swivel Head and Zoom features of the TTL flash (see also *Speedlight Components* on page 11) can solve some distance problems. Acquiring the skill to recognize when and how to move your flash into the correct position takes some practice, but you will reap extra benefits.

The Zoom Head can also be used to even out the near and far illumination for the wedding aisle shot or when making on-camera flash pictures in narrow hallways or stairwells.

Switching from vertical to horizontal, bounce to straight-on, wide to narrow—a Speedlight has so many configurations as to be akin to solving a Rubik's Cube®. Rachet the swivel head for optimum coverage.

Merging environmental illumination with supplemental light is a creative choice. Rather than using your flash to just override the available light, you can blend the two. By doing so, you take charge and improve on nature. Being able to integrate artificial light with available is an acquired skill. Which one should dominate, which one is secondary? Sometimes it becomes a contradiction in terms. *Sometimes you've got it, sometimes you don't. Sometimes you bring it with you. Sometimes you won't.*

Main Light and Fill Light: Definitions

Mixing flash with existing light is called *multiple light source* photography. The following definitions will assist in the decision-making process when mixing flash and existing light, and later when us-

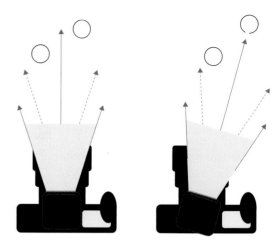

FIGURE 1.7 FLASH SWIVEL
Swiveling the "center" of the TTL flash towards the further subject, illuminating the near subject with the dimmer "edge" of the TTL flash.

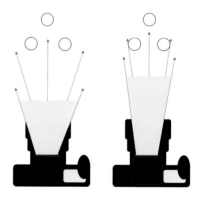

FIGURE 1.8 FLASH ZOOM
The Zoom Head feature can be manually set, changing the angle of illumination of the TTL flash. Setting the flash Zoom Head to a long focal length will illuminate the further subject with the brighter "center" of the TTL flash and the near subject(s) will receive the dimmer "edge" of the TTL flash.

ing multiple flashes. These definitions do not refer to specific lights, only to the purpose and position of the light. Any light source can be considered a Main, Fill, or Accent.

Main light or **Key light** is the predominant, brightest light source on the subject. The Main light creates the direction of light, the placement of highlights, the placement and direction of the shadows, and the predominant color balance/color cast. For digital, the Main light determines the Exposure Value (EV)

FIGURE 1.9 FLASH ORIENTATION
The orientation of the TTL flash reflector can help shape the light. Held horizontal, the light from the flash spreads wider. With the TTL flash held with the reflector vertical, the light from the TTL flash will be taller and narrower.

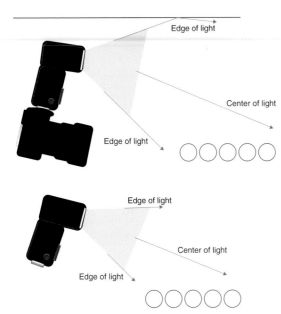

FIGURE 1.10 FLASH TILT
Tip the flash up for elevated crowd shots. The "center" of the TTL flash travels the furthest but illuminates the far subjects with the brighter light. The "edge" of the TTL flash illuminates the near subject with less bright light. This will help even out the flash exposure from foreground to background.

set on the camera. It can come from any position in the frame. To use TTL flash as a directional, off-camera Main, see *Wireless TTL Flash* on page 55 and *TTL Cords* on page 130.

Fill light provides less illumination on the subject than the Main, reduces contrast, and reduces shadow density to provide more visible shadow detail. **Flat Fill** reduces contrast while maintaining the illusion of a single light source illuminating the subject. Flat Fill comes from the camera position, not from the side of the subject. Camera-mounted flash on a professional flash bracket makes an ideal Flat Fill. **Form Fill** is placed in front of the subject's nose, which may be pointing off camera. This is effective and dramatic in portraits.

> Fill light does not improve a poor direction of Main light. It is better to create a more suitable direction of Main light.

With a directional off-camera Main and a Flat on-camera Fill, the Fill light will not and cannot eliminate shadows on the subject, even if the Main and the Fill are equal in intensity. The highlights will always be made up of light from two light sources versus the shadows receiving light from one. You cannot add light to a shadow without creating another.

> To eliminate shadows on a subject, illuminate the subject with a flat, frontal Main light.

Accent lighting gives separation, depth, and added richness. It can be light that is not on the subject but on other surfaces, foreground or backgrounds. **Rim light** or **Edge light** comes from an angle behind the subject. It separates the subject from the background by illuminating the subject's edges. **Hair light** usually comes from an angle behind and above the subject. It is intended to highlight or "rim" just the hair. **Background lighting** illuminates the background behind the subject.

PHILOSOPHY

Light

Since this text is making the claim that mastery of photography is essentially mastery of light, our first chore is to recognize definitive characteristics and components of the myriad forms of illumination sculpted by time, location, and climate. Visible light has infinite variations. There is mood, character, and energy in light even when it is less than ideal. It is the responsibility of photography and photographers to

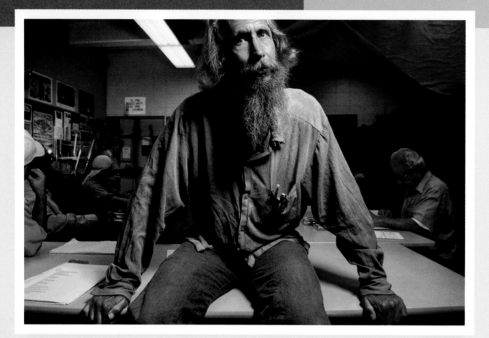

SOLEDAD PRISON

I had to be very frugal with the amount of lighting equipment I carried with me when photographing a book on men/women in prisons all over the United States. Since I was subject to "search and seizure," every nut and bolt and camera had to be itemized and notarized before inspection.

Working alone, I spent all day with these prisoners. I photographed with one or two lights. The warden allowed me to go out for lunch and reenter after a long morning session. Most of the work was candid but after I got to know the people I was able to make individual portraits of a few. A few expressed interest in photography before being incarcerated but had never seen the latest digital equipment.

This image was done with one Speedlight, a small softbox and a lightstand. I put the camera was on a tripod so I could "burn in" his fellow inmates who I positioned behind him with a moderately long exposure.

So often your environment cannot be predicted. Speedlights allow you to easily adapt to the prevailing situation.

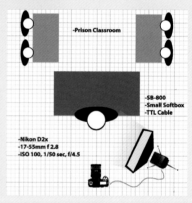

document them all. To *take* pictures that reflect our surroundings is at the foundation of photography. Outside, surveying the natural world, cameras are mirrors held up to reality.

The average person pokes their head outside to see if it will be a sunny and pleasant day to take pictures. This is not an option for the professional, nor does it take into account critical timing or history. The events in question may be unique or too important to wait for more favorable conditions.

If you have no choice about conditions, you may have to take a quantum leap and import your own "sun." No worries. Everything you learn about natural light also applies to artificial light. Conversely, all the techniques you acquire when substituting for sunlight, whether using hot lights, fluorescent, flash, etc., can be applied to all conditions.

Small flashes have become the most convenient choice for photographers. Many people buy an expensive camera, and then attach a flash to the top. This has become such a ubiquitous solution that manufactures are building the flash right into the camera. However, the distinctive omnipresent frontal light is a "signature" of our inability to rearrange the position of the light. Unwarranted shadows are often the byproduct of necessity and

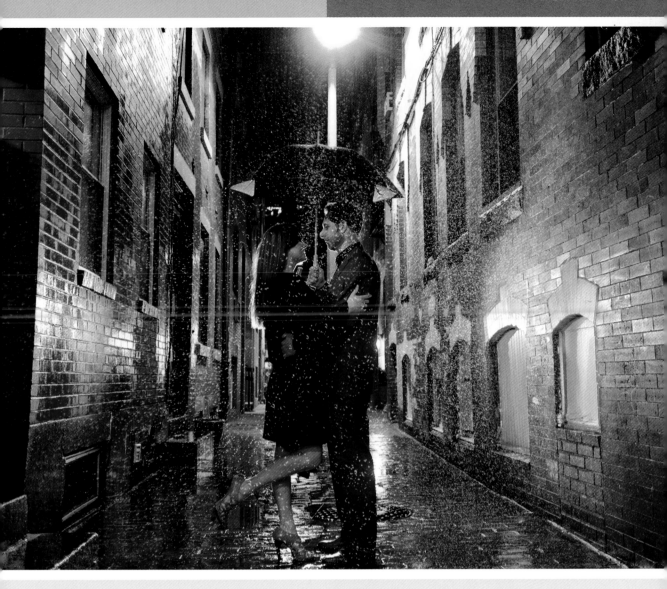

RAIN

Although this shot was designed to only use one Speedlight, it was very complex. There were a number of criteria necessary to make this work. Everyone in the studio suggested locations but we used Google Maps to see the narrow alley, the cobblestones and the rooftops. We bought a very long water hose to simulate rain and got access to the upper floors so we could position an assistant to manage the spray.

Photographing rain is a lighting nightmare. It has to be backlit to show up well. One Speedlight on a lightstand that was positioned directly behind the couple solved that problem. We used PocketWizard® because line-of-sight was interrupted (see *Wireless TTL Communication: Line-of-Sight* on page 61 and *PocketWizards®* on page 125). It also created the glare on the wet sidewalk and walls. The streetlight gave us the ambient green. We asked everybody to close their windows on the hot summer evening and waited for dusk. The whole operation drew a crowd.

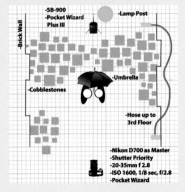

ease. But in much commercial work, the telltale of a photographer's intervention is unacceptable. (The one exception: on-camera flash skillfully used as Fill light to just open up shadow.) With a little extra effort, these flash-on-camera devices can be used to make better pictures.

Traditionally, photographers for whom flash is their stock-in-trade use antiquated methods, standardize their technique, or manually calculate output to guarantee results. Dedicated photographers have developed elaborate formulas, charts, and tricks to calculate and match the output of flashes with the cameras, lenses, and films of choice. Because it is so complicated, equipment manufacturers have conspired to make this task quicker, easier, and even automatic, with mixed results. Devices that measure the light output of flashes make it possible to increase acceptable results from on-camera flashes, but they are slow. Things get even more complicated as soon as you attempt to take that one light off camera. Not only is it harder to predict the quantity of light, but also the quality of the final outcome.

The direction of light has the greatest influence on the veracity of the photography. Heavy-handed lighting can look deceptive, obvious, or artificial. But a little practice goes a long way. And it always helps in predicting the results.

If you engage in the kind of photography that demands flexibility, like photojournalism, event, wedding, and sports, you may not want to transport a lot of extraneous equipment. With one light you can illuminate what you need and remain mobile, but you are limited creatively. However you can exploit those very limitations. While *on-camera* flash most often comes from the same direction and axis as the lens, you can augment its appearance by bouncing it off the ceiling, off the walls, or diffusing and enlarging its apparent size with light modifiers. Throw a reflector into the mix and you give the scene a much more casual appearance.

When you move the light *off camera* you are no longer merely "throwing light." Off camera, the light is coming from *somewhere*. Off camera, one light is a force to be reckoned with. Now you direct the eyes off center for drama and mood; illuminate those parts of the picture you want everyone to see; and obscure those segments you want ignored. Unfortunately,

the larger the separation between flash and camera the harder it is to predict. Even though the light obeys the same laws of physics, it is harder to anticipate the additional perturbations and obstacles it will encounter on its way back through the lens as flash becomes more removed from camera proximity.

Enter the digital SLR and Speedlight. For the first time we can put the light anywhere in the vicinity and not only will the integrated camera and light combination make its best effort to calculate the proper amounts automatically, but it will do so without any physical link between the two. Wireless firing and exposure. Then we view the results immediately on the back of the camera. The LCD confirms whether our placements are achieving the effects we want and whether it is doing it correctly.

Characteristics of Light: Analysis and Decisions

The first step to learning lighting is being able to describe it. Throughout history, cultures have developed subjective ways of doing that. Those who needed to talk about it for practical reasons applied unscientific nomenclature. Scientists and engineers used very theoretical terms such as wavelengths and frequencies. Artists used poetic terms and metaphors. Photographers needed their own useful language.

To make more effective lighting decisions, it is important to understand the language and corresponding behaviors. All light exhibits five distinctive characteristics that can be utilized and/or changed without inherently altering the others. The five characteristics of light are factors which distinguish one kind of light from another, as well as the effect of the light on a subject. The **Five Characteristics of Light** are as follows:

Quantity
Quality
Contrast
Color
Direction

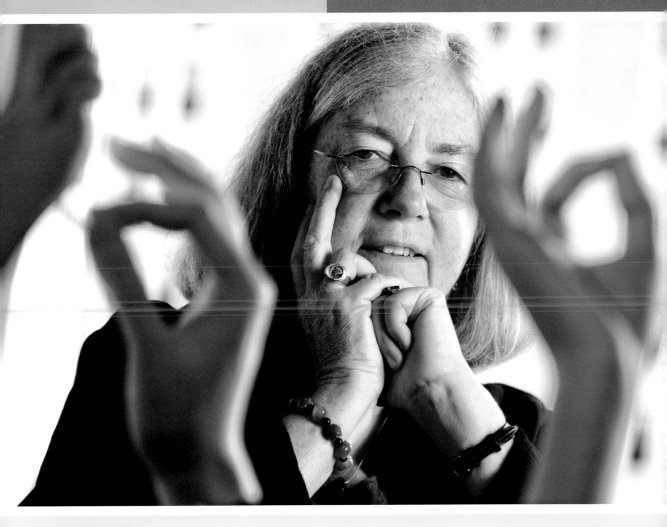

NEUROSURGEON

Time is of the essence in so many corporate portraits. This distinguished research doctor was being photographed for her alumnae magazine. We were only allowed to interrupt her busy schedule in the early hours before work.

There were no appropriate props in her offices. We had to improvise. I saw several sculptures around the rooms and asked their significance. The doctor had commissioned their manufacture because hands and feet have a lot to do with neurological diagnosis. They provided me with all I needed for this first image.

My assistant was a VAL (see *VAL* on page 107). He stood just outside the frame on the right holding a small softbox (see *Softboxes* on page 113). We employed this technique for the entire shoot because we needed several images to satisfy the magazine article and had limited time.

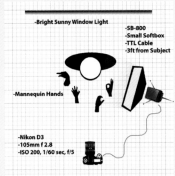

-Bright Sunny Window Light

-SB-800
-Small Softbox
-TTL Cable
-3ft from Subject

-Mannequin Hands

-Nikon D3
-105mm f 2.8
-ISO 200, 1/60 sec, f/5

Quantity, Intensity, or Brightness

To photographers the most important characteristic of light is its quantity, alternately called intensity or brightness. Photographers may need to define many different variations of the same light: the quantity of light falling on and reflecting from a subject, the quantity of light illuminating the highlights, the quantity of light in the shadows, and the quantity of light entering the camera.

Before TTL, incident light meters were placed in the path of the source to measure the quantity of light falling on a subject. All things being equal, the incident meter indicated the correct exposure regardless of scene or subject reflectance. As a general rule in photography, if the light remains the same, the correct exposure remains the same. In most DSLRs reflective light meters measure the quantity of light reflecting from a subject. Reflective meters are sensitive to changes in exposure when subject reflectance changes, even when the light remains the same. Reflected meters require the photographer to compensate for subject reflectance.

The quantity of light determines many factors involved in the outcome. Decisions regarding the following are based upon the available light: ISO, noise,[5] image quality, usable shutter speed and aperture combinations that affect movement, the need for a tripod, and the depth of field. In an image combining both flash and existing light, varying the quantities of existing light and of flash will result in vastly different images.

Quantities of light entering the camera can be altered by selecting a different camera setting, using neutral density filters on the lens, and by changing the light source(s).

Quantity can be reduced by lowering the power or wattage of the source, using filters over the source, increasing the light-to-subject distance, bouncing the light and using diffusion material between the light and the subject.

The quantity of light can be increased by raising the power or wattage of a light, decreasing the light-to-subject distance, using a more efficient lamp reflector, or adding additional sources.

> In general, the eye is drawn to the brightest area of an image first.

Quality

Photographers insist on "qualifying" light. However, the terminology remains elusive. For example, many photographers that are inexperienced use lights from very far away, claiming they do not want the light to be too "harsh." What does that mean in concrete photographic terms? This discussion of quality of light will provide a more specific and suitable vocabulary.

The **quality** of light is referred to as **specularity**. A specular light is a "hard" light and a non-specular light is a "soft" light. The quality of light is analyzed by observing the size and appearance of the reflection from the light source on the subject, called the specular highlight, and the edges and density of shadow.

In the first example, hard light is produced by the direct sun. The sun is a huge star, yet appears as a

> Visualize a vintage car parked at the beach. It is noon on a clear blue-sky day. The edges of the shadows under the car are distinct and clearly defined. The density of the shadow is deep. The difference between highlight and shadow density is great. The contrast is high. The big chrome bumpers reflect the sun in the sky, which is the light source. This specular reflection is small and intense, and called hard light.
>
> The weather changes, clouds roll in, the sky becomes overcast. The edges of the shadows under the car become feathered and indistinct. The density of the shadow is reduced. Shadow and highlight values move closer together. The contrast is low. Those big chrome bumpers show a reflection of the entire sky, which is now the light source. The specular reflection is large, broad, and lustrous. This is soft light.

[5] Noise consists of any imperfections or undesirable flecks of random color in an image. Digital images produced in low light or at high ISO often exhibit this undesirable effect. Noise is the digital equivalent of film grain.

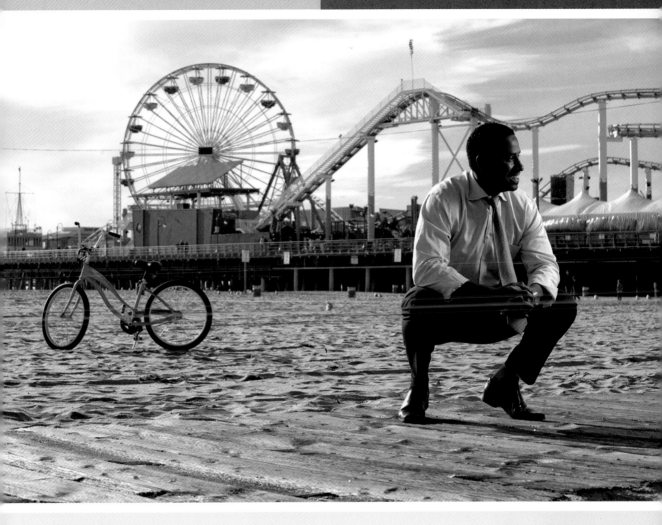

SANTA MONICA PIER

This shot took weeks of preparation. We had to buy permits from the city to shoot a production on the beach with the pier in the background.

Our subject was an entrepreneur in the area. He came with several changes of clothes. This is an example of what can be done shooting in broad daylight. There was one Speedlight in a large softbox off to the right, just outside the frame. It was hardwired to the camera using a TTL cord (see *TTL Cords* on page 130). I sent the owner of the ad agency off to rent the bicycle just before we set up.

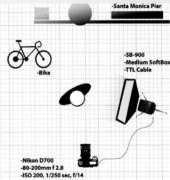

-Santa Monica Pier

-SB-900
-Medium SoftBox
-TTL Cable

-Bike

-Nikon D700
-80-200mm f 2.8
-ISO 200, 1/250 sec, f/14

small pinpoint light source in the sky. When the sky is overcast, the light source is the entire sky from horizon to horizon and produces a soft light. These examples illustrate that quality is related to the relative size of the light source.

> The larger the light source, the softer the light. The smaller the light, the harder the light.

Quality of light helps shape the emotional response to an image. Soft light often evokes a gentler, romantic effect. Hard light tends to be more theatrical, dramatic, and edgy. Hard light can emphasize and define texture, while soft light smooths and flattens.

Changing the distance is a simple way to change the quality of a light source. Rule-of-thumb: the closer the light, the softer it is. Moving any light source closer to a subject will make it larger in relation to the subject. If you desire the softest light from any source, use it as physically close to the subject as possible. Moving any source farther from the subject will reduce its size relatively. If the light source is not movable, move the subject in relation to the light.

Bouncing a light softens its quality by increasing the size of its spread. A single TTL flash can easily be effectively converted into a 20 square foot source by bouncing from a wall or ceiling. (See *Bounce Flash: Direction and Quality of Light* on page 99.)

Diffusion softens quality when the diffusion screen is larger than the light source. Light banks,

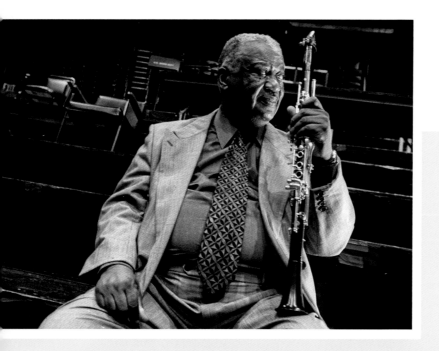

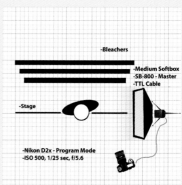

BACKSTAGE

I originally took this photograph of a famous jazz clarinet musician for my large collection of musicians. I chased him for months. Backstage, just before a concert, he finally agreed to a few frames. Celebrities are difficult.

In a panic, I hastened to have him sit down to be comfortable. This is a good example of how to use Rear Curtain Sync/ Second Curtain Synchronization (see *Rear Curtain* on page 110) for more than just blurring. I wanted to take advantage of the dark room, with little detail in the background. With my camera on a tripod, I let Programmed Mode incorporate the minimal available light (see *Programmed Mode (P)* on page 85). I quickly laid the softbox on the stage next to the musician and asked him to look to his left to be sure the light fell on his face.

Against my protestations he got up and walked out of the room after only a few frames. Only the automatic mode of the system insured I had usable images. A year later his record company used the image on the inside of his CD. A few months after that, his family asked to use the picture at his memorial service.

umbrellas, diffusion discs, and reflector panels are popular photographer's lighting accessories. (See *Light Modifiers* on page 111.)

When only a single light source illuminates the scene, quality of light also determines the contrast of the light. (See *Contrast* below for more discussion on this topic.)

Quality and quantity are separate characteristics of light. A single candle flame is a dim hard light. A photographer's eight-foot soft box with 5,000 watt seconds is a bright soft light. Quality of light is not a function of quantity or brightness.

> To produce harder light, use a smaller light source, a more direct light source, or increase the lamp-to-subject distance.
> To produce softer light, use a larger light source, diffuse or bounce (reflect) the light source, or decrease the lamp-to-subject distance.

Contrast

Photography is a two-dimensional medium. Everything is a matter of edges: the edge between two subjects, the edge of the picture, the edge of the prints. You visually differentiate one object from another because of its edges. In black/white, it is one shade of gray separating another that defines depth of field. In color, it is an edge between a red and a green. Edges are contrast delineations. It is how our eyes and brains recognize shapes. Contrast also affects the emotional response of the viewer and helps to express mood.

Contrast is defined as the measured difference between the quantity of light in the highlights and the quantity of light in the shadows. When comparing the difference in shadow and highlight illumination in units of light, contrast can be expressed as **lighting ratio**.

Contrast determines the difference between highlight and shadow detail in the digital image file. Most digital sensors can record detail over a five-stop range. A contrast range exceeding five stops will render shadows as pure black or highlights as pure white, depending on exposure.

Excessive contrast is indicated by a histogram that shows the highlight point and/or the shadow limit off the graph. Excessive contrast is not fixable by exposure. There is nothing we can do to exposure that will change contrast. Exposure only determines what areas hold detail. If less exposure is applied, the histogram will shift to the left, holding detail in the highlights, but resulting in the loss of shadow detail. If more exposure is used, the histogram will shift to the right, preserving more shadow detail, but losing details in the highlights.

However, there are ways to compromise contrast. One way to change contrast is to reconfigure the scene itself. A black hat on white snow is a high contrast situation. Remove the hat and the contrast of the scene is now low. Another way to change contrast is by adding a light. When a scene is illuminated by a single light, the contrast is related to the quality of the light source. Hard light is inherently high contrast, soft light produces lower contrast. The addition of a soft Flat Fill light can reduce contrast while maintaining the quality of a harder main light (see *Main Light and Fill Light: Definitions* on page 30). The shadow density will be affected while the edges of the shadow and the specular highlight remain the same.

Contrast can also be enhanced. Introducing a brighter, directional light will increase contrast, highlight and shadow, and light direction. The new main light can be actually brighter than the existing light or the existing light can be underexposed to make the main light virtually brighter. That way the existing light can be used as fill for the new main. Using "subtractive lighting" and eliminating unwanted light from a subject also elevates contrast and provides a more dominant direction of light.

> In general, the eye is drawn to an area of greatest contrast first.

> In multiple light source photography, Contrast can be independently adjusted without changing the **Quality** of the **Main light**. A hard Main light can produce sharp-edged shadows for dramatic effect and **Fill light** can produce open, low contrast shadow density in the same image. The characteristics of the edges of the shadows and the density of the shadows are analyzed and controlled independently when using both Main and Fill lights.

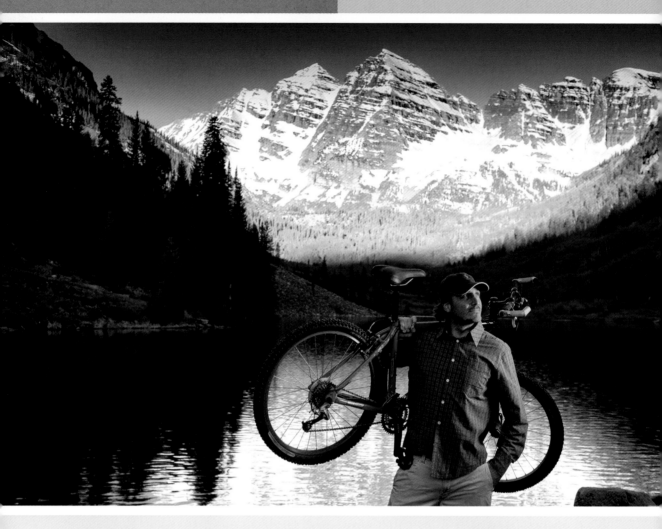

MAROON BELLS
The whole crew arrived at this famous location well before dawn. As the sun crept down the mountain, the extremes of exposure between the snow-capped background and the shadow area was hard to manage. We used a warming gel in the softbox on the model (see *Gels/Filters* on page 133 and *Softboxes* on page 113). The contrast made the shot (see *Contrast* on page 39).

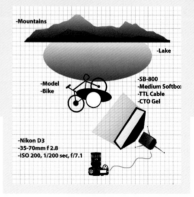

Now you can bracket contrast instead of exposure. It is contrast that is subjective. With Wireless TTL, you can adjust the contrast in the image at any time without worrying about changing the exposure. You will discover more variety, and have more choices about emotional responses to the images. You can respond to your own feelings about an image as you shoot. You can make it softer and more open, edgier

with more drama and punch, or just see the difference, at any time, without interrupting the flow of the shoot. Now you can take more risks knowing it is flexible and easy.

Color

There is no such thing as white light in nature. White light is the result of equal amounts of all the wavelengths in the spectrum. Varying those quantities gives light its color. Tungsten, florescent, halogen, sunrise, and sunset may seem similar to our eyes because the human brain equalizes and adjusts for the differences, but each has its own "palette" and affects the recording medium uniquely.

The study and use of color in photography is an extensive topic. Color affects the composition, sense of contrast, and emotional response to an image. Color creates mood. The color of a light source is expressed in a variety of terms. Mostly we compare one thing to another, i.e. it looks like some common "standard." "That dress looks like a rose." Color may be described alternately as warm, cool, pastel, vivid, painterly, and otherworldly. Clients may object to an unnatural color cast. A tint may be applied for aesthetic purpose.

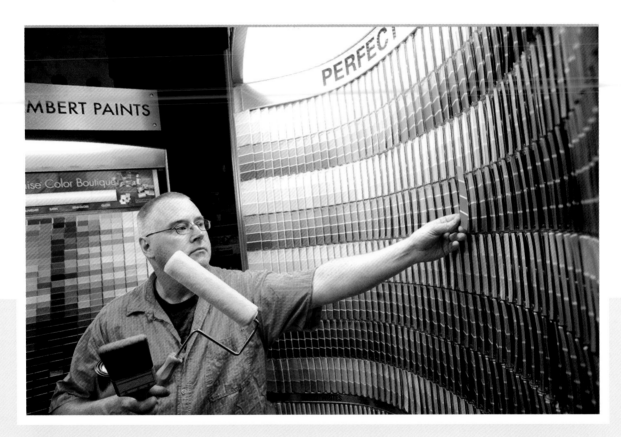

HARDWARE STORE

Simple is often hard to accomplish. My crew had to photograph this hardware store during working hours. That was harder than it looks. I needed something interesting which was familiar to everyone. People were everywhere. Tucked in the back out of the way, I found this paint samples display. I set up one Speedlight on a stand. I asked a patron to pose for us and he held painting implements to drive the point home.

We got really lucky—the display had been carefully outfitted with daylight balanced florescent lights in order for customers to be able to match paint chips. Very little postproduction was required to get the two light sources to match.

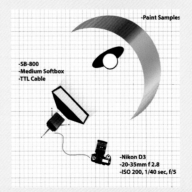

-Paint Samples

-SB-800
-Medium Softbox
-TTL Cable

-Nikon D3
-20-35mm f 2.8
-ISO 200, 1/40 sec, f/5

The way color is recorded in an image is determined by the color of the light source. With today's technology, a dSLR's white balance can be adjusted for the prevalent color of those light sources. Color gels can be used over a light source to match color, to convert to a color for effect, or to change to another specific color balance. (See *Balancing TTL Flash* and *Available Light: Colors of Light* on page 48.) Though often not required for digital, colored filters can also be used over the lens. Mixing light sources can skew the predominant color balance. Between camera controls and filtration, virtually any color can be mimicked.

Color is an independent characteristic of light. Changing the color of a light source does not change the quality or contrast of the light source. Changing color electronically with the digital camera does not affect the quantity of light nor the exposure.

When Canon and Nikon cameras are in Auto White Balance (WB), turning on the flash automatically changes the camera to the Flash White Balance (WB), even though the display on the camera's LCD does not change.

Daylight WB and Flash WB are both 5,500 Kelvin. The only difference is in the Tint.

The flash filters supplied with the Nikon Speedlights and the Canon 600EX/600EX-RT have magnets attached. The magnets help hold the filters in place, and communicate WB information to the camera's computer. With the newer Nikon and Canon cameras, the WB is automatically set to match the flash filter.

> Auto White Balance neutralizes only daylight light sources and may provide acceptable white balance under some fluorescent light sources. For existing light photography under any light source, Custom White Balance/Manual White Balance Preset will provide the most accurate color correction.

Direction

Sun, moon, lamps, headlights, television, candles. Illumination can come from anywhere. For practical purposes some directions are more useful or

> Canon: White Balance Shift provides manual color shift/color correction in both blue-to-amber and magenta-to-green color scales. Any combination of Light Balancing and/or Color Correction filtration can be dialed in electronically to the camera. White Balance Shift is calibrated in mireds, not the usual protocol used by most photographers. Refer to the Eastman Kodak® website to access information regarding the conversion of LB and CC filter designations to mireds.[6] The modification of color using White Balance Shift can be done visually or in conjunction with a handheld color meter.

COLOR SPACES AND THE COLOR TRIANGLE
Mixing any two primary colors will produce a secondary color. The color triangle below simplifies the conversions between RGB (Red, Green, Blue) and CMY (Cyan, Magenta, Yellow). Adding the colors of any two sides will yield the color of the angle between the two colors. For example, Red + Blue = Magenta. Adding the colors of any two angles will yield the color of the side between the two angles. For Instance, Cyan + Magenta = Blue. Adding all three primary colors yields white, which is the center of the triangle. So adding a magenta (which equals red plus blue) filter to the green tint of florescent light is equal to adding red, blue, and green and will be equivalent to white light.

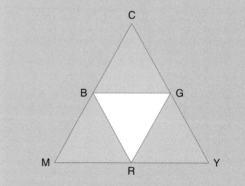

FIGURE 1.11 COLOR SPACES AND THE COLOR TRIANGLE

flattering than others. We may choose to control direction or accept what is provided. The **direction** of light is defined as the angle at which light falls upon the subject. The direction of light determines the placement of highlights and angle of shadows.

Flat light, also referred to as **front light**, comes from the camera position and smooths things

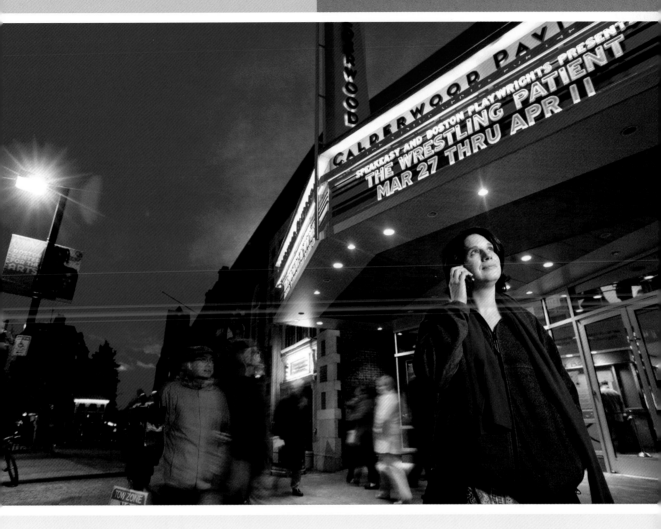

PLAYHOUSE

In order to get this photograph my studio pioneered using social networking. We "tweeted" that we would be shooting in front of this theater at a certain time and anyone who wanted to participate should show up. Several people took us up on the offer.

I wanted the marquee sign to be lit, but I did not want the sky to be completely dark. The day before my studio manager confirmed sunset and we built the shot around that time. I switched the camera to Rear Curtain Sync/Second Curtain Synchronization (see *Rear Curtain* on page 110) to blur the pedestrians in the background to promote the hustle/bustle of the area and to avoid chasing everyone for model releases.

One Speedlight/softbox on a lightstand made up the lighting. My camera on a tripod allowed me to include the whole street, freeze the art director on the cell phone in the foreground and still have motion in everybody else.

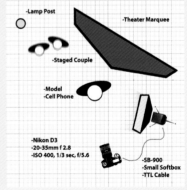

out by minimizing texture and depth. On the other hand, light that skims across a surface at a narrow angle accentuates texture. Light coming from behind a subject creates shadows that stretch towards the camera, giving the illusion of depth in a two-dimensional photograph.

In traditional portraiture, the directions or patterns of light complement and define the human facial structure. **Side light,** either broad or short, promotes a sense of contour and shape. **Broad light** widens the appearance of a face by illuminating the side more visible to the camera. **Short light** narrows a face by putting the side visible to the camera in shadow, creating a more dramatic and three-dimensional look. To create short light, turn the subject's chin to one side or the other and light from the side that they are facing. To create a broad light, move the light to the opposite direction that they are facing.

Many photographers working with controlled lighting for the first time try to eliminate all shadows. This is easy, but rarely interesting. The purposeful placement of shadows for effect is one of the great joys of working with light. Inexperienced photographers also believe that poor placement of shadows is improved by fill. Poor placement of shadows is a problem of light direction, not contrast. Analyze the issue. If the image would be improved by a better direction of light, change the direction. (See *Main Light and Fill Light: Definitions* on page 30.)

Light direction is critical to the success of an image. The change of a few degrees can be the difference between a stunning image and an unsuccessful one. Changing the direction of light is simple: move the light source in relation to the subject or move the subject and camera in relation to the light.

> Make lighting decisions based upon analysis of Quantity, Quality, Contrast, Color, and Direction. Look at the effect of each light in the image. Realize the control you have to make changes to each light source and pre-visualize the results. Explore and experiment. Study the details and nuances of light. Learn the physics of light. Practice. Utilize light intelligently and effectively to obtain the results you desire.

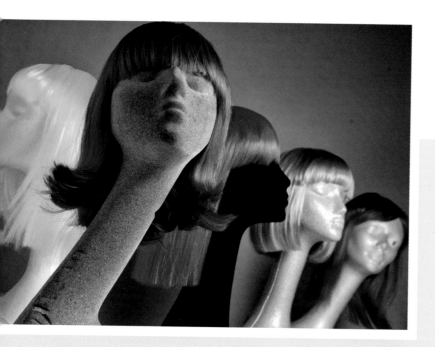

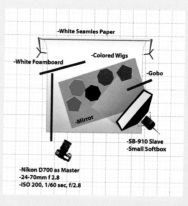

WIGS

Usually we think of lighting with just one light as simple. Sometimes it is not. To illustrate how versatile one Speedlight can be, I strategically placed a small softbox to one side to emphasize directional, off-camera light and carefully placed a number of fill cards to balance the light on the left side of the frame. I also wanted the Speedlight to spill onto the background to separate the colors of the wigs and the shapes of the wig forms. There was a lot of trial and error.

Mixing TTL Flash with Available Light: Quantities of Light

Available light may be beautiful and appropriate, or ghastly and discolored. But all light can be combined and mixed for interesting effects. Being able to alternate exposure compensations for existing light and TTL flash make each light source interchangeable as Main, Fill, Accent, and/or Background lights and play to the strengths of modern Speedlights. Take advantage of every possibility.

Nikon: in automatic exposure modes A, S, and P, camera ambient exposure compensation changes ambient and flash EVs together equally. As you bring ambient exposure compensation up or down, the flash goes with it. Flash exposure compensation changes the flash.

Canon: in automatic exposure modes Av, Tv, and P, the camera ambient exposure compensation changes ambient EV only. Flash exposure compensation changes the flash.

Available Light as Main

When the direction or quality of available light is satisfactory, it is logical to use it as the Main light. **Aperture Priority**, **Shutter Priority**, and **Manual** camera exposure modes are programmed to correctly expose the available light and will instruct the computer to make the available light the Main light. Compensate the metered exposure to correct for subject reflectance and to optimize the highlight placement on the histogram.

> If the quantity, quality, direction, and color of the available light are satisfactory, but the contrast is high, consider using fill light. (See *TTL Flash as Fill* below.)
>
> In low-light conditions, Program camera exposure mode used with flash will likely produce exposures of 1/60 sec. with the aperture wide open.

TTL Flash as Fill

Flash as Fill reduces the contrast of available light Main. While Fill flash was once considered a skill understood only by professional photographers, TTL makes Fill easy and convenient.

All dSLRs have computerized Fill flash programs that balance Available Light as Main and Flash as Fill. **It must be noted that when the camera detects sufficient available light for a "standard" existing light exposure, the TTL flash automatically acts as Fill.** The computer applies Flash Exposure Compensation (FEC), reducing the quantity of flash to avoid overexposure of the existing light highlights. The amount of FEC applied by the computer is not indicated to the photographer. To change the amount of fill flash in addition to that of the computer, adjust the FEC separately.

To set your camera and flash to provide automatic Flash as Fill:

Nikon: access the flash metering system on the flash. Set the flash to "TTL BL."

Canon: access the flash metering system through the camera Custom Function Menu. Set the E-TTL II flash metering system to "Evaluative."

It cannot be emphasized often enough that the standard protocols that apply with manual camera operation undergo a sea change when you add *two* computers, i.e. one for the camera and one for the Speedlight. They work together, but the decision-making hierarchy is no longer linear.

If you choose to override the automatic function in order to provide a "standard" flash exposure without making a "fill" reduction, the result will often be a more prominent effect of the flash in the image. View your LCD monitor and histogram to determine the amount of flash you want in any given situation.

To set your camera and flash to provide "standard" flash exposure:

Nikon: access the flash metering system on the flash. Set the flash Mode to "TTL."

Canon: access the E-TTL II flash metering system through the camera Custom Function Menu. Set the flash metering system to "Average."

In Canon's E-TTL II Evaluative and Nikon's TTL BL, the viewfinder is divided into multiple zones. The computer bases the flash exposure value only for the zones where it reads the greatest amount of returned pre-flash. This is usually from whatever is closest to the flash. The Flash Exposure Compensation will

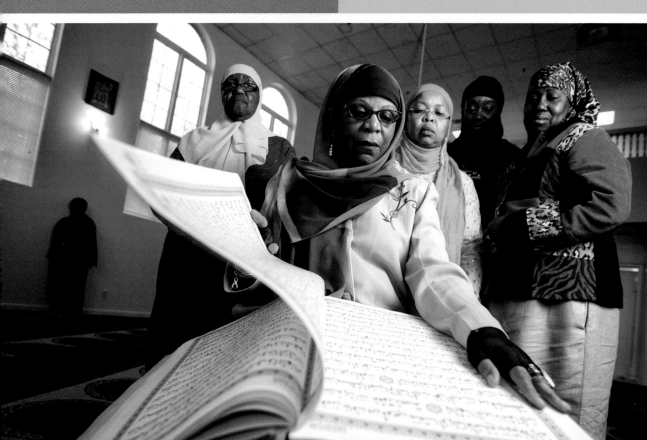

MOSQUE

My crew and I were sent to a remote location to document a woman who was working at a Moslem mosque. We had to wait until services were over and all the men had left. Our subject was very gracious and enlisted many of her friends to participate in the photography. I saw the group as a metaphor for all Islam because they, and their costumes, were so varied.

I was surprised and excited when my subject said we could include the Qur'an in my pictures. Usually books are boring, but this one was so beautiful that I also photographed it alone. Over the years I have noticed how simple and aesthetic one page, being turned, can appear. But something was missing. I placed one lone woman in the unlit negative space in the background. The shadowy figure made the image.

One large softbox was the only lighting. I huddled the other five women uncomfortably close. But they were more than willing to participate. I was very low to the floor with my tripod splayed out to get the angle. The time was well spent and the client was happy.

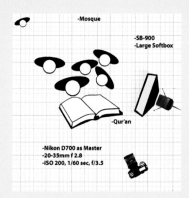

-Mosque

-SB-900
-Large Softbox

-Qur'an

-Nikon D700 as Master
-20-35mm f 2.8
-ISO 200, 1/60 sec, f/3.5

need to be adjusted for the tonal value of the zone(s) the computer is reading. Evaluative and TTL BL are of greatest value when the flash subject is closer to the flash than anything else in the picture; the flash subject is small or isolated in the picture; when the picture incorporates lots of ambient light in the background; and for fill-flash applications where the main light in the picture is ambient. In other words, these settings are of greatest value when only part of the picture is to be illuminated by the flash. The "BL" in the Nikon designation stands for "Back Lit." Using these settings for general flash photography, such as event work, can result in a rollercoaster of over- and under-exposure, and constant changing of Flash Exposure Compensation.

In Canon's E-TTL II Average and Nikon's TTL, the flash exposure value is averaged over the entire viewfinder. The computer calculates the flash exposure for the tonal value of the entire scene. These settings are advantageous where the flash is the main source of illumination for everything in the picture, such as general event candid photography and when using Speedlites in a studio. Because the flash exposure value is averaged over the whole viewfinder, small changes in reflectance value of subjects in the frame often do not call for drastic changes to the Flash Exposure Compensation.

On older Canon models, look in the camera Custom Function Menu for heading E-TTL II, "Evaluative" and "Average." On newer Canons, look in the camera menu for Flash Function Settings, heading "E-TTL II," "Evaluative" and "Average."

Note: do not change the "Flash Mode" setting in the camera menu, and do not change the "Flash Metering Mode" in the flash's Custom Function menu. Do not change the Flash Mode from E-TTL II to TTL! These settings are only for using EX flashes on older Canon cameras compatible with discontinued E-TTL EZ flashes.

On Nikon, use the Mode button on the flash. The flash must be attached to the camera, and the camera must be turned on to change the Mode. TTL BL may not be available in all camera exposure modes, check the camera and flash instruction manuals.

TTL Flash as Main

TTL flash can be the main lighting source when the direction of available light is not sufficient or appropriate for the subject. On-camera, flat, flash as Main light can eliminate unwanted shadows from available light. Flash as Main may be a preferred strategy for event and candid photography.

To make the TTL flash the Main light, underexpose the existing light on the subject. In **Program**, **Aperture Priority**, or **Shutter Priority** camera exposure mode, underexpose existing light by using Exposure Compensation "-". **Manual** camera exposure mode at higher shutter speeds (not exceeding 1/250 sec.) and/or smaller apertures can make it appear that the TTL flash is only light source.

> For general flash photography, such as indoor event coverage, try Manual camera exposure mode, ISO 400, 1/60 sec., and f/4.5. This allows a good amount of available light in the image, makes the TTL flash the main light source, provides a moderate amount of depth-of-field, and maintains good image quality.

A backlit subject, a shaded subject with a sunlit background, or a subject in front of bright windows may require the TTL flash as Main light, not Fill.

In all cases of flash as Main, adjust the Flash Exposure Compensation as needed for subject reflectance and to obtain a satisfactory highlight value.

> Adjust the available light exposure to obtain the desired look of the brighter background. Adjust the Flash Exposure Compensation to provide the desired amount of flash on the shaded subject.

Available Light as Fill

When the TTL flash is used as the Main light, available light can be utilized as Fill. Once a satisfactory highlight value for the flash subject has been achieved with Flash Exposure Compensation, varying amounts of available light can be "burned in" to help control contrast.

Keep in mind, the "correct" available light exposure may be Exposure Compensation "–2" to "+2"

due to subject reflectance. More than two stops may be required to lower the available light sufficiently for the flash to eliminate shadows and become the Main light. Depending on the camera model, Manual camera exposure mode may be required if the existing light needs to be underexposed by more than two stops.

> In **Program**, **Aperture Priority**, or **Shutter Priority** camera exposure mode, make available light Exposure Compensation "–1", "–1²/₃", or "–2." In Manual camera exposure mode, use shutter speed (not exceeding X) and/or aperture to underexpose the available light by –1 to –3 stops.

Balancing TTL Flash and Available Light: Colors of Light

TTL electronic flash approximates daylight in color. Available light comes in many forms. The color of TTL flash can be altered to more seamlessly integrate with the colors of existing light. Color filters for the flash may be obtained from several manufacturers, such as Lee® Filters and Rosco®. Filters may be attached with tape, rubber bands, or Velcro®. (See *Filters/Gels in Equipment Accessories* on page 133.)

Nikon: several color-correction/color-balancing filters are bundled with the SB900/910 and SB800 flashes.

> Although gels manufactured for this purpose are heat resistant, it is recommended to cut the filters slightly oversized and leave air space between the filter and the front of the flash reflector. Filters in direct contact with the front of the flash surface may melt due to heat generated by the flash, damaging the plastic surface.

Mixing TTL flash with available light: quantities of light		
Camera exposure mode		General guidelines
Program, P (and) Program, P		A. check usable flash distance range on the flash LCD panel for the aperture and ISO set on the camera B. change the quantity of existing light by available light exposure compensation C. change the quantity of flash by flash exposure compensation Nikon: set "Slow Sync Mode" for shutter speeds slower than 1/60 sec.
Aperture priority, A	Aperture priority, Av	
Shutter Priority, S	Shutter priority, Tv	A. check usable flash distance range on the flash LCD panel for the aperture and ISO set on the camera B. change the quantity of existing light by available light exposure compensation C. change the quantity of flash by flash exposure compensation D. use a shutter speed that does not exceed "X" * Nikon: set "Slow Sync Mode" for shutter speeds slower than 1/60 sec.
Manual, M	Manual, M	A. check usable flash distance range on the flash LCD panel for the aperture and ISO set on the camera C. change the quantity of flash by flash exposure compensation D. use a shutter speed that does not exceed "X" * E. change the quantity of available light by changing shutter speed and/or aperture Nikon: set "Slow Sync Mode" for shutter speeds slower than 1/60 sec.

FIGURE 1.12 GUIDELINES FOR MIXING FLASH WITH AVAILABLE LIGHT
* unless using High Speed Sync/FP Flash, see *Speedlight Components* on page 11.

Review results on the LCD monitor to determine color suitability. Additional filters may be used to fine-tune the color of the flash as needed. Colors achieved are dependent upon the exact color of the existing light sources, the relative amounts of flash and existing light making up the total exposure, and the correctness of the color balance.

A Custom White Balance/Color Preset can be made for the mix of existing light and flash.

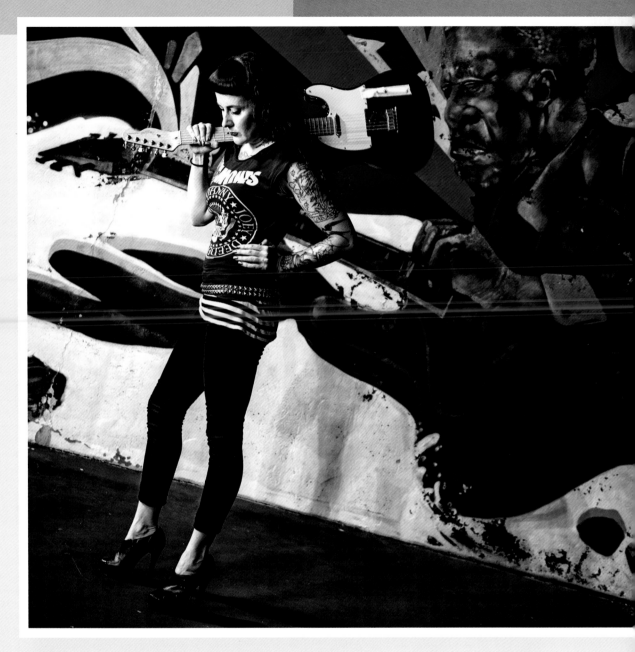

SINGER

I have incorporated this wall into several shots over the years. Graffiti artists compete and paint over each other's work, so the graphics change periodically. This time it was for PR pictures for a female singer.

The shot was taken at night. I had three interns. We decided on wardrobe and hairstyle before we left my studio. When we arrive on location, I had to throw couples who were playing tennis off the court.

Even though I had an idea of what I wanted, none of that worked on location. Our original intention was to create a heavy shadow by using a single Speedlight with a snoot (see *Snoot* on page 119). We switched to a softbox after realizing that the shadow was too distracting (see *Softboxes* on page 113). Being flexible enough to work out the problems on set is important to your career. Then we desaturated the colors in postproduction.

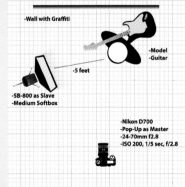

-Wall with Graffiti

-Model
-Guitar

-5 feet

-SB-800 as Slave
-Medium Softbox

-Nikon D700
-Pop-Up as Master
-24-70mm f2.8
-ISO 200, 1/5 sec, f/2.8

General Guidelines

Take time to review and study the image on the LCD monitor and analyze the histogram. Carefully identify and evaluate the effect of each light source in the image. Make decisions on the relative quantities and directions of available light and TTL flash. Adjust each accordingly.

The previous guidelines will assist in achieving the desired balance of existing light and flash.

TABLE 1.1 FILTERS AND GELS
Balancing TTL Flash and Existing Light: Colors of Light

Existing Light Source	Lee Filter®	Rosco® Filter	Camera White Balance
Tungsten	Full C.T. Orange	Roscosun CTO	Tungsten
Incandescent	Full C.T. Orange + $\frac{1}{8}$ to $\frac{1}{2}$ C.T. Orange	Roscosun CTO + $\frac{1}{8}$ to $\frac{1}{2}$ CTO	Custom White Balance
Fluorescent	Plus Green	Tough $\frac{1}{8}$, $\frac{1}{4}$, $\frac{1}{2}$ Plusgreen, Tough Plusgreen	Canon : Daylight + "15 mired Magenta" White Balance Shift or Custom White Balance Nikon : Custom White Balance
Fluorescent (cool white)	CC30M (30 magenta)	CC 30 M	Daylight

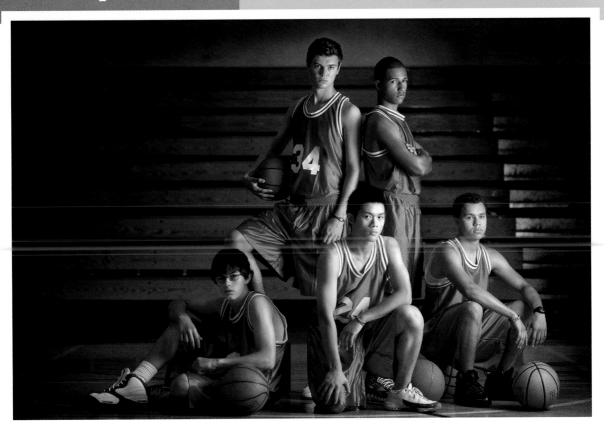

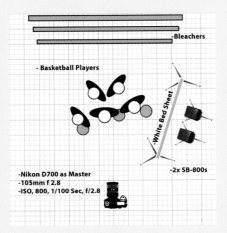

BASKETBALL TEAM

It is especially good to get repeat business. The designer for this basketball team shot and I have worked together for years. He always has "impossible" shots for my studio. I love it.

We were commissioned to take a cover shot and a few complicated shots for an education magazine. The subjects in this photograph were a combination of professional models, people found on Craigslist and friends. The diversity in ages, ethnicities and sizes necessary to convey the right message was harder than you might think. We had the uniforms specially made for the shoot and we rented the gym for the proper environment.

This is a good example of one-source lighting. I carry a king-size bed sheet everywhere I travel. It was strung between two light stands. The white cloth is excellent, cheap diffusion and used constantly to light large groups of people. Two Speedlights were aimed through the cloth. It is like an extra large bank light. I used a long lens to get some compression. So I was quite a distance from the subjects.

I have spent a career posing groups so every position and body limb and head angle was arranged. Then my postproduction assistant vignetted the edges of the image.

LIGHT/LIGHTING

Light

We, through observation and experience, learn to "see" the natural phenomenon of light around us. With time we can detect the subtleties in color temperature, quantity, and quality, and how to use it for our own purposes in art.

Lighting

Becoming proficient enough with light so as not to be dependent on prevailing conditions is one of photography's rites of passage. Transporting your very own light to a location is a major style breakthrough. The next step, with Speedlights, is to realize you can use more than one with very little extra "muscle." Technology has made many of the complications moot. It enables us to be more spontaneous, change our ideas, attempt more variations, and have peace of mind with each successive exposure. Without introducing a stack of manuals, formulas, or calculations, we can intuitively juggle more than one light. And each one can be programmed to perform separate functions. Theoretically we could throw a handful of Speedlights in any direction, manipulate each individually and, without taking a step, make them all work independently … together … wirelessly.

Utilizing only one light is overcoming inadequate light. But when you introduce a second artificial light source you are imitating, supplementing, or improving the environment. As a result, you have entered the nebulous realm of *lighting*. Going on location with multiple lights is constructing your own reality.

Lighting is the physical act of "sculpting" your visual environment—reshaping a three-dimensional space. Elevating selected surfaces

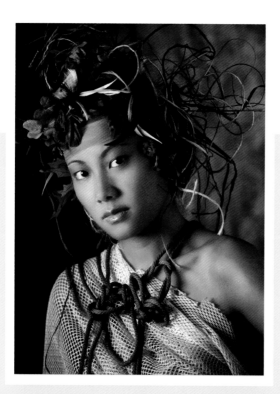

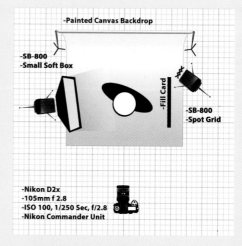

EVELYN'S HEADDRESS

Doing beauty shots is one of the great traditions of having a studio. It is quid pro quo. Attractive models need to work with different photographers for experience. We get to work out new ideas and techniques.

I had worked with Evelyn often, so we already had a rapport. The whole shot depended on the talents of the makeup/stylist with whom I have collaborated for years. I drew a diagram of what I had in mind, but Audrey embellished, using her imagination and experience to make the headdress come to life.

Evelyn is such a natural beauty the makeup needed only to be fairly traditional and simple. But her exotic nature was strong enough to enhance the over-the-top flotsam and jetsam in her hair.

Lighting was simple—classic portrait lighting with a softbox and reflector with a light on the painted backdrop to separate the model from the background.

toward the "sun" and shading others from it. We may not have the power to control what goes on in the world, but with lighting, we can control exactly what our audience sees of it. We decide whether objects of interest will be perceived as static or in motion. Lighting can lead the viewer into or out of the frame. We can delineate between drama and melodrama. We can surprise and obfuscate. Lighting gives credence to what otherwise would not even exist.

Unfortunately, if the methods are obvious, we have failed. But if it was easy, everybody would do it. Speedlights simply make it *easier*. With a smaller, lighter kit and with the new methods of checks and balances, the dedicated photographer has a head start.

Because we are the sole architects when we build with light, we reside in the netherworld of fantasy and dreams whether in the fields of commercial or fine art. When shedding darkness anything is possible. We can investigate inside our minds as well as the interiors of our monuments.

The ability to utilize, combine, and manipulate available and manufactured lighting is the ability to enhance imagination or make more compelling photographs. But the most important skill in lighting is being able to repeat it.

As photographers we can safely accept the *light* that nature provides us or we can take on the task of *lighting*. Everyone approaches it differently, but there are stages that end up in most everyone's agenda:

Design
Execute
Review
Postproduction

Design

Lighting starts in the mind. When you walk into a scene, you should first survey and assess your surroundings rather than relying on trial and error. Determine whether the light is sufficient or whether you have to supplement it. Pre-visualize what you eventually want your audience to see. Take time to theorize the overall mood you want to create, whether bright and clear, or dark and mysterious. You may have requirements to be formal or stylized. This is

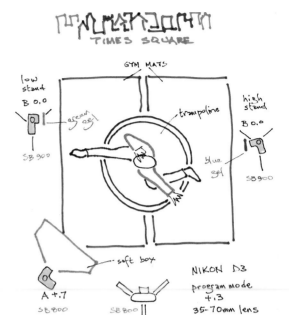

FIGURE 2.1 COMP FOR TIMES SQUARE PHOTOGRAPH

the **Design** phase. You estimate what equipment you will need, what are the problem areas, where you will position each light and its contribution to the final output. Even check where all the electrical outlets are before you have to drag equipment around. As you become more adept, much of the work is done in your head first. In elaborate productions you can sketch placement of camera and lights on graph paper to see if it will work. This phase can take place days or weeks before the actual shoot.

Execute

Next comes the **Execute** stage. After rearranging furniture or building sets, you move your equipment, then your subjects (models, products, props, etc.) into place. It may be time-consuming, but it can be the most exciting part. Shooting often becomes anticlimactic because it is the very last part of *execution*. If you have designed well enough in advance there may be very little alteration. But if not, you redesign and re-execute. You can "bracket" for **high dynamic range** (HDR) applications in postproduction. This is the step where you have the greatest creative freedom. But *shooting* is what photography is all about. It is where all the elements

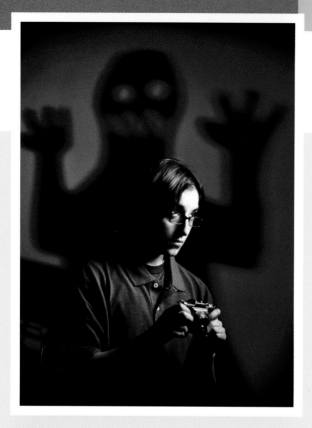

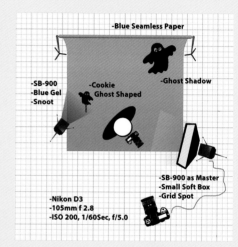

-Blue Seamless Paper

-Ghost Shadow

-SB-900
-Blue Gel
-Snoot

-Cookie
Ghost Shaped

-SB-900 as Master
-Small Soft Box
-Grid Spot

-Nikon D3
-105mm f 2.8
-ISO 200, 1/60Sec, f/5.0

GHOST

We did this photograph to illustrate a story on **fear in photography**. Since we were required to do several of these pictures on a limited budget, I ushered my studio editor into service as the model. I also incorporated an antique camera and eyeglasses from my prop closet.

I sketched a scary figure onto a piece of cardboard to act as a "cookie." It was about 12" tall. My assistant cut it out using a matte knife. With a snoot and a blue gel on a Speedlight to cast a hard shadow onto the seamless background paper, I achieved the fantasy we all conjure up when we are afraid (see *Snoot* on page 119).

The single Speedlight inside the softbox had a ribbon grid (see *Ribbon Grid Soft Box Attachment* on page 116) on the front to columnate the light and focus it only on the model, almost like a spotlight. This gave me the ominous mood that connotes mystery, apprehension, and dread.

come together. When you "pull the trigger," all conditions, the model's wardrobe, and timing are in synchronization. Excitement crescendos. In photography this is synergy. It is where the magic happens.

Review

Because of the newest technical advances you can "test" the design and **Review** your execution as you progress utilizing the LCD and histogram built in to your camera or by tethering to a computer right on set. You and your clients have a ringside seat. You can review the influence of mixed lighting and override the bias of unwarranted *color tempera-*

tures. Using both the **LCD to judge aesthetics of the shot and histogram to monitor the technical contributions** makes execution seamless. Since you are recording the pictures and sampling them simultaneously there is no time lost and there is no anxiety as to whether you have succeeded. This overlap is the safety net that digital affords you.

Postproduction

After you complete the assignment, you can go back and manipulate any image that you deem worthy. This is considered **Postproduction**. If you shoot in RAW, everything but exposure is malleable.

FIGURE 2.2 TYPICAL POSTPRODUCTION SUITE

Reminiscent of the darkroom, with software you can alter, brighten/darken, change contrast, correct color, and eliminate defects that might have been overlooked during execution. In addition, we can improve such things as sharpness and lens correction, and we can do it selectively to any portion of the image. Besides basic retouching, you can use these programs to execute extensive image compositing, special effects and more. The objective is to optimize the images for archiving, reproduction, or publication.

Commercial, advertising, architectural, still life, and large format photography may require more power, modeling lights, or other attributes. Speedlights are not intended as substitutes for larger strobes, but they provide a less expensive, small, portable, convenient, quick, flexible, and predictable alternative. The permutations increase exponentially with each new light added. But there is no limit. To shine light on any subject we choose is monumental. To change the way the world looks is supernatural because "only gods can move the sun."

WIRELESS

The second attribute in the definition of Speedlights is that they operate cordlessly (see *Why Speedlights?* on page xvii). Speedlight units are unfettered by long, cumbersome, unreliable cords or external devices that traditionally have been needed to "hardwire" multiple lights together. The freedom this affords today's shooter is the breakthrough that drives this book.

Wireless TTL: Remote/Slave Flash

Wireless TTL is a proprietary, closed-loop system with the capacity to transmit firing and flash exposure information to single or multiple, compatible Remote/Slave TTL flash units. Exposure for the TTL Remote/Slave(s) is metered in-camera, **through the lens (TTL)**. Flash Exposure Compensation for the TTL Remote/Slave(s) is controlled from a master flash, which needs to be connected to the camera through the hot shoe. The master flash may be mounted directly on the camera, or connected with a TTL cord (see *TTL Cords* on page 130). Exposure strategies for mixing available light and flash remain the same as with single, on-camera TTL flash. Many flash features remain operational: Flash Exposure Lock/Flash Value Lock, Modeling Flash, Flash Exposure Bracketing, Manual Flash, and FP Flash/High Speed Sync.

In effect, the modern photographer can set up compatible Speedlights in every corner of a location and just as quickly command each one to emit a specific, individual output without moving.

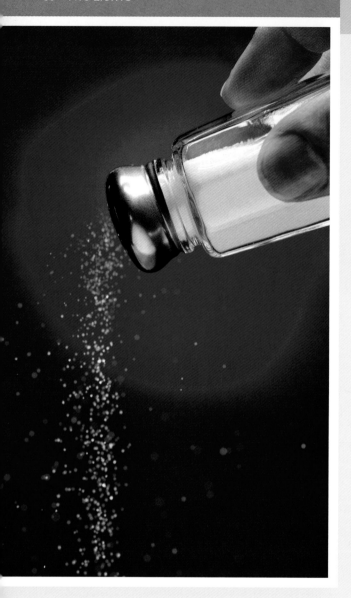

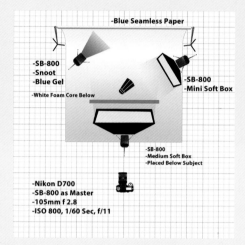

-Blue Seamless Paper

-SB-800
-Snoot
-Blue Gel
-White Foam Core Below

-SB-800
-Mini Soft Box

-SB-800
-Medium Soft Box
-Placed Below Subject

-Nikon D700
-SB-800 as Master
-105mm f 2.8
-ISO 800, 1/60 Sec, f/11

SALT

To illustrate an article on salt/pepper, I had the idea to show a classic, common saltshaker. I borrowed one from my local breakfast diner and mounted it in order to prevent it from moving. The logistics were complicated since it was just my assistant and me. I manicured my right hand for the shot while he focused the lens then ran around and poured salt just behind the setup. I triggered the camera with a cable release using my left hand. We had to do it several times to get everything lined up and the right exposure. He erased the extraneous salt in postproduction.

Wireless TTL: Additional Trigger Devices Need Not Apply!

Radio slave, infrared, and photo eye slave are remote flash triggering devices that fire a remote flash. However, they do not transmit flash exposure information. Most of these devices are not Wireless TTL, nor required for Wireless TTL. (See *Remote Triggers* on page 123.)

The SB-910, SB900, and SB800 have built-in, non-TTL photo electric eye triggers allowing these flashes to be used with and fired by manual non-proprietary flashes in non-TTL flash modes.

All Wireless TTL optical transmitter and receiver equipment is built into the 550EX, 580EX, 580EX MkII, 600EX, 600EX-RT, and SB910, SB900, and SB800 flashes. No additional or accessory devices are required to utilize optical Wireless TTL with these flashes. The Canon 600EX-RT offers both optical and radio wireless TTL.

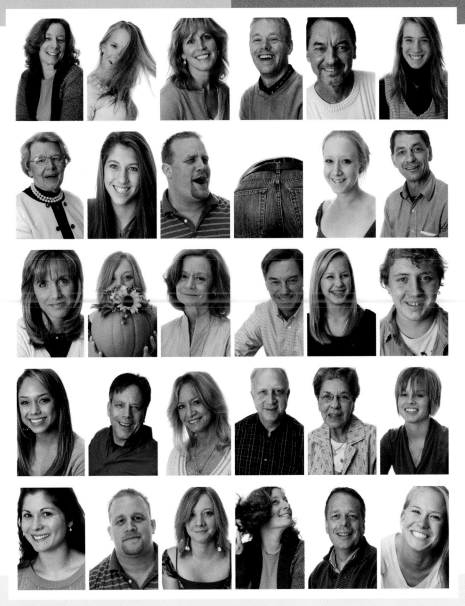

THANKSGIVING FAMILY PORTRAIT

On Thanksgiving my mother and father's families gathered together, 26 people in all, to cook and devour enormous amounts of food and drink plenty of wine. A rare occasion, I needed to document the three generations.

I had three Speedlights and my camera, but nothing else. Searching through my family's basement we found cardboard boxes, stands, and linens. Good enough. We cut a hole in the back of each cardboard box for the Speedlight swivel head, making sure not to block the sensor. We attached pillowcases to the front opening of the boxes. The "softboxes" were attached to stands. (See *DIY = Do It Yourself* on page 130.)

One "softbox" lit the subject while the other was positioned behind a white bed sheet background. With the white background and consistent lighting I was able to focus on the individual characteristics that make each person unique.

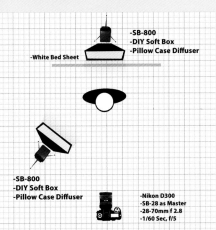

-SB-800
-DIY Soft Box
-Pillow Case Diffuser

-White Bed Sheet

-SB-800
-DIY Soft Box
-Pillow Case Diffuser

-Nikon D300
-SB-28 as Master
-28-70mm f 2.8
-1/60 Sec, f/5

Nikon SU-4 Mode

The SB800 and SB900 and SB910 can be used as slaves to any strobe in the SU-4 mode. This wireless flash mode can be accessed through the custom settings menu. SU-4 type wireless multiple flash can be performed in two ways: (1) in the auto mode, in which the wireless remote flash units start and stop firing in sync with the master flash unit, and (2) in the M (manual) mode in which the wireless remote flash units only start firing in sync with the master flash unit. The mode button will toggle between these states when the flash is set to SU-4. You will want to rotate the flash body so that the light sensor on the lower left corner of the front of the flash faces the Master flash.

Wireless TTL Transmitters: Master

The Nikon SB900/910 and SB800, Canon 600EX-RT, 550EX, 580EX, and 580EX MkII have built-in Wireless TTL transmitters. The Wireless TTL firing and exposure signals are encoded into the light burst of these flash units. Attached to the camera hot shoe, directly mounted on a TTL cord, and through the menu on the Speedlight set to Master, these flash units can control several groups of Remote/Slave(s). Multiple Remote/Slave(s) can be included in each group.

The Master flash can be used as flash and transmitter or as transmitter only if no light from the camera position is desired. Used as transmitter only, the Master will still appear to fire. This is a low-powered Wireless TTL pre-flash signal and will have no adverse effect on the photograph. The most common effect is a secondary central *catchlight* (reflection of the Master flash) in a subject's eye or a reflective surface. The Wireless TTL transmitter signal works when fired through diffusion panels, softboxes, and other light modifiers, allowing all sorts of choices in light quality. Plastic bags can be used for lighting effects and/or weather protection (see *Accessories* on page 121).

Refer to the manufacturer's flash instruction manual for specific information on operating the flash as a Master.

Nikon: some cameras have a built in Wireless TTL transmitter system, providing Wireless TTL for a single or multiple Remote Nikon flashes. Activate the transmitter by setting the camera to Commander Mode. The SB900 and SB800 operate as either Master or Remote. The SU-800 Commander device operates as a Master only.

Canon: the 600EX-RT, 550EX, 580EX, and 580EX MkII are interchangeable as Master and Slave. The optional STE-2 transmitter, used in place of a flash as a Master, can control up to two groups of Slave flashes.

CELLO

Musical instruments are beautiful, sensual things. They repeat as icons in my photography. This was not the first shot we did with this cello. We rent from the same supplier often.

In this case we were trying to reiterate the cliche that guitars, violins and cellos are similar to the female form. In this image the stringed instrument takes the place of the model's body.

The problem was positioning the softbox exactly so it lit the woman and gave highlight on the strings which completes the metaphor. The extreme sidelight made it two photographs: the dramatically lit right side and the shadow left side which creates important negative space. The Speedlight on the painted background separated the subjects without being distracting.

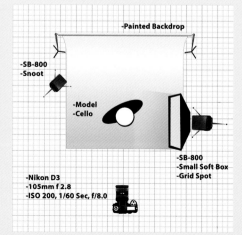

-Painted Backdrop
-SB-800
-Snoot
-Model
-Cello
-SB-800
-Small Soft Box
-Grid Spot
-Nikon D3
-105mm f 2.8
-ISO 200, 1/60 Sec, f/8.0

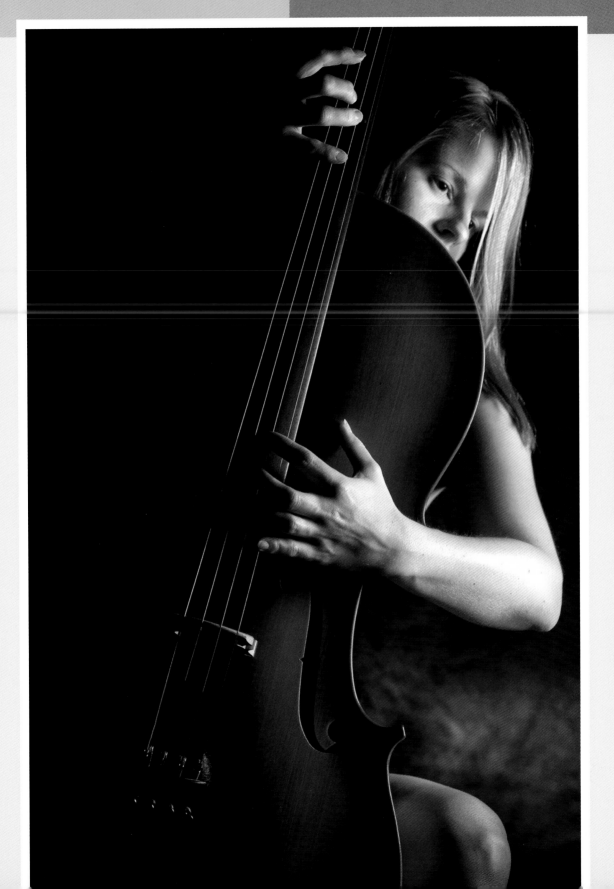

Wireless TTL Receivers: Remote/Slave

The Nikon SB900/910, SB800, SB600, Canon 600EX-RT, 550EX, 580EX, 580EX MkII, and 420EX have built-in Wireless TTL receivers. Any of these flash units can serve as a Remote/Slave with a compatible Master.

Refer to the manufacturer's flash instruction manual for specific information on operating the flash as a Remote/Slave.

> Exposure Compensation on the Remote/Slave(s) should be set to "0."

Canon: activate the receiver by setting any flash to Slave. Any EX flash can be operated as a Slave.

Nikon: activate the receiver by setting any flash to Remote. The SB900/910, SB800, and the SB600 can be operated as Remotes.

Canon: Features Flash Control from the Camera Menu Screen

All flash functions and settings that can be made on the flash screen can be made through the camera menu screen. This is especially valuable when the Master is used off the camera on the TTL cord. In the camera menu, first select External Speedlite Control or Flash Control depending on camera model. Then select Flash Function Settings. EOS digital cameras released since 2012 display all flash functions for Normal flash shooting, Radio Wireless TTL with the 600EX-RT, and Optical Wireless TTL. EOS digital cameras released from 2007 through 2011 display Normal and Optical settings. Operate the 600EX-RT through the menu screen on the flash. Some EOS cameras also display Flash Custom Function menus.

The Canon 600EX-RT is the first Speedlite to have a built-in Wireless TTL radio transmitter and receiver. The 600EX-RT radio signal has a range of 98 feet, and can be used with a total of 16 600EX-RTs.

Using Radio Transmission, five Groups are now available: A, B, C, D, and E; with individual Flash Exposure Compensation or each Group. Main, Fill, Edge, Hair, and Background lights can each have their own control. Each Group can be set to a different Flash Mode within the same set-up. ETTL-II, Manual, and External Flash Metering can be mixed for maximum flexibility and depending on need. Groups can be set to stay the same flash exposure value while others can be set to respond automatically to changes in reflectance.

Radio waves travel faster than the light of the optical transmission. The 600EX-RT radio transmission enables Rear Curtain Sync and High Speed Sync with Slave flashes. Modeling Flash can be fired from a Slave. Remote Release from a Slave fires compatible cameras simultaneously with the Master; the scene can be captured from multiple angles by multiple cameras at the same time.

Auto Scan finds usable radio channels; channels may be set manually in case of interference. The Link Light confirms radio communication between Master and Slaves. Memory Function stores frequently-used settings. Lock disables control buttons and dial, avoiding inadvertent changes to settings. A Color Filter Holder and two amber filters for tungsten and incandescent are included; with compatible cameras white balance is changed automatically to match the filter.

When we generate light, we generate heat. Rapid firing, stroboscopic flash, modeling flash, light modifiers, and high ambient temperatures can all cause overheating. The 600EX-RT and 600EX have automatic Flash Firing Restriction due to Temperature Increase. The display turns red or blinking red to warn of two levels of overheating. Recycle times are lengthened from 8 to 20 seconds until the flash cools and the warnings cease.

The RT can be set for Optical Wireless TTL. In Optical, the RT can be used as Master and Slave with the 550EX, 580EX, 580EX MkII. Mixing Radio and Optical is not possible at this time.

All functions of the 600EX-RT work with all EOS digital cameras released since 2012. With EOS cameras equipped with E-TTL, released up to 2011, flash modes for radio transmission are limited to Manual and Multi. Use optical transmission for automatic flash photography.

For ETTL-II EOS cameras released up to 2011, "X" is one stop slower when using radio transmission; a blinking "Tv" indicates a too fast shutter speed. Group Flash A, B, C, D, E is not possible.

The "RT" suffix adds about $100.00 to the price of the 600EX. The RT adds unprecedented radio capa-

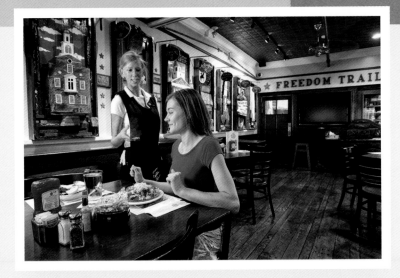

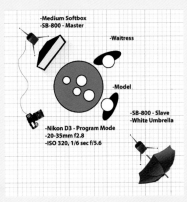

RESTAURANT

The famous, historical restaurant would only allow us to photograph the interior in the hours before they opened, so it was impossible to make the environment appear crowded. However management was otherwise accommodating and served up fake food and beverage for the picture. They lent us their favorite waitress to pose too.

I wanted to use three lights for such a large space, but one of the Speedlights was acting up. Instead, I made two lights do the work of three. The large umbrella filled the entire back of the room and the small softbox lit the server and my assistant.

bilities built-in for about half the price of aftermarket add-on systems.

Wireless TTL Communication: Line-of-Sight

One of the most misunderstood components of flash is the function of Line-of-Sight. In order for multiple flashes to work they must "see" the light pulses from the Master. To "see" means that one receptor physically detects a light emanating from another source. This direct path is called **Line-of-Sight.**

Optical slave technology has been in place for decades and works exceptionally well. Every flash has the ability to trigger other lights in the system if it "sees" an instantaneous flash from another source, whether that source is a flash bulb, a lighter, lights turning on and off, etc.

Speedlights have similar technology, but they use coded pre-flashes. In order for multiple Remote/Slave(s) to work they must "see" the light pulses from the Master. The signal for Wireless TTL in most cases is not radio-activated.

Obstacles or barriers that block the light signal can prevent Wireless TTL from working or give unreliable results. The signal may not be strong enough to work if you hide flashes in light modifiers or put them behind walls or other impediments. A TTL cord connected between camera and Master enables use of the Master off the hot shoe and offers more flexible line-of-sight.

The Speedlight's bounce and swivel head can point the Master at a Remote/Slave behind or beside the camera. In small, light-colored interiors, the Wireless TTL signal from the Master may sufficiently bounce off surfaces to fire all Remote/Slave flashes even if the receivers are not facing the transmitter (see *Bounce Flash: Direction and Quality of Light* on page 99). But anywhere the signal does not bounce, especially outdoors, line-of-sight is required between the Master transmitter and the Remote/Slave receiver(s).

Many third party manufacturers of remote triggers would have you rely on their radio technology to enhance the signals. Our first book stated that these auxiliary triggers were not fully compatible with the complicated functions of Nikon/Canon Speedlights/Speedlites. Many of them have corrected that since. We will deal with that in Chapter 6.

Adding another expensive gadget between your

camera and Speedlight has advantages, but also many disadvantages. Besides adding expense, weight, and complexity to the equation, every connection added will make it more difficult to detect the root of a problem when it arises. Line-of-sight is a very reliable method and is simple, direct, and cheap.

When set to Master, the flash will automatically zoom to the 24mm lens setting to provide the widest spread of the Wireless TTL signal. In general, the Wireless TTL signal from the Master radiates in an 80° wide "cone" in front of the Master, and is effective to over 30 feet outdoors and over 40 feet indoors. The Manual Zoom feature is still operable on the Master, but changing the angle of illumination from the Master also changes the spread of the TTL transmitter signal.

> Diffuser modules, even typing paper stretched over the Master, will increase the spread of the triggering signal.

In some lighting scenarios, no direct line of sight between Master and Remote Slave is possible. Example: a background light or veil light behind a subject or in a banklight pointed toward the camera. The electronics are sensitive enough that reflector discs, reflector panels, and mirrors can be used to bounce the Wireless TTL transmitter signal around corners and at angles to the Remote/Slave. Because of the interchangeability of Master and Remote/Slave, you can place flashes to receive the signals in clever arrangements to ensure that they all get the message.

> Nikon: the Wireless TTL receiver is the small black round window on the side of the Remote flash.
> Canon: the Wireless TTL receiver is the red panel on the front of the Slave.

> Use the bounce and swivel head of the Remote/Slave to point the receiver toward the Master, while pointing the flash reflector at the subject.

Release yourself of the idea that Master/Slave or Master/Remote connotes any pecking order. The Main light may be quite removed from the camera. The Master should be thought of as: (1) a controller; (2) a trigger, etc.

Finite

An optical Master Speedlight can activate three groups and, according to Nikon, there is no limit to the number of Speedlights in each group. But is there eventually some limit to the number of Speedlights that can be used in a shot? Does the pre-flash process take longer if we add lights? Since light travels one foot in about a nanosecond, the distance between the Speedlights is insignificant. While each group makes a separate light measurement in sequence, this time delay does not depend on how many Speedlights are in the group. The camera's computer makes the final exposure calculation based on the light measurements from the Master Speedlight and up to three Remote/Slave groups. Theoretically, the calculation is only based on a maximum of four light measurements and does not take any longer if more than one flash is in a group. The final data transmission to each of the remote groups and the firing of the flashes is also independent of how many Speedlights are in any one group.

How much light do you need? Is AC power available? For a location shot, packing several Speedlights might be a little easier, assuming you own several Speedlights. Finally, there is a cost trade-off which will really depend on your ambitions as a photographer.

The Canon 600EX-RT can control a maximum of 16 600EX-RTs in radio mode.

Wireless TTL: Channels

Four proprietary Wireless TTL operating Channels are available from each manufacturer. The Master will ignite all the Remote/Slave(s) set to the same Channel (and only those set to that Channel) at the same time. Multiple operating Channels avoid interference from other photographers using same-brand Wireless TTL in the same location (see *Wireless TTL: Privacy* on page 65).

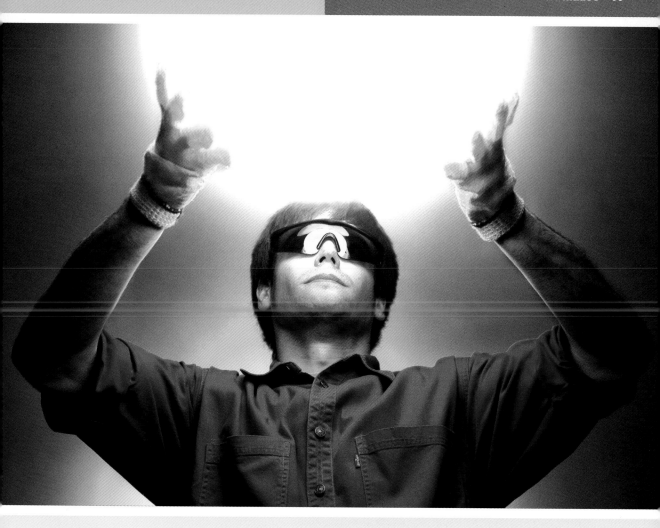

INDUSTRIAL

It can take days, weeks, months to put the props together for a photograph. My studio rejected about half a dozen pairs of gloves. I found the glasses in a hardware store. The giant plastic globe was especially hard to find.

Inspiration came from the industrial era imagery of movies like **Metropolis**, modern sci-fi films, and the ancient myth of Prometheus.

It should be noted that the principle subject in the picture is also the main light. Since the idea was to appear as if the sphere was radiating light, I put a Speedlight inside. Consequently, that light source spilled light everywhere. We had to gobo it from the background. To accomplish the outglow, I put a diffusion filter on the lens. The whole set-up made for a wild histogram.

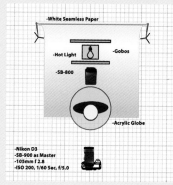

-White Seamless Paper
-Hot Light
-Gobos
-SB-800
-Acrylic Globe

-Nikon D3
-SB-900 as Master
-105mm f 2.8
-ISO 200, 1/60 Sec, f/5.0

WIRELESS TTL: REMOTE/SLAVE ID GROUPS

Remote/Slave flashes can be identified as Group A, B, or C. All Groups fire at the same time. Flash power for each Group is adjusted by changing Flash Exposure Compensation settings on the Master. More than one flash can be assigned to the same Group. Multiple flashes assigned to the same Group will provide approximately the same flash output. The camera's computer views all flashes within the same Group as a unit.

Nikon: Master is identified and controlled separately as an M.

Canon: Master is always part of Group A.

Wireless TTL exposure control for multiple Groups is illustrated by the following flow chart:

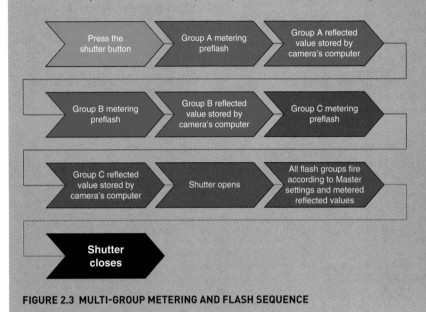

FIGURE 2.3 MULTI-GROUP METERING AND FLASH SEQUENCE

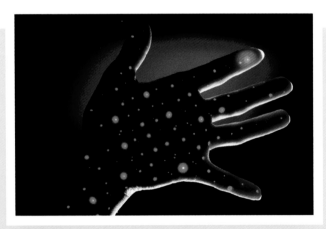

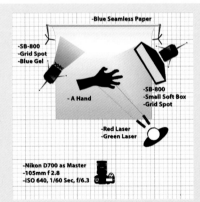

LASERS

I bought the laser lights from a vendor on the street in Shanghai, China. I finally had the opportunity to use them for a photograph produced for my stock agency.

My assistant backlit the model's hand with a softbox and pointed another Speedlight with a grid spot covered by a blue gel at a blue seamless. The combination of blue filter and matching background produces a very saturated color. Then another assistant pointed the red laser at the single finger and the green laser at the hand.

Exposure was determined by setting Shutter Priority so the continuous light from the lasers "burned in" bright enough (see *Shutter Priority (S/Tv)* on page 83). Intensity of the other lights was dialed down a little to match.

With sufficient numbers of flashes, the Channels feature can provide flexibility and speed on location or in studio. Pre-set lights in different parts of a room, or lights set for different visual effects on a subject can be accessed instantly. For example, a "hard light" set-up can be placed on Channel 1, and a "soft light" set-up can be placed on Channel 2. The photographer can switch back and forth from one lighting effect to the other simply by changing the Channel setting on the Master.

Wireless TTL: Privacy

Only the same manufacturer's flashes set to Master and set to the same Channel will fire Wireless TTL Remote/Slave(s). The light of "point and shoot" flashes will not trigger Wireless TTL Remote/Slave(s) nor are they fired by the same manufacturer's flashes not set to Master.

Both Nikon and Canon are proprietary systems with four interflash communication Channels. Four Nikon photographers can utilize Nikon Channels 1

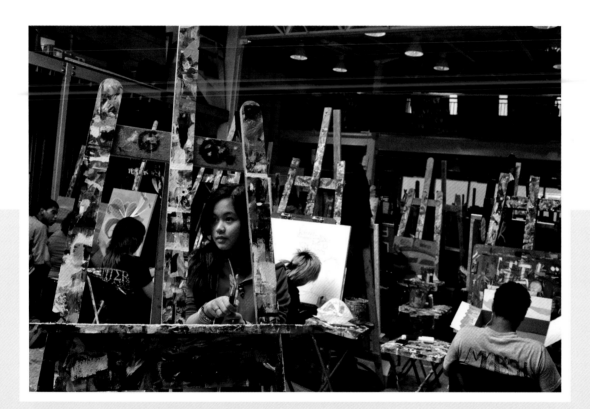

ART CLASS

A foundation that provides funding for educational programs hired us to document an art class. The school had been very successful with the scope of services they provided children in the community.

The painting class was held in a very large room with high ceilings. There were dozens of students working on their projects. I shot their activities from every angle. Because the well-worn, paint-splattered easels were a metaphor for what they were learning, I wanted to include them and the repetitive forms they created.

One small softbox is lighting the girl in the foreground. There is another Speedlight on a tall lightstand bounced off the ceiling to brighten up the voluminous background (see *Bounce Flash: Direction and Quality of Light* on page 99). The D700 pop-up flash acted as the Master. By employing the Speedlights on automatic, my assistant and I were able to move fairly quickly from one set-up to the next.

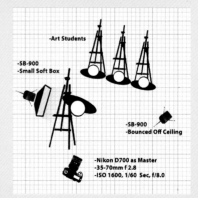

through 4. Four Canon photographers can utilize Canon Channels 1 through 4. All can have a flash set to Master. Eight different Wireless TTL lighting set-ups can fire in the same room with no interference. Canon: for the 600EX-RT in radio transmission mode, set the wireless radio ID for 600EX-RT radio Master and Slave(s) to give further privacy from radio interference.

Wireless TTL: Basic Settings for Master and Slave

The following lists provide the basic settings for preparing a Wireless TTL multiple flash set-up:

Nikon SB900/910 or SB800 as transmitter only with one or more Remote Groups

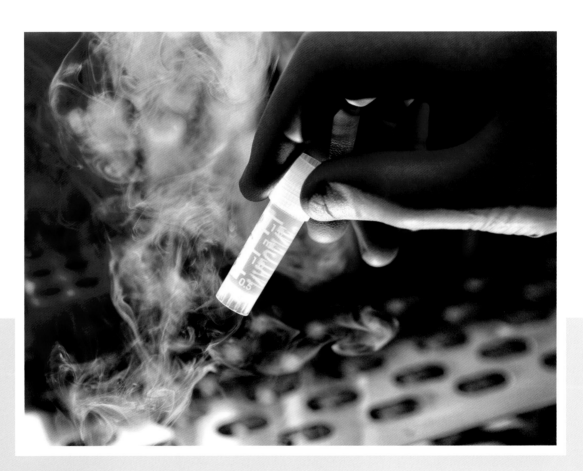

PHARMACEUTICALS

Clients think that every shot is merely clicking the shutter. Their simple requests become nightmares. Actually, I love the challenge. Crossing the United States to photograph for a pharmaceutical company, we had to show the product stored in extremely cold containers.

In order to solve some visual problems, you have to light what's NOT there. In this case, I backlit the two main objects in the photograph: the vial and hand, and the voluminous condensation. In the extremely tight, hostile space, I was attempting to pass light through the chemical and, at the same time, shine light through the smoke so that it would show up.

Both the technician wearing the glove and I could only withstand the frigid temperatures for a few frames before we had to recover. I had a very slight blue gel on the smoke light to differentiate it from the light on the hand. The whole set-up was an experiment and I "built" the lighting, step by step, until I arrived at a satisfactory result.

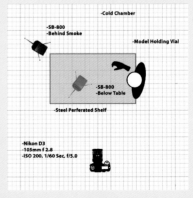

On-camera flash Mode set to "-----".

On-camera flash set to Master.

Remote(s) set to A, B, or C as needed.

Master and Remote(s) set to the same channel: 1, 2, 3, or 4.

Nikon SB900/910 or SB800 as flash and transmitter with one or more Remote Groups

On-camera flash Mode set to TTL

On-camera flash set to Master

Remote(s) set to A, B, or C as needed.

Master and Remote(s) set to the same channel: 1, 2, 3, or 4.

Optical Transmission Wireless E-TTL/E-TTL II

Canon 550EX, 580EX, 580EX MkII, 600EX, 600EX-RT as optical transmitter only; with one Slave Group at the same flash exposure value:

On-camera flash set to Master.

600EX-RT: Wireless Setting to Optical Transmission.

On-camera flash Master Flash Firing off.

Master will still fire a pre-flash.

Ratio off.

Slave(s): set the Flash Exposure Compensation on the Slave(s) to "0."

600EX-RT: set to Optical Transmission and Slave.

Slave(s) set to A. Multiple Slaves can be in the same Group.

Master and Slave(s) set to the same channel: 1, 2, 3, or 4.

Confirm operation. Press the Master's test button (ready lamp). Master, then Slave(s), should fire in sequence.

Master Flash Exposure Compensation changes the flash exposure value of the Group.

Canon 550EX, 580EX, 580EX MkII, 600EX, 600EX-RT as optical transmitter only; with two Slave Groups:

On-camera flash set to Master.

600EX-RT: Wireless Setting to Optical Transmission.

On-camera flash Master Flash Firing off.

Master will still fire a pre-flash.

Ratio on. Ratio A:B.

Slaves: set the Flash Exposure Compensation on the Slaves to "0."

600EX-RT: set to Optical Transmission and Slave.

Slaves set to A and B as needed. Multiple Slaves can be in the same Group.

Master and Slaves set to the same channel: 1, 2, 3, or 4.

Confirm operation. Press the Master's test button (ready lamp). Master, Group A, Group B should each fire in sequence.

Master Flash Exposure Compensation is for the exposure value of A. Ratio is for the contrast between A and B.

Canon 550EX, 580EX, 580EX MkII, 600EX, 600EX-RT as optical transmitter only; with three Slave Groups:

On-camera flash set to Master.

600EX-RT: Wireless Setting to Optical Transmission.

On-camera flash Master Flash Firing off.

Master will still fire a pre-flash.

Ratio on.

Ratio A:B:C.

Slaves: set the Flash Exposure Compensation on the Slaves to "0."

600EX-RT: set to Optical Transmission and Slave.

Slaves set to A, B, and C as needed. Multiple Slaves can be in the same Group.

Master and Slaves set to the same channel: 1, 2, 3, or 4.

Confirm operation. Press the Master's test button (ready lamp).

Master, Group A, Group B, Group C should each fire in sequence.

Master Flash Exposure Compensation is for the exposure value of A. Ratio is for the contrast between A and B.

Flash Exposure Compensation C changes exposure value for C.

Canon 550EX, 580EX, 580EX MkII, 600EX, 600EX-RT as flash and optical transmitter; Master and Slave(s) as one Group:

On-camera flash set to Master.

600EX-RT: Wireless Setting to Optical Transmission.

On-camera flash Master Flash Firing on.

Ratio off.

Slaves: set the Flash Exposure Compensation on the Slaves to "0."

600EX-RT: set to Optical Transmission and Slave.

Master is always A. Slave(s) set to A.

Multiple Slaves can be A.

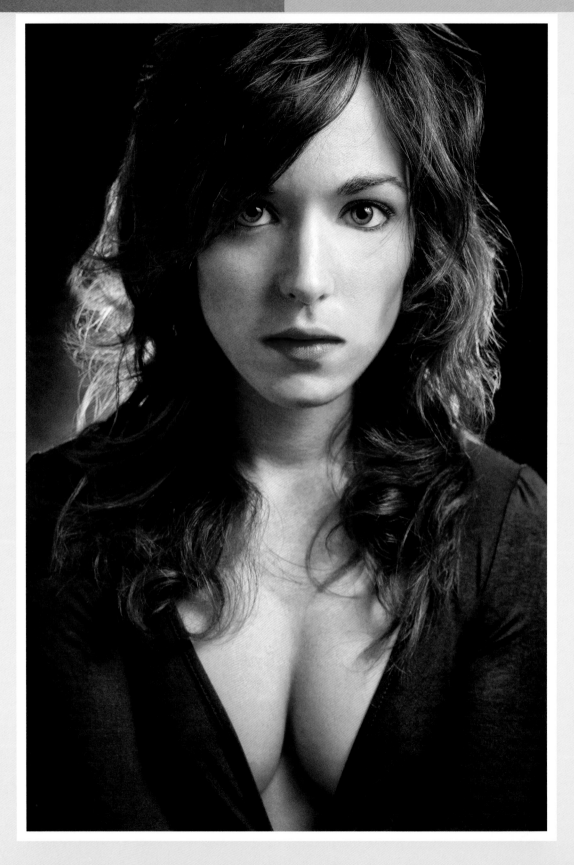

Master and Slave(s) set to the same channel: 1, 2, 3, or 4.

Confirm operation. Press the Master's test button (ready lamp).

Master, then Group A, should each fire in sequence.

Master Flash Exposure Compensation changes the flash exposure value of the Group.

Canon 550EX, 580EX, 580EX MkII, 600EX, 600EX-RT as flash and optical transmitter; Master and Slave(s) in two Groups:

On-camera flash set to Master.

600EX-RT: Wireless Setting to Optical Transmission.

On-camera flash Master Flash Firing on.

Ratio on, Ratio A:B.

Slaves: set the Flash Exposure Compensation on the Slaves to "0."

600EX-RT: set to Optical Transmission and Slave.

Master is always A. Slave(s) set to A and B as needed.

Multiple Slaves can be A or B.

Master and Slave(s) set to the same channel: 1, 2, 3, or 4.

Confirm operation. Press the Master's test button (ready lamp).

Master, Group A, Group B should each fire in sequence.

Master Flash Exposure Compensation is for the exposure value of A. Ratio is for the contrast between A and B.

Canon 550EX, 580EX, 580EX MkII, 600EX, 600EX-RT as flash and optical transmitter; Master and Slave(s) in three Groups:

On-camera flash set to Master.

600EX-RT: Wireless Setting to Optical Transmission.

On-camera flash Master Flash Firing on.

Ratio on, Ratio A:B:C.

Slaves: set the Flash Exposure Compensation on the Slaves to "0."

600EX-RT: set to Optical Transmission and Slave.

Master is always A. Slave(s) set to A, B, C as needed. Multiple Slaves can be in the same Group.

Master and Slave(s) set to the same channel: 1, 2, 3, or 4.

Confirm operation. Press the Master's test button (ready lamp).

JULIE IN GREEN

The background is black seamless colorized with a green-filtered Speedlite. The green was selected to complement the clothing and eye color, and to add mood. Firing a filtered flash into the black background produces intense, saturated color and quick falloff for a dramatic haloed vignette effect.

The combination background/hair light effect is produced with one Speedlite behind the subject. The Speedlite is on a low stand, tilted straight up, covered with green gel, and is fitted with a diffusion material "sleeve" (see *Diffusion Sleeve* on page 131). The sleeve effectively turns the Speedlite into a soft, diffused flash that fires in predominately two directions. Light striking the background gradates beautifully and light going forward illuminates the edges of the subject producing a rim of light. If I wanted to illuminate only one side, I would place a black report cover over the opposite side of the sleeve as a gobo.

The Main light is a Speedlite in a 12" × 16" white-lined softbox. I move my lighting in close, looking for the edge of the softbox in the viewfinder, then backing it up only an inch or two so it is out of the picture. The physical closeness of the light results in the glowing skin tones. It also produces large bright catchlights to add life and bring attention to the eyes. Classic Rembrandt lighting was created by using the light at 45 degrees to Julie's face, accentuating and complementing the facial structure. A 3' × 6' white reflector was positioned to camera left as fill. It picked up some of the background light resulting in the green cast in the shadows.

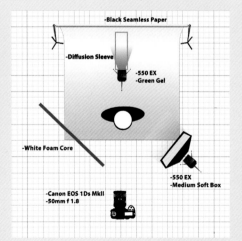

Master, A, B, C should each fire in sequence.

Master Flash Exposure Compensation is for the exposure value of A. Ratio is for the contrast between A and B.

Flash Exposure Compensation C changes exposure value for C.

600EX-RT Radio Transmission Wireless Flash

There are restrictions on radio functions when the 600EX-RT is used with older ETT-L EOS cameras; these cameras were released up to 2011. Flash sync speed is one stop slower than X. High Speed Sync and Group Flash cannot be used. Radio transmis-

sion of the ETT-L information is not possible. Use manual flash mode or stroboscopic when using radio transmission with these cameras; or use optical transmission. Please refer to the flash instruction manual or contact the manufacturer for the list of EOS cameras with ETT-L.

All flash functions work with ETTL-II EOS digital cameras released since 2012.

Wireless TTL: Controlling Exposure and Contrast

To continually emphasize this paradigm shift in digital/Speedlight technology, we no longer rely on the old habits of controlling flashes with aperture and shutter speed and manually raising and lowering flash power. Now, all decisions go through two independent computers, one in the flash and one in the camera, and they insist on giving you "correctly" exposed images every time despite any misguided choices. But everything in TTL flash is relative. Any adjustment you make in an automatic mode tends to make all the lights re-level themselves to get you that proper exposure. If you come to understand this interdependency, the rest is easy.

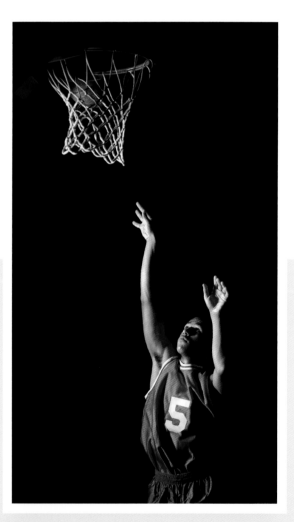

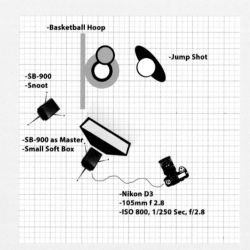

JUMP SHOT
Although my staff pulled the shades and turned off all the lights in this huge basketball gymnasium, we were not able to get the background dark enough. Instead, I controlled the ambient lighting using a fast shutter speed. It practically eliminated all detail behind the shooter.

Exposure strategies for Wireless TTL multiple flash photography and mixing these flashes with existing light remain basically the same when using on-camera TTL flash.

Flash exposure for *each* Remote/Slave group is controlled by Flash Exposure Compensation and/or Ratio settings on the Master. At first, Group, Flash Exposure Compensation, and/or Ratio settings in Wireless TTL may seem confusing to those accustomed to manual flash and incident metering, or to those unaccustomed to working with controlled lighting.

> Using multiple TTL flashes is analogous to swimming pool lane buoys. They are all held together by a single cord. When you pull one buoy down underwater, they are all partially displaced by different but predictable amounts to hold the one submerged afloat. Likewise, each Speedlight contributes more or less light to balance the overall shot.

It is always helpful to have a pre-visualized purpose for each flash Group, as this gives a good starting point for Flash Exposure Compensation and/or Ratio settings (see *Main Light and Fill Light: Definitions* on page 30). Adjustments in Flash Exposure Compensation and/or Ratio settings should be judged both visually on the LCD monitor and graphically on the histogram. Review the highlight point of the histogram to determine exposure and the shadow point to determine contrast (see *Contrast* on page 39). Believe your eyes. Wireless TTL operates by comprehension, intent, and observation, not by linear formula.

Wireless TTL flash exposure is based upon reflected meter values. The Exposure Compensation for each Remote/Slave Group is set according to the brightness value desired in the image and the reflectance of the area being illuminated. Wireless TTL flash Groups are adjusted in relation to each other, rather than a hypothetical baseline. In most cases, all other flashes are adjusted in accordance to the brightest flash. As more existing or continuous light is incorporated in the exposure, the overall effect of the Speedlight will be reduced. In general, satisfactory highlight exposure should be obtained before attempting to judge contrast.

Group A is being used as a Fill light.

Group B is being used as a Main Light

No available or continuous light is relevant in the image.

The brightness of the Main light Group B determines the highlight exposure and its value. In this example, adjusting the value of Main light Group B will change the highlight exposure in the image file.

Contrast can be analyzed once a satisfactory highlight exposure value for Main light Group B has been established. The relationship between the Main light and the Fill light determines the density of the shadow areas and the amount of detail visible in those shadows.

To compress highlight and shadow (to lighten the shadows and to reduce contrast), the exposure values for the two Groups must be brought closer together. To increase contrast, the exposure values for the two Groups must be pushed further apart.

Increasing or decreasing the Main light Group B will adversely affect the highlights, so the contrast in this example is controlled by changing the value of the Fill light, Group A.

Fill light Group A "–" will increase the difference between Main and Fill, increasing shadow density and increasing contrast. Fill light Group A "+" will do the opposite.

If Fill light Group A is set to "–2", it will fire at a reflected value two stops less than the Main light Group B, regardless of whether the Main light Group B is adjusted up or down.

Wireless TTL exposure for multiple flashes is also based on the total amount of flash entering the camera. As one flash Group is made brighter, other flash Groups may become darker. With manual flash each change is Independent. But with multiple lights, any change in any of the lighting, available or flash, affects all the others (see *buoy* analogy on page 62). Adjust flash Groups accordingly.

Since multiple wireless TTL Speedlights work in unison, adjusting any one may automatically change others and the overall look of the picture. To illustrate the need for a visual and flexible approach to setting Wireless TTL, consider these examples:

> If a Background light is made brighter or darker, the Main light may also need to be adjusted. The total amount of flash entering the camera is changed, therefore the TTL flash settings may need to be changed.
>
> When a TTL flash Group illuminates a small portion of the subject or the frame, it will have a tendency to overexpose. A Rim light, Edge light, or Hair light may need to be set to a low value even if it is the brightest light in the image.
>
> If a subject changes from a dark shirt to a light shirt, the TTL settings may need to be adjusted for the change in subject reflectance.

Once an exposure relationship is established between multiple TTL flashes, the camera computer works to maintain that relationship even if the lighting set-up changes. Consider these examples:

> Main: the Main light may be moved to create a different direction without adjusting the TTL flash settings.
>
> Main and Fill: once a satisfactory highlight point (exposure) and shadow point (contrast) are established, the Main light may be moved closer to, or farther from, the subject to change the quality of light without further adjusting the TTL flash settings.
>
> Main and on-camera Fill: once a satisfactory highlight point (exposure) and shadow point (contrast) are established, an on-camera Fill light may be moved closer to, or farther from, the subject to change the composition without further adjusting the TTL flash settings.
>
> Main and Fill: once a satisfactory highlight point (exposure) is established, the Fill light exposure compensation/ratio may be changed to adjust the contrast without affecting the highlight point.

In review, if the amount of existing light in the image changes, by either exposure or actual brightness, the camera computer will adjust the flash values accordingly. The quantity of existing light in the image is changed by adjusting a camera setting: existing light Exposure Compensation, shutter speed, aperture, and/or ISO. To change the brightness value of any or all of the Wireless TTL flash Groups, adjust the Flash Exposure Compensation and/or the Ratio settings for those Groups. The amount of TTL flash in the image is altered with the brightness of the TTL flash(es).

The number of settings, choices, and decisions may be the most intimidating aspect of Wireless TTL photography with multiple flash Groups. But the system really is almost foolproof. If you succeed in getting the Speedlight to fire, the LCD will give you instant feedback as to whether they are doing what you want. Just be sure you keep in mind they are rarely making the mistake. They are simply doing what you tell them . . . perfectly.

Nikon and Canon use distinctively different control protocols for adjusting the relationship between multiple Remote/Slave Groups. The following sections are manufacturer specific for Wireless TTL control system settings.

Canon:

The LCD panel on the Master flash features Flash Exposure Compensation and Ratio controls for Slave Groups A, B, and C. The Master is always part of Group A. All flash Groups fire at brightness values relative to each other as dictated by the photographer. The flash brightness values are also affected by the quantity of existing or continuous light. The controls for all of these light sources can soon become intuitive if time is taken to analyze the effect of each one. If the Master and all the Slaves are in the same flash Group, they might fire at different powers but will all provide approximately the same brightness value.

Use the key words to regulate the flash control to the effect desired in the image: *Flash Exposure Compensation* is used to adjust the flash highlights, i.e. the highlight exposure value, *Ratio* is used to change contrast, often referred to as lighting ratio.

Ratio A:B establishes the brightness value relationship between Groups A and B. The Ratio is shown as units of light. The dots in between the numbers represent intermediate ratios. An A:B Ratio of 1:4 translates into one unit of light emitted from Group A for every four units emitted from Group B, resulting in Group B being two stops brighter than Group A. An A:B Ratio of 4:1 translates into four units of light from Group A for every one unit from Group B. The Ratio feature can be set to any Ratio shown on the flash LCD.

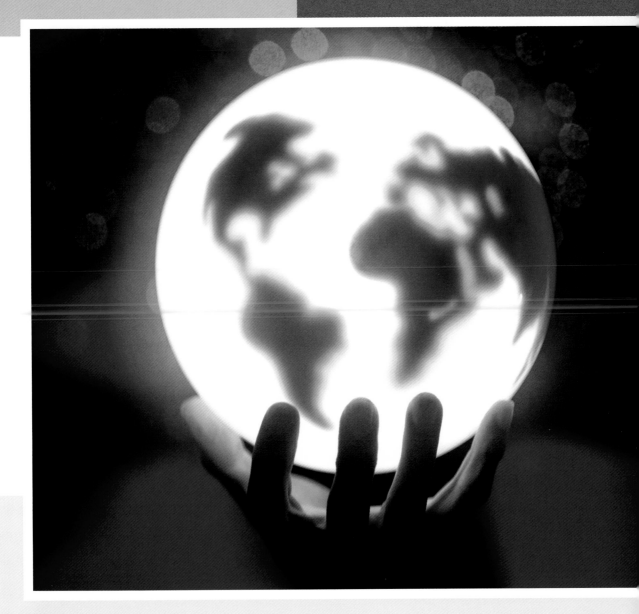

GLOBE

A NGO (non-governmental organization) wanted to communicate how their organization lent assistance to charities all over the world. And they had a modest budget. They needed a twibbon for their Facebook/Twitter sites. In a dream I got the idea to put a cutout of the world inside this translucent plastic ball with a Speedlight inside so it emanated light. My intern cut out the gobo for the shadows on the background and I used a laser to make the stars. The camera lens had a heavy diffusion filter on it to enhance the outglow from the globe. That is my hand holding the sphere. My assistant tripped the shutter.

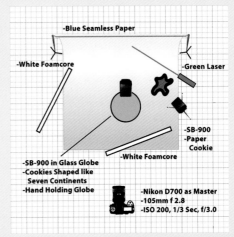

-Blue Seamless Paper

-White Foamcore

-Green Laser

-SB-900
-Paper
Cookie

-White Foamcore

-SB-900 in Glass Globe
-Cookies Shaped like
 Seven Continents
-Hand Holding Globe

-Nikon D700 as Master
-105mm f 2.8
-ISO 200, 1/3 Sec, f/3.0

Ratio A:B

(6:1) (3:1) (1.5:1) (1:1.5) (1:3) (1:6)
8:1 ● 4:1 ● 2:1 ● 1:1 ● 1:2 ● 1:4 ● 1:8

A is three stops brighter than B	A and B are equal	B is three stops brighter than A

Ratio A:B:C provides the same A:B Ratio control as above, with Group C being controlled by a separate Flash Exposure Compensation of "-3" to "+3" relative to the total brightness values provided by Groups A and B.

Ratio A:B:C

(6:1) (3:1) (1.5:1) (1:1.5) (1:3) (1:6)
8:1 ● 4:1 ● 2:1 ● 1:1 ● 1:2 ● 1:4 ● 1:8

A is three stops brighter than B	A and B are equal	B is three stops brighter than A

C "-3" to "+3" Flash Exposure Compensation relative to the total brightness of A:B

Flash Exposure Compensation on the Master changes the quantity of flash provided by the Master and all Group A Slaves. Since the other flash Groups respond to changes in any one flash Group, the Flash Exposure Compensation on the Master effectively raises or lowers all flash Groups equally.

Consider a two Group lighting set-up providing a Main and a Fill. The Main light is often used close to the subject. But let's suppose that the Main light is an off-camera Slave. Identify the Slave as Main and Group B. The on-camera Master is ideal for use as a flat, frontal Fill light. Used with a TTL cord, the same Master can also become a Form Fill (see *Main Light and Fill Light: Definitions* on page 30). With Canon, the Master is always part of Group A.
 The difference in brightness between the Main light and the Fill will determine contrast. To make the Slave Group B Main light two stops brighter than the Master Group A Fill, set the A:B Ratio at 1:4. This will provide four units of light from Group B for every one unit from Group A. Group B as Main will be two stops brighter than Master Group A as Fill.

When needed, adjust the Group C Flash Exposure Compensation to make Group C brighter or darker relative to Groups A and B.
 Use these guidelines as a starting point to obtain a traditional 3:1 Main:Fill contrast range:
 If the Main is A and the Fill is B, start with the A:B Ratio at 3:1.
 If the Fill is A and the Main is B; use 1:3.
 View the contrast range on the histogram.
 Adjust the Flash Exposure Compensation for C (if being used) to obtain satisfactory results.

Nikon:

The LCD panel on the Master flash features Flash Exposure Compensation for Remote Groups M, A, B, and C. On some camera models, these controls are accessed through the camera LCD when the camera is set to Commander Mode. The Master is always Group M. All flash Groups fire at brightness values relative to each other as dictated by the photographer. The flash brightness values are also affected by the quantity of existing or continuous light. The controls for all of these light sources can soon become intuitive if time is taken to carefully analyze the effect of each one. All Remote flashes in the same Group will provide approximately the same brightness value.

The flash Group compensations are adjusted to create a brightness relationship between the Groups, rather than an intrinsic individual base.

Consider a two Group lighting set-up providing a Main and a Fill. The Main light is often used close to the subject. It is likely that the Main light will be an off-camera Remote. The on-camera Master is ideal for use as a flat, frontal Fill light. Used with a TTL cord, the Master can also become a Form Fill (see *Main Light and Fill Light: Definitions* on page 30). To control the brightness values of the Remote Main and the Master Fill (Group M) relative to each other, assign the Remote Main to your choice of Group A, Group B, or Group C.
 The Remote Group Main light will provide the highlight brightness. Set the Flash Exposure Compensation for the Remote Group Main light to "0" to provide a standard flash exposure.
 The difference in brightness between the Main light and the Fill light will determine contrast. To make the Master Group M Fill light two stops less than the Remote Group Main light, set the Flash Exposure Compensation for Group M to -2 EV. Master Group M Fill light will now remain at two stops less than the

Remote Group Main light, even if the Flash Exposure Compensation for the Remote Group Main light is raised or lowered.

If additional Remote flash Groups are added, adjust the Flash Exposure Compensation for these additional Groups in relation to the Main and Fill to achieve the desired brightness values. Use these guidelines as a starting point to obtain a traditional 3:1 (Main:Fill) contrast range:
Start with the Main at "0" and the Fill at - 1.7 EV. For more dramatic contrast, set the Fill at -2.3 EV to -3 EV. For less contrast, set the Fill at -1 EV.
View the contrast range on the histogram.
Adjust the Flash Exposure Compensation for any Remote Group to obtain satisfactory results.

With one or more Remote(s)/Slaves you can press the Flash button on the back of the Speedlight Master and each Group will ignite in sequence to demonstrate that the Wireless feature and the entire system is working. It is quite an impressive display. You can activate the Master and have dozens of Speedlights firing one after another. It's a veritable stroboscopic light show.

As with traditional manual flash and Polaroids, it may take several test images and adjustments to successfully place tonal values where desired. Experimentation and experience with the Wireless TTL system will make the process more fluid and intuitive.

MANUAL FLASH

Canon Speedlites and Nikon Speedlights can be operated on Manual. The Manual mode changes the fundamental operation of the flash system, disconnecting the flash from the in-camera reflective meters and computer, returning to "old school" flash photography. In Manual flash mode, the camera's computer will no longer change the quantity of flash automatically. The photographer regulates flash power, distance, and aperture. Each flash group will now provide a fixed, unchanging quantity of flash. Flash brightness values are changed by flash power rather than Flash Exposure Compensation.

How It Works

Manual flash is a combination of the basic physics of light and photographic mechanics. Exposure for Manual flash is determined by a combination of ISO, flash power set by the photographer, flash-to-subject distance, zoom head position, and aperture. The following explains the significance of each component of a Manual flash exposure value.

ISO is the relative sensitivity to light. ISO determines the quantity of flash sufficient to properly expose capture medium.

If the range of flash power settings cannot provide the desired aperture and/or span the flash-to-subject distance, change the ISO.

Flash power changes the amount of flash. Flash power does not make the flashtube brighter or dimmer. It controls flash duration, the amount of time the flashtube is lit. Maximum flash power, also called full power, is represented on the flash LCD display as "1/1." Maximum power is the longest duration, and the greatest amount the Speedlight can produce. Full power may be needed at small apertures, low ISO, or if the subject is far away from the flash. Minimum power produces the shortest duration. Because of the short flash duration, low flash power can freeze very fast action. Low flash power is for large apertures, physically close subjects, or high ISO settings. Flash in Manual mode is adjustable in 1/3 stop increments. The actual amount of flash is expressed as a guide number (see *Guide Number* on page 4). See manufacturers' instructions for specific steps of setting Flash Power in Manual flash mode.

The Nikon SB900 and SB800 are adjustable in full stop increments from 1/1 to ½ power, then 1/3 stop increments from ½ power to a minimum power at 1/128.

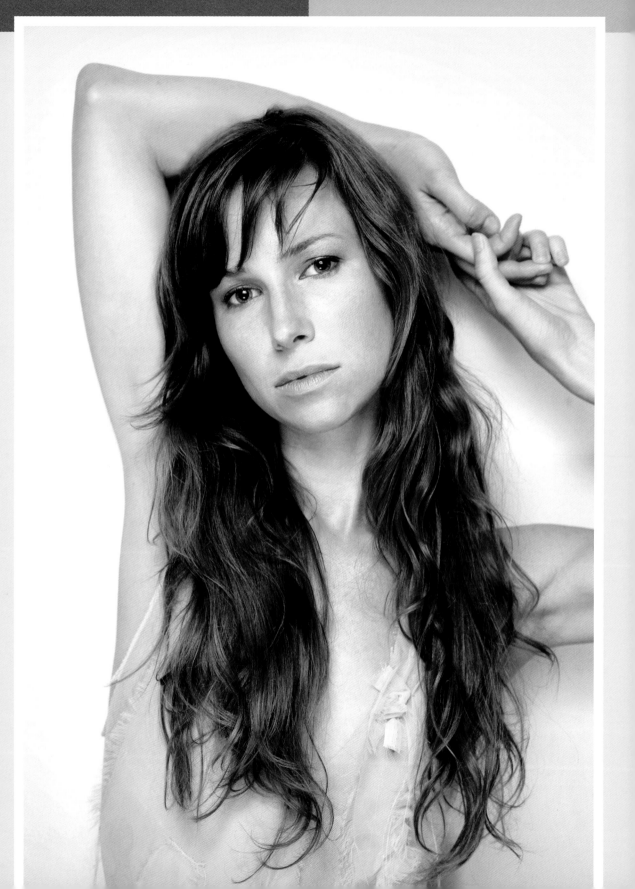

Reducing Flash Power: if 1/1 Full Power were to provide f/8 worth of flash at a certain distance, 1/2 Power would provide half that, requiring an aperture of f/5.6 for the same distance. Quarter power would provide 1/4 the amount, for an aperture of f/4 at the same distance and so on.

If 1/1 Full Power at an ISO were to provide f/11 for a subject 10 feet from the flash, 1/4 power at the same ISO would provide f/11 worth of flash for a subject five feet from the flash (see *Inverse Square Law* on page 7).

If 1/1 Full Power at ISO 100 were to provide f/16 for a certain distance, 1/2 power at ISO 200 would provide f/16 at the same distance and 1/4 power at ISO 400.

The flash-to-subject distance, at any power setting, affects the amount of flash reaching the subject.

Adjust the flash power, aperture, and/or the ISO to provide a correct flash exposure for a subject at any given distance from the flash.

Adjust the flash power and/or the ISO to achieve a desired aperture value.

Different combinations of flash power and aperture can all result in a correct flash exposure value.

The zoom head position controls the angle of illumination, spreading the light to cover a larger area for wide-angle lenses or concentrating the light for greater range and efficient use with longer focal lengths. The zoom head position affects the guide number and intensity at any given distance.

Off-camera flash can maintain a constant flash to subject distance for constant exposure values while allowing the photographer to move, changing the camera position without changing aperture or flash power.

Flash power and/or aperture may need to be adjusted for each change in focal length when the flash zoom is set to Auto.

Setting the zoom head manually will allow a constant aperture at different focal lengths at the same distance and same power. Set the flash zoom head manually to cover the widest focal length being used. Aperture will not have to be changed when zooming the lens to a longer focal length at the same distance.

Flash LCD

ISO, flash power, flash-to-subject distance, zoom head position, and aperture can all be used as starting points for a Manual flash picture. When a single Speedlight set to Manual flash mode is used on the camera hot shoe, or used with a TTL cord, the LCD on the back of the Speedlight provides a guide to

EMILY

Emily is a fashion designer and is wearing one of her own creations. I decided on a high key look, based on her light skin tone and pastel dress. By blending dress and background, more attention goes to eyes, face, and hair. The background is the freshly painted white wall of the studio. The ambient light level in the studio was low, opening her pupils and contributing to the dreamy expression.

For an overall soft, even light, "stack lighting" was used. One slave Speedlite was bounced onto a 3' × 6' white reflective panel positioned below the lens. Slave Group IDs were changed for top and bottom lights depending on if I wanted the relative brightness values the same or different for the two lights. I experimented with equal, top brighter, and bottom brighter, and achieved a variety of effects. The Ratio is top light Group A:bottom light Group B . . . 3:1 here.

Lights placed on either side of the lens produce two sets of highlights and two sets of shadows cast to both sides. Lights placed above and below the center axis of the lens cast shadows directly behind the subject and allow the edge contours to fall off into shadow. Look carefully at the image. A subtle line of shadow separates each edge of the subject from the white background. There is an illusion of a single, predominant, more natural direction of light. The soft light and large aperture help create the more romanticized, painterly appearance of the image.

-White Wall
-550 EX -550 EX
-3' x 6' White Reflector -3' x 6' White Reflector
-Canon 1DS MkII
-50mm f 1.8
-ISO 100, 1/125 Sec, f/5

obtaining correct Manual exposure settings. Even in Manual flash mode, the computer will continue to display information to aid the photographer.

> Attach a Speedlight to the hot shoe of a camera with a zoom lens attached. The flash should not be in Master or Remote/Slave modes. The flash head should be in the straight-ahead (not bounce) position. Turn on the camera and flash, and set the flash mode to Manual. A single usable distance will be indicated on the flash LCD. Canon displays this distance as a bar under a single distance number on the bottom of the LCD. Nikon displays this single distance numerically. This displayed distance will change with: changes to the ISO setting on the camera, changing flash power, changing focal length, and/or changing the f/stop setting on the camera. To obtain a correct Manual flash exposure, make adjustments to flash power, aperture, and/or ISO until the distance displayed on the flash LCD matches the actual distance between the flash and the subject.

> Set an aperture on the camera for depth of field. Determine the flash-to-subject distance. Referring to the flash LCD, adjust the flash power until the LCD indicates the correct distance.
> Select a flash power. Determine the flash-to-subject distance. Referring to the LCD, adjust the aperture on the camera until the LCD indicates the correct distance.

Canon Speedlite LCD Display

```
                                      Zoom
    M (Power)
                   —
   1.7  2.3  4  5  7  10  15  20  30  40  60 ft
```

The line over the distance indicates a correct flash power and aperture for a correct exposure at the indicated flash-to-subject distance.

Nikon Speedlight LCD Display

```
                6.6 Ft
```

The displayed distance indicates a correct flash power and aperture for a correct exposure at the displayed flash-to-subject distance.

> A handheld flash meter can be used to determine exposure when a single Speedlight is set to Manual flash mode and is connected to the camera hot shoe. The use of a flash meter is recommended when a Speedlight, set to Manual, is bounced or used with a softbox or diffuser. A handheld flash meter may not be effective with Wireless Manual flash (see *Wireless Manual Flash* on page 82).

The flash LCD displays usable distance when the Speedlight is connected to the hot shoe of the camera and the flash head is pointed straight ahead. It is disabled when the Speedlight flash head is tilted or swiveled, and when the Speedlight is set to Master and/or Remote/Slave functions. Use guide number, histogram/blinkies, trial and error, or a handheld flash meter in these configurations.

> - If the correct flash-to-subject distance cannot be obtained by adjusting the aperture and/or the flash power, change the ISO.
> - If the subject is underexposed, increase the flash power, use a larger aperture, or use a higher ISO.
> - If the subject is overexposed, decrease the flash power, use a smaller aperture, or use a lower ISO.

In situations where the various TTL flash modes may not seem satisfactory, manual flash mode can provide the solution.

TTL flash modes can be problematic in certain fast-moving situations, such as a wedding processional where people are rapidly moving toward the camera and dressed in various light- or dark-colored clothing. In a TTL flash mode, each tonal value change in the subject requires a change in Flash Exposure Compensation to obtain a satisfactory exposure. The photographer working in a TTL flash mode may not have time or the experience to adjust to the correct compensation for each new subject hurrying down the aisle. Manual flash can provide reliable and consistent flash exposure in this situation. With Manual mode, if all people are photographed at the same distance, the same power,

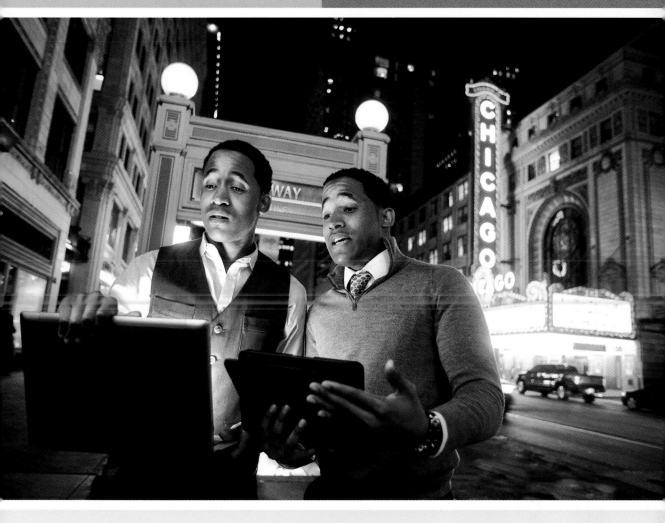

CHICAGO THEATER

This shot is another case of obtaining photography permits from the city's film board. The red tape is endless. It was a busy street but the beat cops only asked us if we had them but never asked to see.

It was a very cold evening and the twin brothers kept warm inside a coffee shop until my assistant and I were ready. Their business is based on online sales so we had them demonstrate. The concept was worked out long before we got to town. The Main light is from a Speedlight in a small Mini/Max softbox set right on the laptop (see *Softboxes* on page 113). The Fill light providing the real lighting for the subjects was from a large softbox just outside the frame on the left. Then it was just a matter of balancing the marquee light, streetlights and Speedlights for a realistic look.

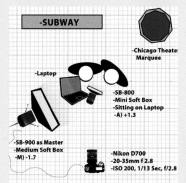

-SUBWAY

-Chicago Theater Marquee

-Laptop

-SB-800
-Mini Soft Box
-Sitting on Laptop
-A) +1.3

-SB-900 as Master
-Medium Soft Box
-M) -1.7

-Nikon D700
-20-35mm f 2.8
-ISO 200, 1/13 Sec, f/2.8

BUBBLES

Many objects reflect the source used to light them. When this happens we have to be especially conscious of what the light fixture looks like, otherwise it could be very distracting. So I erected two softboxes facing each other to show off the beauty of bubbles.

The light banks were on the extreme sides of the delicate spheres so they had a contrasting edge against the black background. This technique emphasizes the physics of light spectrum interference and kaleidoscopic colors of the thin soap films. But it was mostly done to take advantage of the whimsy in a child's toy.

My assistant "shot" a bubble gun between the softboxes and I prefocused right in the middle of their path.

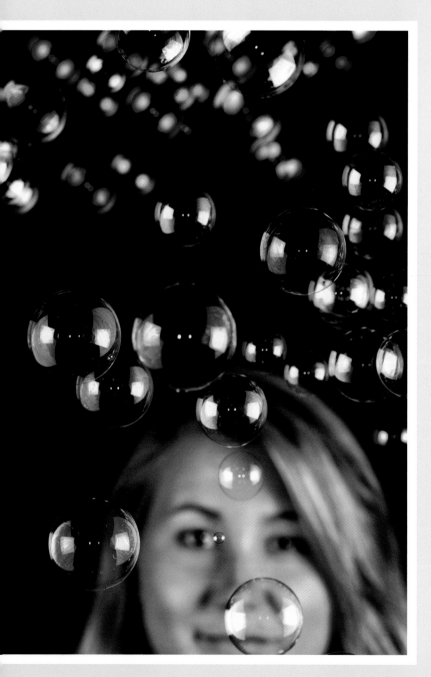

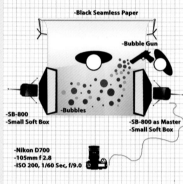

-Black Seamless Paper
-Bubble Gun
-SB-800
-Small Soft Box
-Bubbles
-SB-800 as Master
-Small Soft Box
-Nikon D700
-105mm f 2.8
-ISO 200, 1/60 Sec, f/9.0

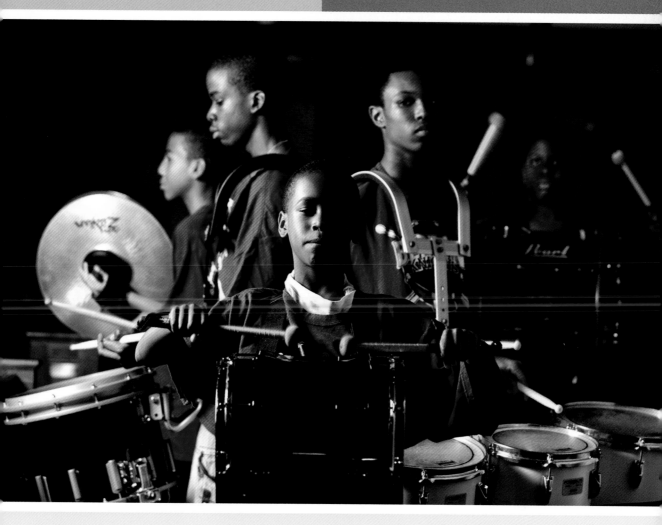

DRUM LINE

On assignment ideas spring up quickly. Speedlights allow us to move as quickly as our imagination. I was photographing an after-school program that has a very large music component. After shooting all afternoon to highlight the teachers I threw this drum corps together just before everyone went home. My assistant erected the king-size bed sheet we always carry as a large diffuser, aiming two Speedlights through it, on the left of the shot. In the dark church I had to manipulate the shutter speed to get detail behind the group of boys. I worked fast but their patience and cooperation made the shot.

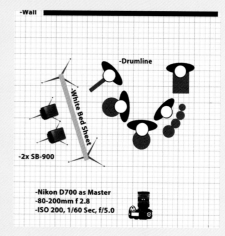

-Wall

-Drumline

-White Bed Sheet

-2x SB-900

-Nikon D700 as Master
-80-200mm f 2.8
-ISO 200, 1/60 Sec, f/5.0

An average full-length portrait with a normal focal length lens[7] will place the subject about 12 feet away from the camera. Shut off the autofocus and prefocus the lens at 12 feet. Set the aperture on the camera to f/8. This will provide sufficient depth of field to get from approximately ten feet to 15 feet in focus. If the flash power is adjusted manually to provide f/8, all subjects at 12 feet will be correctly exposed regardless of light or dark clothing or skin tones. As each subject steps into the 12-foot distance from the camera, providing a pleasing full-length image, the photographer makes the picture. Focus and exposure are virtually guaranteed for each image. **Continuous autofocus can also be used if the photographer can judge the distance by the size of the subject in the viewfinder, or by noting when a subject passes a particular feature in the scene used as a "marker" to indicate correct distance, such as a bow on a pew at 12 feet away from the camera.**

Manual flash mode can be advantageous in static situations where a variety of subjects must be photographed using the same lighting set-up. A good example is a location set-up in a conference room, where the job calls for individual portraits of a number of employees; and all exposures and images must be uniform.

Another example where Manual flash mode may be appropriate is in volume prom couple photography. Manual allows the photographer to make pictures of the dark suit, the white shirt, the light blouse, the dark sweater, and the lab coat subject all the same.

and the same correct f/stop, exposure values for all subjects will be correct. This is the principle of **scale focusing**, a simple solution for pictures of moving subjects with Manual flash.

Wireless Manual Flash

The Wireless transmitter and receiver built into the Speedlight remain usable when the Speedlights are set to Manual flash mode. Master, Remote/Slave, Group, and Channel settings remain the same (see *Wireless TTL* on page 55). Wireless TTL flash modes control flash group brightness values by flash exposure compensation and/or ratio settings. It also controls flash group brightness values by changing power settings for each group. The power for each group can be selected on the Master, or each Remote/Slave flash can be set individually. Setting the Master to Manual Flash Mode will set all Remote/Slaves to Manual. Then power for each Remote/Slave group can be set through the Master. Manual flash is not metered in-camera (some Canon camera models meter Manual flash). In Wireless Manual flash, changing the power for one group will not change the power and brightness of other groups.

Exposure and flash power settings for multiple groups of Wireless Manual Speedlights may have to be determined by measuring flash-to-subject distances and calculating with guide number, or by trial and error adjustment of each group's flash power and observation using the LCD, the histogram and blinkies. Handheld flash meters may not be effective with Wireless Manual flash, as the Speedlight's Wireless transmitter emits a pre-flash that will give a false meter reading, often resulting in extreme overexposure. See manufacturer's instructions regarding specific Wireless Slave/Remote operations and functions.

In summary, in a manual flash set-up:

1. To make the light from one particular flash brighter or darker, change flash power for that flash unit only.
2. To make all flash equally brighter or darker without changing f/stop and ISO, equally increase or decrease the flash power on all flashes. For example: if flash power is doubled on each flash, the overall flash brightness value would increase by one stop.
3. If no existing light is in the picture: to make all flashes equally brighter or darker without changing depth of field, change the ISO.
4. If no existing light is in the picture: to make all flashes equally brighter or darker and change the depth of field, change the f/stop.
5. To make only existing, ambient light brighter or darker, change shutter speed.

[7] Normal focal length is approximately 30mm for a 1.6x sensor, 35mm for a 1.4x sensor, and 50mm for a 35mm full frame sensor camera.

6. To make both existing light and flash equally brighter or darker, change f/stop or change ISO. As the amount of existing light increases, flash power may have to be reduced to avoid overexposed highlights.

Mixing Speedlights with Studio Flashes

Manual flash mode allows the use of the Speedlights in conjunction with other, traditional flash units, such as studio strobes or older, non-TTL flashes.

The Nikon SB900/910s and SB800s have a built-in photo electric eye trigger that will fire these units when it sees a light Impulse (see *SU-4 Mode* on page 58). The SB900/910 and SB800 also have traditional PC flash cord terminals, allowing triggering by wired connection to the PC[8] outlet on a camera, infrared triggering device, or radio slave receiver.

The hot shoe on the Canon Speedlites can be fitted with a variety of devices for remote triggering when the Speedlites are used with non-TTL flashes. Hot shoe photo electric eye triggers and PC-to-hot shoe adapters allow the Canon Speedlites to be triggered by the light from another flash, or by wired connection to a PC terminal on a camera, infrared triggering device, or radio slave receiver.

AUTOMATIC FLASH

The reason computers were put into cameras was to make the task of proper exposure easier. Computers were put into flashes for the exact same reasons. A design that allows the two devices to communicate with each other has pushed image making far beyond any technological decision since digital was introduced to photography. We have survived and adapted auto advance, auto exposure and autofocus for generations. We now accept auto white balance and auto resolution. It makes sense to accept the assistance available from "auto lighting."

Choosing the shutter speeds and f/stops for flash photography has been a crapshoot since its inception. All forms of measuring techniques have been attempted to make it more manageable. Until the LCD was introduced, we had to wait until the film was developed to know if we had a proper exposure. The TTL (through-the-lens) technology has made a lot of this simpler. Automatic usage makes it nearly foolproof.

On automatic, the most significant change in image capture is that the camera/Speedlight combination will ALWAYS strive to make a "perfect" exposure, no matter what information you feed into the system. To prevent unusable exposures, the Speedlight makes the decisions so that virtually all photographs you attempt are "correct." The disconnect with many photographers is that "good image" may not be the image you had in mind.

Rather than the first guess being random, as it so often is in unfamiliar territory, we have an acceptable framework, making your initial starting place perfectly usable. From here, your creative input can tailor the automatic settings easily to get anywhere your imagination can take you. Besides eradicating the burden of missing those once-in-a-lifetime shots, it speeds up our workflow in the studio and encourages creative experimentation.

But automatic is not just one function. It comprises three subcategories: Aperture Priority, Shutter Priority, and Programmed Mode. Each one of these automatic modes will coordinate with the TTL, eTTL of your camera but each can perform an entirely different role in your creative vision. Each can separately oversee their appropriate function but, as a side effect, they are capable of doing amazing things.

Shutter Priority (S/Tv)

In many situations, shutter speed has little to no effect on the final exposure. The flash duration is far faster than most shutter speeds. Where available

[8] A PC cord is a simple wired connection between the flash and camera or the flash and a triggering device. The PC cord carries only a firing signal. It does not transmit exposure information. A PC connection terminal is found on many cameras and remote triggering devices. It is a round connection terminal with a single pin protruding in the middle. PC cords are available in a variety of styles, lengths, and from many manufacturers. The "PC" refers to Prontor® and Compur®, the two shutter manufacturers that collaborated to standardize this connector.

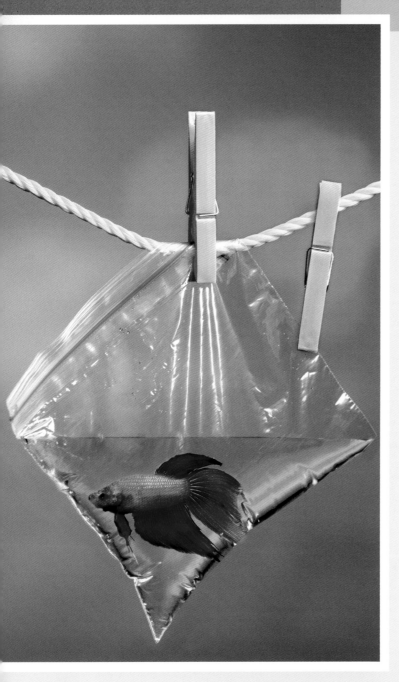

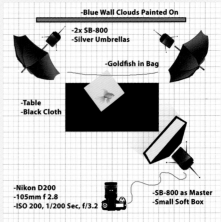

Blue Wall Clouds Painted On

-2x SB-800
-Silver Umbrellas

-Goldfish in Bag

-Table
-Black Cloth

-Nikon D200
-105mm f 2.8
-ISO 200, 1/200 Sec, f/3.2

-SB-800 as Master
-Small Soft Box

FISH

A large segment of my work over the years has been what used to be called **photoillustration** where I have had to "illustrate an idea" with a conceptual photograph. A client once asked for a series of photographs to highlight a story concerning different aspects of ecology—some were negative and some positive. This one represented something like "preserving clean water."

With the help of the shop owner, my assistant and I spent a long time, at a pet store, scouting and researching fish that could withstand the treatment of being enclosed in such confined quarters. I wanted as much color as possible but I was told the prettiest fish were also the most delicate. We had to acclimate our "model" by slowly adjusting the water temperature.

For each exposure we had to position a mirror just right for the fighting fish to see his reflection, get excited, and flare his fins. We made the idyllic blue sky with puffy clouds by spray-painting seamless background paper and lighting it.

Since I spent so much time thinking about concepts that were eventually turned into photographs, I have had to develop systems that resulted in abstract but legible ideas. My theory for good photoillustration is that the more ambiguity the more successful the idea. After the shot one of the authors took the fish home to his children.

light is low or insufficient, the flash provides most of the exposure.

However, on automatic the camera tries to integrate the existing available light. Therefore we can force the camera to include more of the environment using longer shutter speeds. Also, we can introduce movement and blur by manipulating the shutter speed. Each change in time can increase/decrease how much available light is apparent in the picture. It is a wonderful creative tool.

Aperture Priority (A/Av)

We can control depth-of-field with precision with A/Av. By choosing wide open f/stops we ask the Speedlight to add a little bit of light. If we need a great depth-of-field, we ask the flash to put out a lot more power which allows us to use a larger f/stop number. At all times the camera is striving to give a proper exposure. But you are making a creative choice.

Programmed Mode (P)

Although you have less control over shutter speed and aperture with programmed mode, the intent is for the camera's computer, using feedback from the flash, to choose the appropriate combination for the complicated mixtures of lens, ISO, light level, etc.

In a very dynamic lighting situation that changes rapidly, you might go from light to dark quickly and exceed the limits of A/Av or S/Tv. Programmed Mode will always choose something that works.

If shutter or aperture is not that important and you are moving though uncertain light and shadow, programmed mode will perform very well and never be foiled.

Visit vimeo.com/loujones to watch an instructional video on manual vs. automatic.

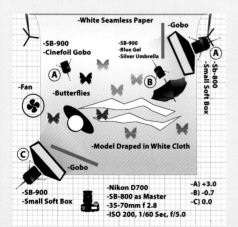

BUTTERFLIES
Inspiration can come at any moment. The idea for this production came to me in South America. I sketched it out in a pad I carry everywhere.

I had two interns go online to find outlets to purchase the different butterflies. As they arrived in the studio we constructed a complicated set. First, we erected the camera on a tripod and arranged the cloth. Then we strategically hung butterflies on wires, making sure they were unobtrusive in the viewfinder. It took three days.

Lighting provided another problem. We split lit the background seamless, one side white, one side blue. In order to accomplish that, we gelled the umbrella Speedlight on the right side and concentrated the white light with a CineFoil® snoot on the left (see *Snoot* on page 119). We made a lot of test shots before the model stepped in. A high-powered fan just out of frame blew the hair. My studio digital technician removed all the unwanted wires in postproduction.

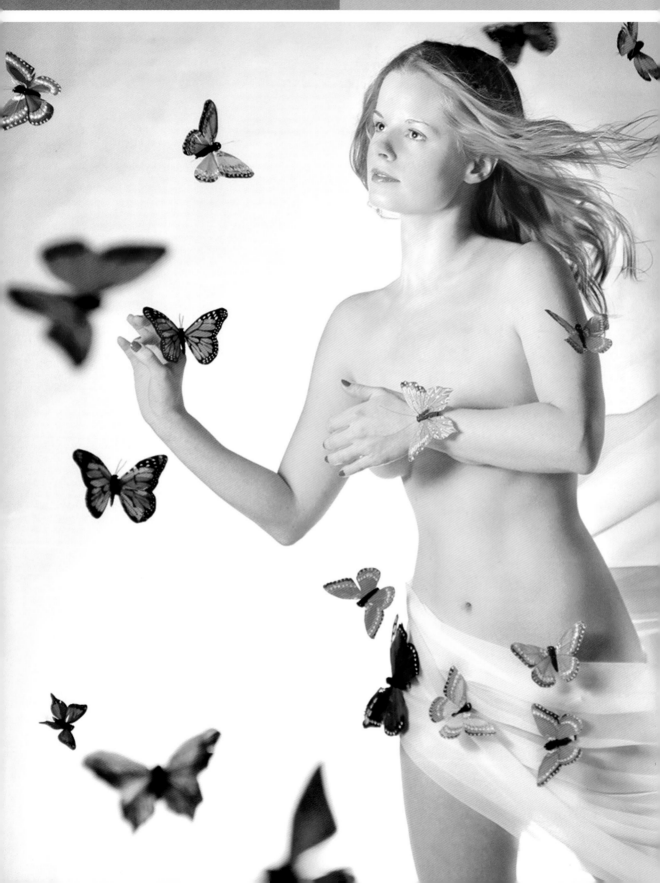

Chapter 3

Three Lights and more

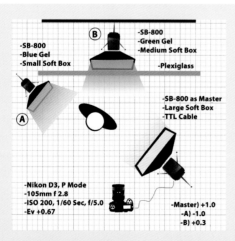

-SB-800
-Blue Gel
-Small Soft Box

(B)
-SB-800
-Green Gel
-Medium Soft Box

-Plexiglass

(A)

-SB-800 as Master
-Large Soft Box
-TTL Cable

-Nikon D3, P Mode
-105mm f 2.8
-ISO 200, 1/60 Sec, f/5.0
-Ev +0.67

-Master) +1.0
-A) -1.0
-B) +0.3

DOCTOR

For many years I have photographed health-care assignments: hospitals, pharmaceutical companies, medical schools, insurance companies. Getting good photographs in these places is all about access. And once in operating rooms, research facilities, and nursing homes, speed is a big issue. The situations can change quickly because of vacillating health conditions, privacy issues, or a patient's whims. We used only three Speedlights for this photograph, all outfitted with softboxes: small, medium, and large. We added light gels to two of the flashes, green to the lightbox used to illuminate the CAT scans and chemical beakers in the background. I was trying to duplicate the fluorescent color it normally emitted and light blue on the flash and small softbox directly behind the foreground CT scan. We were directed to emphasize the doctor in an environmental portrait. Strategic placement of Speedlights can be very directional and increase the drama of a potentially mundane scene.

One Two Three . . . Infinity.[9] This concept from the famous book title ironically alludes to the anthropological construct that in some cultures anything over the number *three* becomes too many to count. It is similar in photographic lighting too. After you figure out how to coordinate *two* lights, three or more are basically academic.

Many neophytes to photography mistakenly fantasize that as soon as you acquire the right equipment, i.e. if you cobble together a digital camera, the software to run it, and a portable flash, you qualify for the appellation "photographer," when indeed your journey is just beginning.

How hard can it be to push a button? It is deceptively simple to wed image to film. But just like any craft it takes time, effort, patience, and talent to become proficient taking pictures. Even though translating the world that we see with our eyes into a more permanent medium has been made so much easier with the advent of more ergonomically designed and technically proficient equipment, doing it well remains just as elusive as when alchemists coated their own collodion wetplates behind large wooden bellows cameras. Rather than just recording what happens in front of them, real artists are exposing silver or charging electronics to communicate ideas. So interjecting the perfect volume of illumination upon just the right target can advance that quest enormously. In capable hands, light can dazzle the senses. To successfully intermingle the light you have with what you bring is the charge of a seasoned craftsman.

Prevailing wisdom has it that in most multiple lighting arrangements one light is the primary source and all others are ancillary. The first light sets the tone and the second adds dimension. So learning how to position just one extra light influences your vision exponentially. It is a skill that will revolutionize your photography. Second lights can be diffused, bounced, spotted or gelled . . . just about anything. They "elevate" a scene and serve as building blocks toward the final outcome. Whether you are meticulous and use formulas and calculations, or you are capricious and fly by the seat of your pants, entrance into the digital world accommodates all personalities and makes the journey more heroic.

The capacity to nuance lighting using the technology built into the new Speedlight empowers you with unprecedented ability to shoot, get immediate feedback and rebuild any idea your imagination can conjure. Relinquish control and let the camera and Speedlight dance a pas de deux together so you can spontaneously chase the evolving action or weather condition. Or micromanage how each influences the picture right in front of you and adjust virtually every frame. The ease of changing from one scheme to another as you add a second, third . . . infinite number of lights, all being manipulated by whim, magnifies your capacity. You do not have to be a "techie." Speedlights are not about equipment. They are about intuition.

All the laws of physics you have committed to memory still apply but we cannot stop thinking and advancing. Embrace change. Shed your fears. Acquiring a digital SLR and two Speedlights is *potential* energy. What you do with them, all *kinetic*.

This book proposes to teach you something you thought you already knew. Reacquainting yourself with a time-honored technique stimulates rapid progress to become comfortable with every aspect and more proficient with all its facets.

MULTIPLE LIGHTS

Studio

The well-equipped, organized photographer has complete control in the secure environment of a photography studio. All of his/her equipment, paraphernalia, gadgets and techniques are in one place. The studio is where the magic happens. Every little device that he/she has ever acquired is on hand and can be applied to every job. Comfort Zone.

Speedlights were never meant to replace those traditional relics, just enhance them. Speedlights can reside right next to the standard studio strobes or hot lights of our past lives. They are a welcome addition to the tools we already have to make great pictures.

[9] **One Two Three . . . Infinity: Facts & Speculations of Science** by George Gamow.

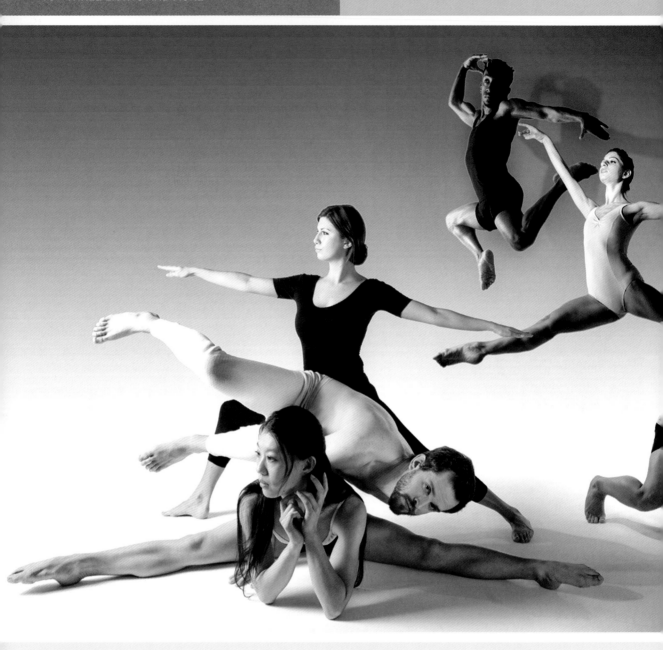

DANCERS

We rented a studio with a large cyc wall for this photograph. Counting the dancers, makeup artist, choreographer, assistants, studio manager, tech assistant, and filmmaker, there were over 15 people in the room. A mad house. For shots like this, mostly what I do is direct.

The shot was originally designed to be shot all at one time, but the cyc was not quite large enough. We made an executive decision to do it in pieces. After locking down the camera so the angles and scale would match, a choreographer worked with each group to produce contemporary dance positions.

The camera was tethered to a computer so we could precisely align the parts and be sure we had optimum poses (see *Tethering* on page 106). The dancers who were leaping got their elevation from trampolines that were removed in postproduction.

In addition, the entire production was filmed so that we could create a how-to video. (Visit **vimeo.com/loujones** to see a behind-the-scenes video.)

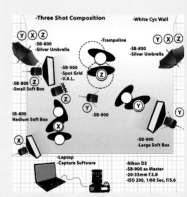

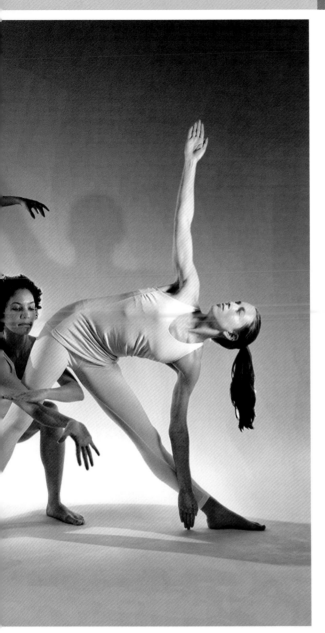

Although Speedlights are the progeny of portable and small, the superior prodigy of quick and easy, they have most of the qualities of their predecessors. Today you can set up a very credible, state-of-the-art studio with Speedlights as the main system. In addition, they are a less expensive alternative that can go on the road with you. They can be easily retrofitted into the old modifiers but they now have their own dedicated gear.

Still Life

Most users think Speedlights are intended for mobile subjects but they are perfectly suited to still life too. Because the units are so small, they can be positioned closer and more strategically than their larger studio counterparts. They can be individually dialed up and down to introduce more or less light to different parts of the set. With all sorts of small light modifiers it is easier to light small objects or small areas in product shots.

On Location

The life of photography's road warriors has always been arduous. Every assignment different and every territory unfamiliar, presenting a new slew of problems and new logistics. Small flashes made the transition much easier because of portability, but we always seemed to sacrifice something: power, nuance, speed. But with "digital lighting," i.e. Speedlights, we eradicate so many of those previous disadvantages. If you put the time in to understand all their advantages, they will transform your location photography into another dimension.

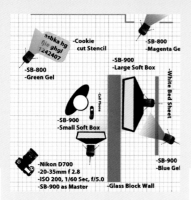

CELL PHONE

Sometimes when there is no obvious location to shoot an assignment, you have to create it. This gentleman had designed apps for the cell phone. So I latched on to the technology aspect.

We rented a studio in the city where our subject lived and arrived hours before he did to build our environment. The large white area behind the glass block wall is a softbox to simulate a monitor. My intern made the abstract gobo with the alphanumeric stencils on the four-hour ride to the location. Then we aimed a Speedlight through it with a green gel. It took everything we had to make all five strobes fire since we had very limited line-of-sight.

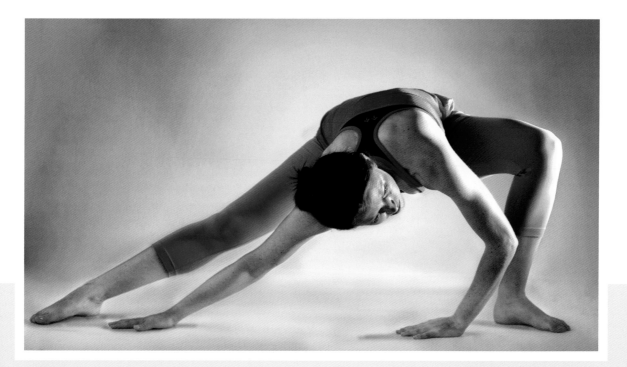

YOGA

Making photographs look simple is often the hardest lighting task. But inside the studio we can control every detail. Choosing complementary colors, talented models and experimenting with new lighting solutions can be pivotal in developing new methods and for future solutions. What we learn in the security of the studio will translate out in the uncertainty on location.

For this shot about the health benefits of yoga I enlisted someone who could perform the difficult maneuvers and whose body lines would complement the delicate image I was after. The color palette was chosen to be calming but contemporary, clean, soft, yet vibrant. The positioning of the model needed to match the colors too. I wanted her to look dynamic but strong. It evokes a mood.

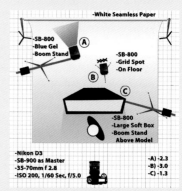

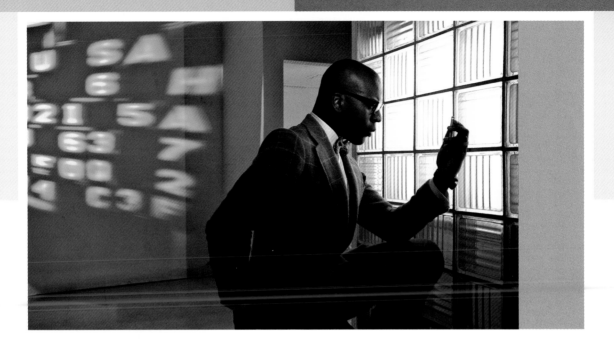

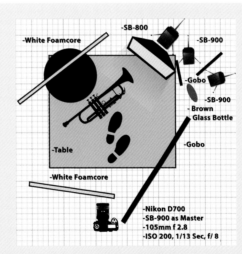

SHEET MUSIC

It is easy to think of Speedlights as portable—for use on location. But they should be considered just as well for still life photography. However, the philosophy of lighting still lifes is very different from lighting people or interiors. For small objects, you often highlight particular shapes or surfaces. Speedlights are especially suited to direct small beams of light and can be arranged in tandem to selectively illuminate individual products. Pinpointing the important features is easy for Speedlights.

Space was limited in this relatively small set, but several flashes were positioned in close proximity and aimed precisely. To get a specific effect, shadow, sidelight, or color, each Speedlight had a different kind of modifier—a softbox, grid spot, gobo, or gel (see *Accessories* on page 121). I was able to dial the flashes up or down, side by side, so that the two light outputs had very different levels of power.

I collected all the props over months and rented the trumpet from a music instrument company. The camera was rigged to shoot straight down onto the small set, which made it easy to arrange the devices around the legs of the tripod. I made the exposure using a diffusion filter to get the hazy effect off the shiny trumpet highlights.

Shooting still life is very painstaking work. You make very intricate adjustments and shoot often just to see how it looks.

SPIRAL STAIRCASE

We knew it was very ambitious to try and take advantage of this architectural detail. It was chosen for its visual impact rather than historical significance. In addition, running up and down the staircase was exhausting. To get dramatic spread from the Speedlights without them showing in the frame was a lot more complicated than I first thought.

Each level was a physical obstacle to line of sight. So the light banks containing the Speedlights were just outside the frame hidden by the floor above. It was like assembling a puzzle. Distance was also a problem. From top level to the first floor was pushing the limits of wireless range. Since the softboxes were placed various distances from the models we controlled their different powers all from the Master.

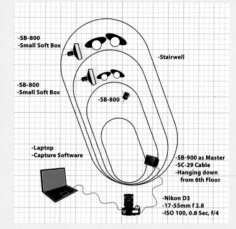

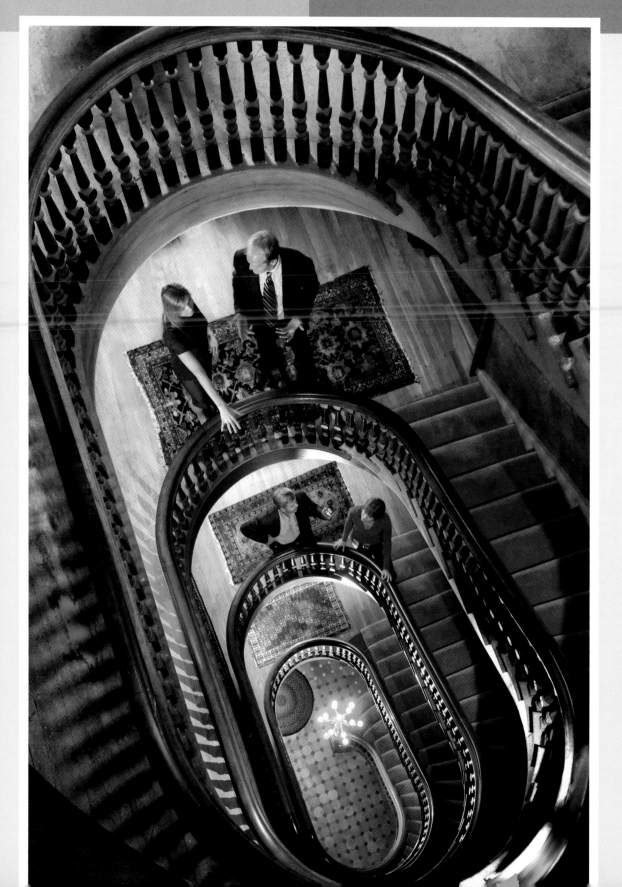

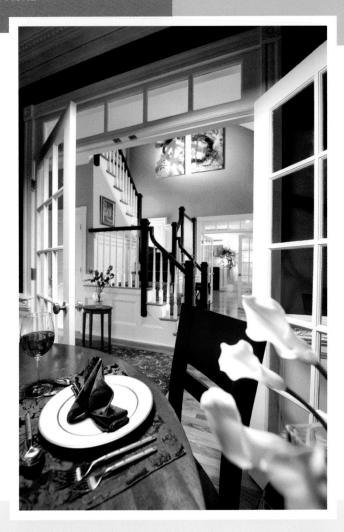

ARCHITECTURAL SHOT

Interiors are designed around light. So when scouting this residential location with the property owner light was streaming into the front foyer and illuminated it beautifully. I thought the available light would do most of the work. Of course on shoot day the weather turned ominous and there was little help from the sun.

Shooting architectural photographs with a 35mm camera has been transformed with the advent of digital. The ability to employ very wide-angle lenses means you can work in more restricted spaces and maintain good depth of field. Camera movements can be managed even though there are no swings or tilts. Keeping lines parallel is a decision that can be made while shooting or afterwards, with software.

To best illustrate the space, I almost always strategically position the camera first, then arrange everything else around it. I find the architectural elements first, and solve the logistics problems second. We had planned on bringing many of the props with us—neon sculpture, flowers and plants, diptych painting—but the rest was impromptu. My assistants moved a lot of heavy furniture out of the picture and replaced them with preferred pieces. Then we slowly "built the light," adding another Speedlight wherever necessary.

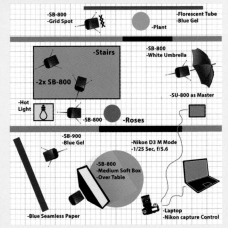

Step by step we substituted Speedlights for nonexistent sunlight then accented different areas to control the contrast. A large blue seamless background paper was moved just out of frame on the extreme left to be reflected in the glass doors on the right. We lit the paper with a blue gel and you can see the intentional glare in the glass pane and on the black chair. Eventually seven flashes were needed to make the scene appear "natural."

Chapter 4 Techniques

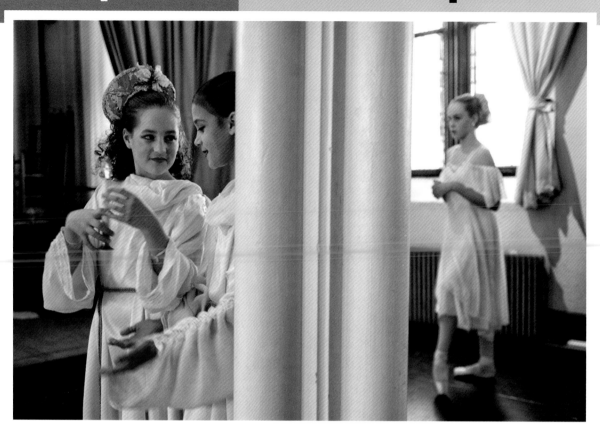

If you have reached this far in *Speedlights & Speedlites: Creative Flash Photography at Lightspeed,* you have probably mastered one light and have tried multiple lights. Now comes the hard part of getting the equipment to work properly for making believable pictures.

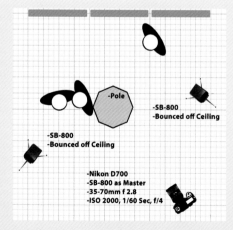

NUTCRACKER

Clients continually ask you to accomplish impossible feats. The NGO (non-governmental organization) was funding cultural institutions and needed pictures of this dance company. Of course the company allowed us in, but it was during Nutcracker Suite season. Working somewhat surreptitiously, I could not interrupt practice for their impending performances.

Because it was a dress rehearsal, all the colors and dances and pageantry were in evidence. An unbelievable opportunity, but we had to be almost invisible. My assistant and I put two Speedlights up on lightstands and bounced them off the high ceiling. The Master flash was triggering all the Slave/Remote Speedlights. I shot sugar plum fairies, toy soldiers, snowflakes, etc. (See *Wireless* on page 55.)

During a quiet moment I noticed two girls talking just off stage. In the background was one of the principal soloists stretching. Speedlights were able to adjust the automatic exposure and compensate for the available light to document this once-in-a-lifetime juxtaposition. And although I got lots of great images, this was my favorite.

Up until now we have dealt with the building blocks of lighting. This chapter intends to share practical techniques to get the lights to work for you and your creativity. We will move from simple techniques that every user can employ to fairly sophisticated methods that require dedicated motivation in order to produce the best results.

From the beginning of photography, practitioners have tried to duplicate the conditions they observe. Other innovators have attempted to make light do the impossible. The evolutions of equipment and methods for modifying available, artificial, and manufactured light have been nothing short of miraculous. Some inventions are a matter of careful engineering, but some are clever "mothers of necessity."

While Speedlights are small, a mere handful generates incredible energy. Consequently, the usual objective is to make them "bigger," to harness their power and redirect it, to bend them to our subjective wills. But we are just at the embryonic stages of their full potential. Both amateurs and professionals are forcing flashes to perform in ways that were never intended. Techniques are coming online that stretch our perceptions of light's intended purpose.

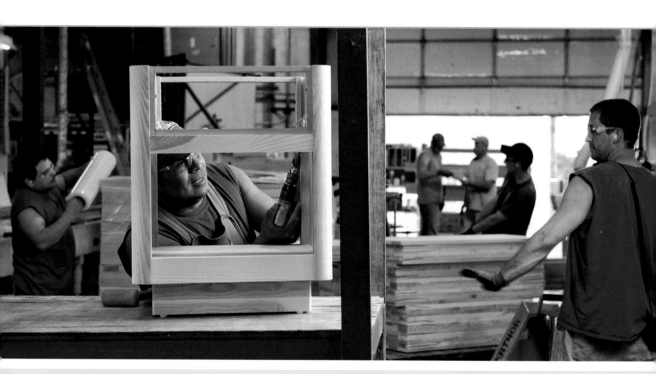

FURNITURE

Traveling to the Pacific Northwest to photograph a custom furniture manufacturer, I photographed the entire operation from beginning to end over a number of days. The images were slated for brochures and the Internet. This was one of the final shots I produced once I was familiar with all the different stages.

I locked down a camera with a long lens on a tripod, then moved workers, several pieces of machinery and forklifts into line, and set up a nearly completed cabinet in the foreground. Since I was working alone, I meticulously erected several Speedlights to light the different "actors" and checked each through the LCD. (See *The LCD* on page 16.)

The idea was to illustrate all the different operations and craftsmen necessary to fashion their quality products. Since the dynamics of each person was important to make the image look realistic, I ran back and forth to each subject and worked with them for something they would actually do.

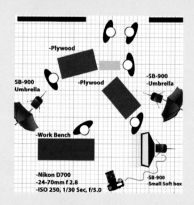

We can take pages from our colleagues' efforts to make lighting better and take more creative pictures. From flashbulbs to "digital lights," we have come a long way. Speedlights have not only changed the speed, ease, and convenience of lighting, they have rewritten the book.

Moving Light

Aiming a flash at someone is a very aggressive act. It is invasive and can be scary. While it blatantly announces your presence and may alter an interesting activity, it may be necessary to insure readable pictures. A flash is nearly a point source of light, with all of its resulting immediacy, direction, and harshness; a little finesse may be called for to get the best results. The most recent generation of Speedlights is very malleable. Even when locked on camera, its light head has "swings and tilts." You can point it anywhere. Point it to be efficient. Point it to be subtle. Point it to be bigger or smaller. Point it to hide or shed light on the world. You can effectively fold the light around corners, "defying" the laws of physics.

Bounce Flash: Direction and Quality of Light

Accomplished photographers are always striving to do unique things with light. They only use direct flash to illuminate pictures in certain special situations as it is a clumsy use of such a sophisticated tool. One of the most skillful accomplishments is lighting that looks "natural." Natural light comes from the sky, a window, overhead—anywhere but from directly in front of the viewer.

Bounce flash is a technique where the main light is redirected at a wall, ceiling, or some other surface in order to broaden and diffuse the light falling on your main subject. It is an easy and effective method used to produce soft but directional light with a TTL flash. Bounce flash makes small camera-mounted flash look like large directional off-camera light.

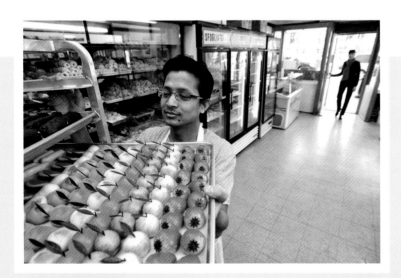

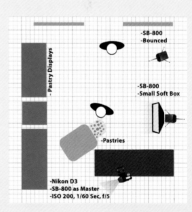

PASTRY SHOP
My crew had to arrive before the pastry shop opened for business. They started very early to make all the confections for the day. Because there would be no customers in the shop, I arranged for a friend to meet me there. That model is who you see in the doorway.

I had to climb a ladder to get behind the camera which was on a tripod atop the main counter. When the baker rolled out a new batch of colorful cookies, I had my focal point. I used a combination of a softbox on the main subject in the foreground and a Speedlight bounced off the ceiling in the background. But it was not enough. Whereas normally I only use the on-camera Speedlight to trigger the others, this time I instructed it to contribute light into the scene. I bounced it off the wall/ceiling behind me.

COMPREHENDING DIRECTIONS OF BOUNCE FLASH

In Newtonian Physics all light travels in straight lines. Light reflects off of a surface at an angle opposite to the angle at which it strikes that surface. Where I is the angle of incidence and R is the angle of reflection, then: $I = R$.

This is illustrated below:

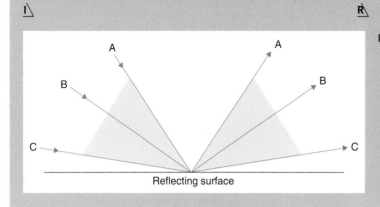

FIGURE 4.1 LIGHT REFLECTION

Visualize the "straight lines" of light leaving the flash head, striking the bounce surface and reflecting toward the subject. Study the image on the LCD monitor to determine the direction and visual effect of the bounced light on the subject.

Turn or tip the flash head sufficiently. Avoid hitting the subject with direct flash from the edge of the flash reflector (spill).

Bounce surfaces will absorb some light and some light may be reflected in directions away from the subject. Bounce flash also increases the distance of light travel, effectively reducing the light quantity because of the Inverse Square Law. (See *Inverse Square Law* page 7). It is not so much an efficient use of light as an aesthetic one.

You may need to use a higher ISO and/or larger apertures. Check the flash Exposure Confirmation and the histogram when using bounce flash.

The compound articulation of the Speedlight swivel head means you can twist and turn the flash in almost any direction, i.e. up, down, behind you, and to the side, regardless of the orientation of the camera. In order to keep the light bounced off an appropriate reflector when switching from horizontal to vertical, you may have to ratchet the head like a Rubik's Cube®.

The usable flash distance range display on the TTL flash is disabled when the flash head is in a bounce or swivel position.

White or light-toned walls and ceilings are ideal for bounce, since they do not taint the color of light. The direction of the flash head in relation to the bounce surface will determine direction of light on the subject. Bouncing flash is analogous to "shooting billiards" with light. Lower, residential ceilings provide a more natural direction of bounce. High ceilings may produce a "top light" similar to noontime. With on-camera flash, close camera-to-subject distances can also produce an undesirable "top light" appearance.

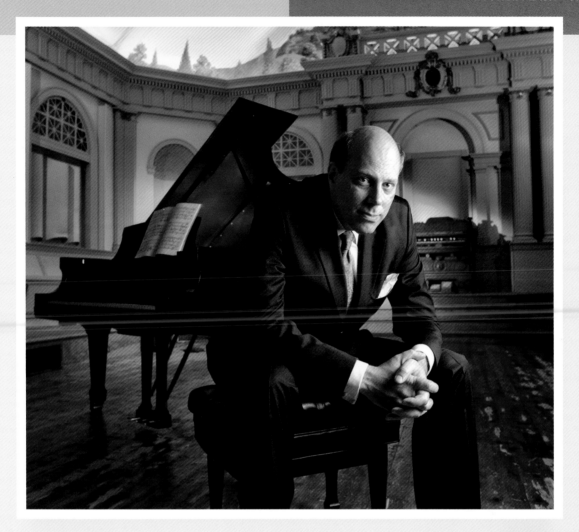

CONCERT PIANIST

It is the greatest compliment to be entrusted with a fellow artist's "public face." Many years ago I had photographed this concert pianist's first black/white PR pictures. And it is doubly flattering that he tracked me down again after so long to photograph his CD cover.

He sent over a preliminary music CD so my studio could listen and derive inspiration. Then we scouted several locations for the shoot. But with each suggestion the degree of difficulty escalated. Finally, when I saw the studio where he made his recordings, many of the problems (but not all) were solved. The famous portrait photographer Arnold Newman could not have been more correct when he said, "Photography is one percent talent and 99 percent moving furniture." We rearranged everything in the studio.

Many Speedlights went into this image and I applied gels to some to add color to an otherwise monochromatic setting. But the biggest obstacle: grand pianos are black. The dark wood absorbs all light. We tried a lot of tricks but the only thing that worked was putting a light right inside. Another blue gel to tone it down and we were off. (Visit **vimeo.com/loujones** to see a behind-the-scenes video.)

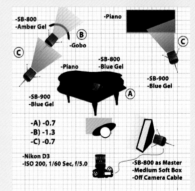

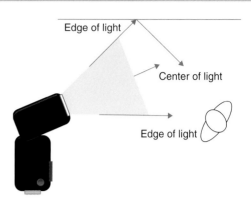

FIGURE 4.2 FLASH SPILL

Flash head tipped too low. "Spill" from the edge of the flash reflector strikes the subject as direct light, causing hard-edged shadows and uneven illumination.

FIGURE 4.3 TILT TO AVOID SPILL

The flash head is tipped upwards sufficiently to illuminate the subject with only soft, reflected light. No direct "spill." Lower, residential ceilings provide natural looking, 45° light.

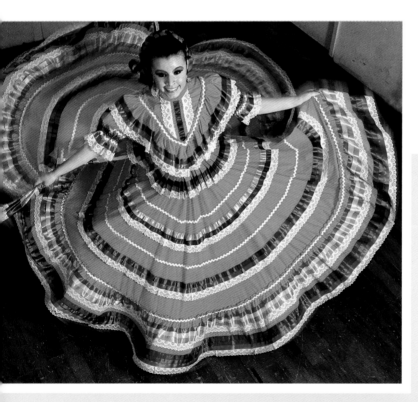

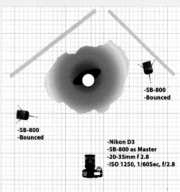

DRESS

After watching a roomful of traditional Mexican dancers spin and twirl, I was fascinated by how the women's dresses were designed to augment their movements. So I climbed up on a ladder and tried to make clothing the star.

So as not to hamper the woman from being able to spin anywhere she wanted, I clamped two Speedlights onto stands and bounced them off the ceiling. (See *A Clamps* on page 131.) This gave me a fairly directionless, flat light falling onto the colorful layers of cloth. After that it was simply a matter of timing. I had to anticipate when the dancer would reach maximum rotation and also be facing the camera. It is not as easy as it sounds. My intention was to have the dress nearly fill the frame.

FIGURE 4.4 ADJUSTING FLASH TILT FOR CAMERA ANGLE

Turn and tip the flash head up when the camera is tipped down.

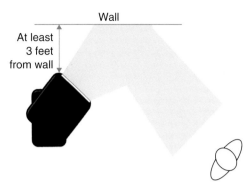

FIGURE 4.6 CREATING WINDOW LIGHT

To create "Window Light," turn the flash head sufficiently toward the wall. Avoid direct spill from the edge of the flash reflector striking the subject. Turn the subject slightly toward the wall, towards the direction of light. A custom white balance/white balance preset can be used for off-white walls.

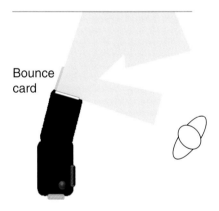

FIGURE 4.5 BOUNCE CARD

The bounce card directs "spill" from the flash reflector forward, providing Fill. The built-in bounce card is small, creating a harder Fill. A larger white card attached to the flash with a rubber band or Velcro® can provide softer Fill.

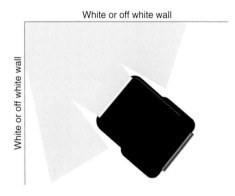

FIGURE 4.7 BACK WALL BOUNCE

Turning and tipping the flash into a light-toned wall, or walls, behind the camera creates a broad, soft, light that can be used as a front-lit Main or a Fill.

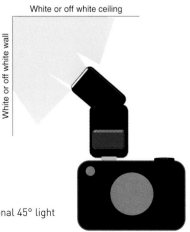

FIGURE 4.8 CORNER BOUNCE

Directing the flash up at a 45° angle to the side creates a directional 45° light on the subject.

SPEEDLIGHTS IN USE

As in many experiences, the prevailing wisdom has always been "bigger is better." Multinational corporations, large format cameras, athletes, jumbo airplanes, mega-megapixels, huge studio strobes. However, as recent history tells us, smaller companies can sometimes be more innovative and adapt faster; small athletes can outmaneuver bigger competitors; and small cameras can get closer to the action. Most importantly, little lights are quickly proving their worth.

The most progressive photographers are making great strides forward with small flashes. And they have only scratched the surface for the potential of Speedlights. We continue to learn from them. As with all modern appliances, "think small."

ON-CAMERA AND OFF-CAMERA USAGE

On-Camera Flash

On-camera flash is the starting block of all Speedlight mastery and is the most common method of using Speedlights. Employing battery-powered flashes in studio or on location gives you greater flexibility and portability. You are no longer attached to heavy power packs and their restrictive cables. Along with these new lights there is an array of techniques and modifiers that produce attractive lighting effects.

Hot shoe flashes can be bounced (see *Bounce Flash: Direction and Quality of Light* page 99) toward the ceiling, to the side and backwards. Attaching diffusion attachments (see *Modifying Flash: Quality of Light* page 111) and using them in combination, wirelessly, with other Speedlights as a light, or just as remote triggers expands their usefulness.

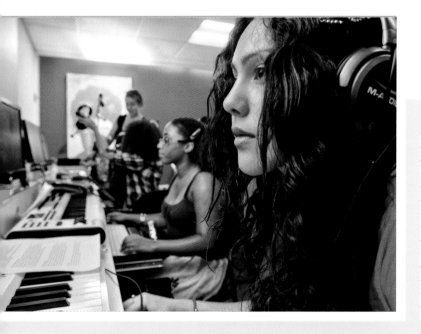

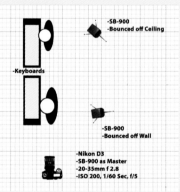

HEADPHONES

It is tremendously uplifting to witness adolescents undergoing the creative process. We were entrusted with the task of showing that in several locations for a client. These students were being taught music composition. The kids were intent and creative.

Because the keyboards were lined up against the wall, it was hard getting a camera in a position to show their faces. The lighting was even more daunting. I struck upon just bouncing one flash off the wall directly in front of the girl closest to the camera and a second flash off the ceiling in the background to light the rest of the room. It worked like a charm.

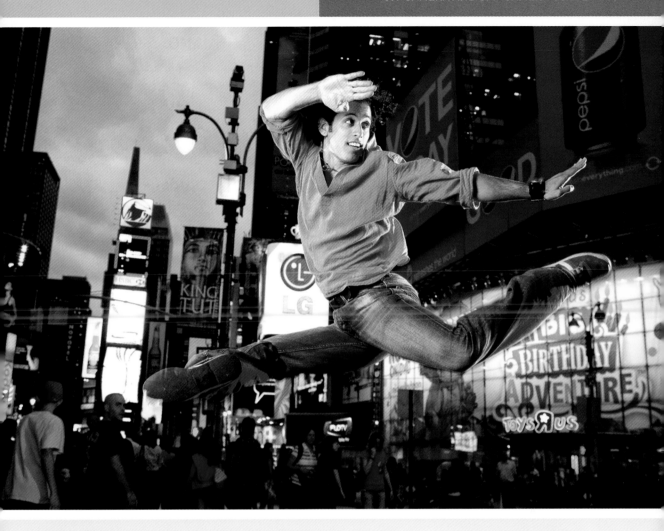

TIMES SQUARE

The assignment was to photograph a dancer/choreographer starring in a Broadway musical. We were surrounded by almost a thousand curious tourists in Times Square. The client and an agency principal were on set too. The subject brought his own entourage.

We transported in a trampoline so our subject could repeatedly jump higher and longer. I gelled the two sidelights so they simulated light from the ambient commercial neon lights. The dancer was so agile and competent, he was able to give me lots of energy and repeat every successful position until we got it right.

New York is very efficient in this kind of production. We have purchased photography permits from the city often. Once you solve the parking, logistics, client comfort, toilet and weather obstacles, the photography is relatively easy.

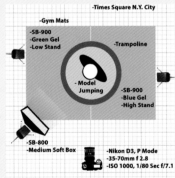

Times Square N.Y. City
-Gym Mats
-SB-900
-Green Gel
-Low Stand
-Trampoline
- Model Jumping
-SB-900
-Blue Gel
-High Stand
-SB-800
-Medium Soft Box
-Nikon D3, P Mode
-35-70mm f 2.8
-ISO 1000, 1/80 Sec f/7.1

Pop-Up Flash

Some of the medium level dSLRs and prosumer cameras are outfitted with pop-up flashes. These flashes are intended to be an intermediate, convenience tool. Although not as powerful as their hot shoe counterparts they can perform many of the same functions, i.e. as a light and as a controller for other ancillary flashes. While they are simple to use, they are menu driven, so you may have to enter the camera menu to change most functions. Thus, in some cases, using pop-up flash is not as easy or as fast as using hot shoe flashes. Another shortcoming is that they cannot be angled, aimed to the side, or behind.

Fill Flash

The on-camera status of both hot shoe flash and pop-up flash is especially applicable to fill flash (see *Fill Flash* page 106). On TTL, when used in situations where ambient light is sufficient, both hot shoe and pop-up flashes default to fill flash status, i.e. the available light will override the contribution of the fill light.

With available light or the main light providing the most dramatic illumination, on-camera or pop-up flash can be scaled back to just open up unwanted shadows that the primary lighting cannot reach. You can adjust it to be hardly noticeable.

Off-Camera Flash

Although there are several reasons besides ease that might require on-camera flash, the real objective is to get the Speedlight off your camera connecting with a sync cord or remote trigger. Detaching that single light expands its capabilities exponentially. Off-camera adds directionality, allows the lighting to look more natural, and lets you "build" your lighting scheme.

TTL Sync Extension Cords

A TTL Sync Extension Cord allows tethered use of TTL flash removed from the camera hot shoe. They allow for better angles.

Tethering

Tethering allows dSLR users to connect their digital cameras by a special cable and display the captured image on a computer, iPad or even an iPhone. There are a number of reasons you the might want to do this. The primary reason is that you can get much better resolution and detail from the larger screen on your auxiliary device than from the camera's LCD. Even with ample practice, peering through a viewfinder does not substitute for how a picture will look in two dimensions.

If you need better precision on a commercial shoot in order to fit a tight layout, this technique cannot be beat. Tethering also assists when there are multiple decision-makers who have to approve the photography as it is evolving: photographer, art director, client, model. It is much easier to elicit consensus when everyone is seeing the image at the same time.

Lastly, you can control the camera remotely from the computer. If the camera has to be in an awkward position or it needs to be placed where a human presence might interrupt the action, a remote, tethered laptop could be appropriate.

Extra implements are needed when tethering. You have to use a cable long enough to allow you flexibility. You need a USB or firewire port on your camera. And you must be sure you have proper software for your specific camera and computer. Uploading your images directly to your computer is a very deliberate way to speed up your workflow.

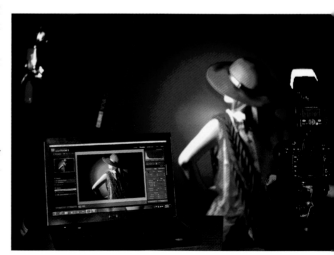

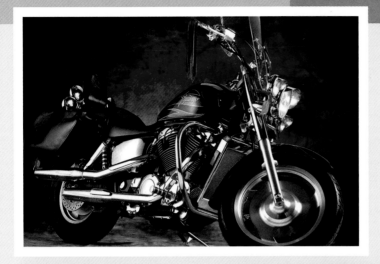

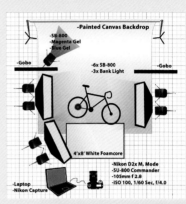

MOTORCYCLE

Advances in technology have improved so much that small Speedlights emit power that belies their size. Batteries continue to be the weak link but they have advanced enormously over the last few years. Therefore Speedlights can be considered for large jobs that were never possible before. Used in groups they can affect digital sensors like much bigger strobes.

Seven lights were employed for this "beauty" shot of a vintage Honda. Motorcycles are big, shiny, highly reflective objects and require precise lighting. Employing several different methods of diffusion in this case eliminated the point source characteristics of the Speedlights and gave them a "broader" appearance. Modified with diffusion materials, they presented a very large rake of light that "fell off" gently around the edges to the left side of the motorcycle and on other surfaces they could be employed to highlight smaller sections of the vehicle as well as the background.

A single Speedlight is hardly enough to illuminate such a large object professionally . . . successfully, but the cumulative effect of placing a sufficient quantity on contrasting surfaces is another strength of the portable lights.

However, there are a few downsides to tethered shooting. Movement is limited because you are attached to your camera. Being tied to the extra screen restricts you. And there is often an appreciable lag time while you await transfer of image files to your computer.

Tethering is usually utilized in the studio where you have more control. When the action is broad or on location or outside, it can be difficult to move quickly and adequately. Your instinct and eye are your most valuable assets to detect good photographs and you need to trust your experience but there may be more complicated elements at play.

VAL

Up until Speedlights, lighting schemes were relatively inflexible. At one time you set up lightstands, concealed cables, adjusted until you achieved the desired results. If and when you wanted to alter things you basically started over. But with wireless capabilities of Speedlights, you can assign your

assistant to follow any subject around. And because of TTL, the distance from the camera is not a factor. They become a VAL (voice-activated lightstand). You gain incredible freedom. It adds a very journalistic appearance to the photographs while maintaining total control over the lighting.

Speedlights using TTL and automatic make well-exposed pictures every time. Put a Speedlight in a small or medium softbox and you accomplish studio lighting while your VAL moves with your subject without interrupting the action. This technique works very well with editorial, corporate, or industrial assignments.

Backwards

Because the lights are so compact and flexible, there are many idiosyncratic methods being employed. If your technique is dependent upon on-camera flash, you can point it forward, bounce it straight up or sideways, or, in the right conditions, you can aim it behind you. This can be done on-camera or

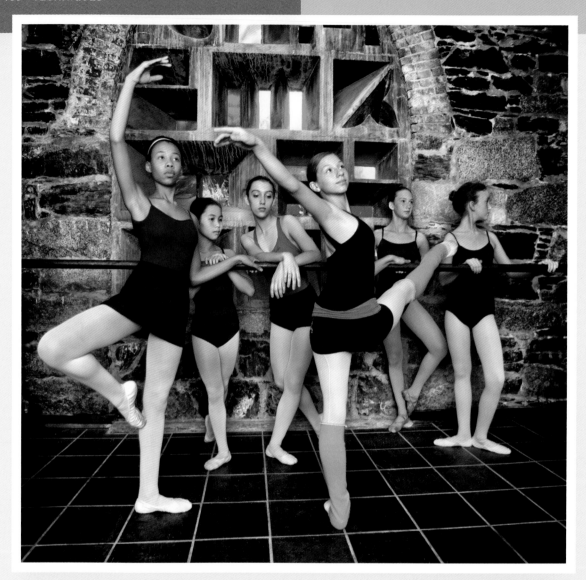

BALLET SCHOOL

The ballet school was overrun with girls and boys of every age. But even after careful planning, the school was only able to spare three young girls for a public relations session. And there was no spare room either. So we took our models to the front vestibule. After attempting a few poses, their three friends snuck out of class to see what was going on. I had my critical mass.

I know nothing about dance technique, so the girls did all the work. They suggested position after position. I moved them around, but they gave me more than enough. I bounced a single, on-camera flash off the white wall directly behind me. I was able to work fast and get all the pictures I needed before their teacher realized they were missing.

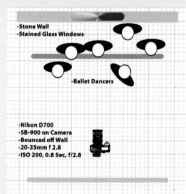

-Stone Wall
-Stained Glass Windows

-Ballet Dancers

-Nikon D700
-SB-900 on Camera
-Bounced off Wall
-20-35mm f 2.8
-ISO 200, 0.8 Sec, f/2.8

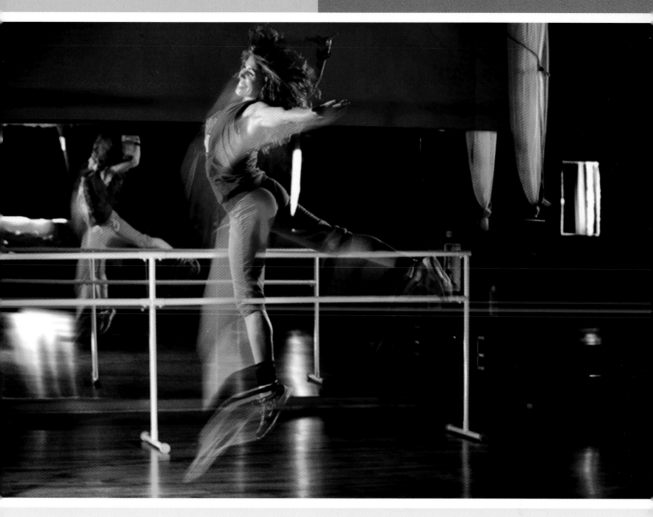

ZUMBA

Your life is made so much easier if you work with professionals. Even though the Latin dance instructor could not speak English very well, she could perform the moves I needed over and over.

The shot was very complicated. On location we laboriously darkened the studio and used a couple of incandescent work lights to insure adequate blur. We turned on Rear Curtain Sync/Second Curtain Synchronization (see *Speedlight Components* on page 11) to get the blur trailing in the logical place. The LCD was essential in judging the dancer's position and amount of movement.

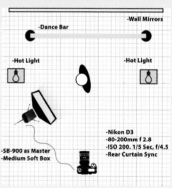

handheld. In a reasonably sized room with mostly white walls, the little light will fill the space with directionless, all-surrounding illumination. It is fast and easy. Practically foolproof. Excellent for weddings, events, large groups, business meetings, etc.

Rear Curtain

Rear Curtain or Second Curtain was developed because photographers complained that they wanted to be able to include blur that smeared in the right direction when integrated with flash. The manufacturers accommodated this by introducing an option of having the flash fire at the end of an exposure rather than the beginning. This small change places the blur behind the action rather than awkwardly in front.

This works well for its intended purpose, but the "by product" is the camera now makes its main exposure measurement before the flash is added. Therefore, the ambient light has a more significant impact on the final result. It fills in the background lighting and sometimes the picture appears more realistic. Without Rear Curtain/Second Curtain, your shot may have more contrast and appear more dramatic. But, using flash on Rear Curtain/Second Curtain may just look better.

You can achieve some very interesting results if you manipulate both flash and ambient light, and work with the ISO. It is easy to shift back and forth between the two styles. The automatic exposure makes the adjustment flawlessly. From there it may be a judgment call.

Chapter 5

Light Modifiers

For generations photographers have tried to harness the laws of physics and control one of the most irrepressible forces of nature. We have made light stronger, bigger, softer, wider, and sharper.

We have also attempted to focus, segment, square, and eradicate it. Add color, shadows, movement, and definition. To accomplish all that, we have assembled a myriad of factual and fictional props and theories to recreate the nature of light. Each device has its time and place, but use of most of these implements is mostly a matter of personal preference and fashion, even though each can play a vital role in experimentation.

Speedlights cannot do it alone. At one time we were forced to retrofit preexisting tools. Now many manufacturers have recognized how much the new market has expanded. Fortunately, all the gadgets and gizmos that have been developed for larger lights are now being fabricated for the smaller flashes. There is even competition which presents better choices for lighting modifiers.

Grids, snoots, umbrellas, and gobos[10] are bizarre words and even stranger looking devices. They often make our set-ups resemble Rube Goldberg's convoluted machines.[11] You will never use all or most of them, but "the right tool for the right job . . ."

In this chapter we will enumerate the most popular light modifiers and show examples of how and why they might become part of your photography kit. Mixing, matching, and combining different pieces is an endless pursuit.

MODIFYING FLASH: QUALITY OF LIGHT

The Wireless TTL signal from the Master remains effective if bounced or passed through a diffusion screen. In-camera flash metering and automatic flash exposure remain operational. Exposure strategies remain unchanged. Master and Remote/Slaves can be used with reflector panels or discs, diffusion panels and softboxes. Several brands of 5" × 8" softboxes attach directly to the flash with VelcroÒ. Speedlights can also be attached to much larger banklights. A variety of manufacturers produce brackets and rings to mount a TTL flash to extra small, small, medium, and large light modifiers.

Accessories for Speedlights mostly divide into three categories: light modifiers, such as softboxes, umbrellas, grids, snoots, etc.; clamps/fasteners that hold Speedlights in or on things; and gadgets.

Attaching your Speedlights to devices or lightstands is frustrating. They are not well designed for that. Many fabricators and manufacturers have weighed in to solve this problem.

Umbrellas

As lighting modifiers go, umbrellas are one of the first, high-tech implements. There are several variations but two basic types. The original type has an opaque outer surface and white inner surface that reflects most of the diffused light toward the subject. The parabolic shape concentrates

FIGURE 5.1 SPEEDLIGHT USED WITH REFLECTOR UMBRELLA

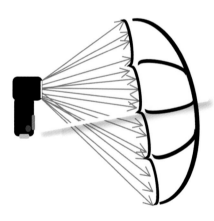

FIGURE 5.2 SPEEDLIGHT USED WITH TRANSLUCENT UMBRELLA

[10] Gobo = Go Between. Originally used in film, it is a physical object placed in front of a lighting source to block the light from falling on background subjects or from spilling into the lens. Sometimes it is used to manipulate the shape of a light which is cast over a space or object.

[11] Rube Goldberg (1883–1970) was a famous Pulitzer Prize winning cartoonist best known for his series that depicted complex contraptions that made simple tasks complicated.

most of the light back and makes it a very efficient reflector.

The umbrella is good for general lighting. It "throws" a lot of light in one direction toward your subject. It is perfect if you have to illuminate a large area. Reflector umbrellas also come with silver or gold inner surfaces. Silver is very efficient and delivers harsher shadows. Gold introduces a warming color or effect to the light. Nearly everyone involved in lighting makes some form of umbrella.

The second type, shoot-through umbrella, is made from white translucent material. The light is able to pass through the diffusion. It is usually considered to be a softer light. However, it is far less efficient and the light is dispersed everywhere, backwards and forward.

Certain configurations, such as bounce umbrellas, may block the Wireless TTL signal. In this situation, white shoot-through diffusion umbrellas may be a better option as the umbrella does not come between Master and Remote/Slave.

Calumet (calumetphoto.com)
Calumet makes many multipurpose umbrellas which are made of rugged white inner fabric, backed by removable silver lining with black backing. By removing the silver/black lining you get the shoot-through type too.

Softboxes

First we were given the banklight, a large, heavy, semi-permanent but excellent light diffuser. Its front surface made the light within bigger. Out of necessity the inventors utilized high-tech materials and computer-aided design to develop a lightweight, collapsible SOFT box that is a staple of the industry.

Like its name suggests, a softbox is basically a box that is opaque on all sides but one. The light source is positioned on the side opposite the diffusion material. Manufacturers have introduced all sorts of intermediary baffles in the interior to make the light output even and still allow maximum efficiency.

When used with Speedlights, the softbox acts as an enclosed diffuser. Figure 5.3 shows how the Speedlight fires directly toward the front panel of the softbox, which creates a larger light source and somewhat scatters the direct light. By the increase

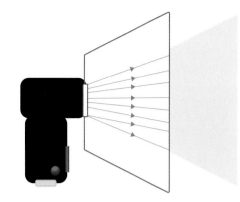

FIGURE 5.3 SPEEDLIGHT WITH SOFTBOX

in size and the slight scattering, the softbox turns the Speedlight into a softer light source.

When used with "studio" strobe heads that have removable reflectors, the softbox becomes a mixing chamber as well as a diffuser. When the bare flashtube of the studio strobe is in the softbox, light is directed not only at the front panel, but at the internal reflecting panels of the softbox. This mixing can produce a more homogenous, softer light from the same softbox, as shown in Figure 5.4.

The Speedlight can be made to mimic the bare tube head. The Nikon Speedlight comes bundled with a snap-on dome diffuser. A similar diffuser is available from independent manufacturers for the Canon Speedlite. Used alone, this diffuser does not soften the light and the size of the light source remains the same. Instead, the dome diffuser bounces light in all directions. Study the edge of the

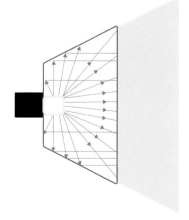

FIGURE 5.4 STUDIO FLASH WITH SOFTBOX

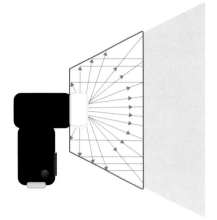

FIGURE 5.5 SPEEDLIGHT WITH DOME DIFFUSER AND SOFTBOX

shadow on the subject with and without it. When used indoors, overall contrast is reduced and more light is provided in the background of the picture. The dome diffuser used on a Speedlight inside a softbox turns the Speedlight into the equivalent of a bare tube flash, as depicted in Figure 5.5. The quality of light from the dome diffuser Speedlight in a softbox may be softer than a straight Speedlight without the dome.

Softboxes are available in a variety of sizes and specifications. The larger the light, the softer the light. The greater the softbox to subject working distance, the larger the softbox needed to maintain a soft light. Silver-lined softboxes will have more contrast and specular highlight than white-lined

softboxes. Several brands have interchangeable interior fabrics and secondary, removable internal diffusion baffles.

Recessed front softboxes provide a more narrow angle of illumination than flush front. Recessed fronts allow more control over the spread and feathering of the light. Flat, flush fronts may be better if there is extensive use of reflectors as fill. Recessed front softboxes often can be fitted with fabric egg-crate grids, providing a soft, spotlight effect. Barndoors, purchased or fashioned, may be available to further control the spread, spill, and placement of the light. Circular masks change the shape of the catchlight in the eyes.

Strip lights are long, narrow softboxes designed for full-length portraits and fashion, for use as edge or hair lights, or any time long, slender highlights are desired, such as in photographing bottles or glassware. Small Speedlights can be used with a large softbox. Set the zoom head to the widest to evenly illuminate the front diffusion screen.

Shape the light to better match the subject. The horizontal or vertical orientation of the softbox can change the look of the image. A vertical subject may be best with a vertical light. Group pictures may call for a horizontal light. Using a large softbox horizontally for a portrait may yield less contrast and more of a "wrap around" look, as the wider softbox illuminates the subject from more angles. A very large horizontal softbox may successfully take the place of separate Main and Form Fill lights for portraiture.

BRAIN

This photoillustration was done for a science client. This is a case where I had the initial idea but I had to "build" the picture gradually. It took hours of work and false starts to get approval for the final shot.

The cobalt blue head was a prop from another shoot. The camera had to be on the same level as the very long mirror. The egg crate baffling on the small softbox was intended to reduce spill on the background but its reflection was so intriguing we kept it. The Speedlight behind the head that created the "brain" was gelled magenta only after being dissatisfied with plain white. I did not like the sharp edge of the mirror so I crumpled up CineFoil® to make a "mountain range."

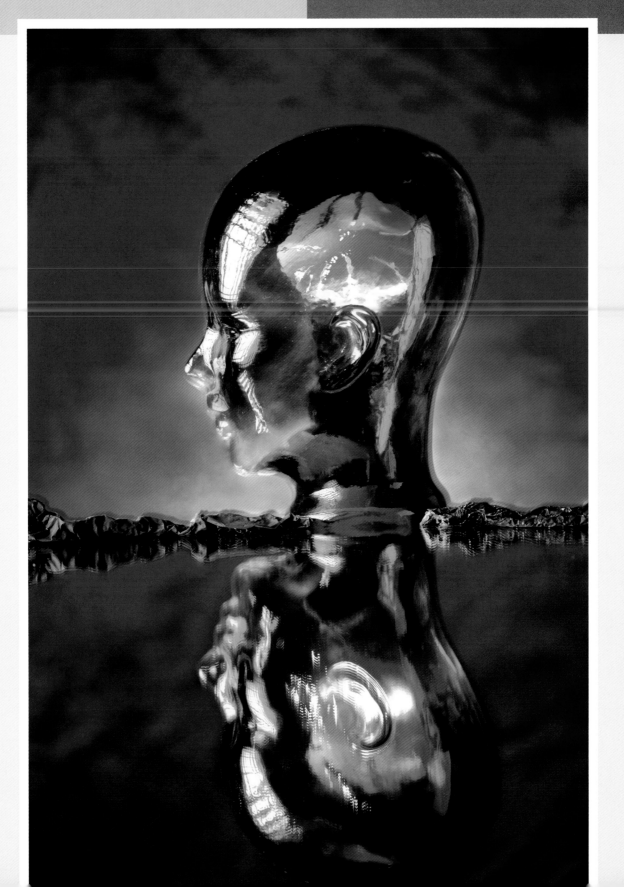

Softboxes mount Speedlights on the rear of the light modifier. When the Speedlight/softbox combination is used in front of the camera, closer to the subject, it is easy to maintain line of sight between Master transmitter and Slave/Remote TTL receiver. Make sure the softbox mounting bracket flash shoe rotates so that the receiver always faces the transmitter and the flash head faces into the softbox.

> Set the zoom head of the flash to a wide setting to provide even coverage across the diffusion screen. Multiple TTL flash units, set to the same Remote/Slave ID, can be rigged or mounted firing into the same bank for increased light output.

Calumet (calumetphoto.com)
Calumet makes an assortment of softboxes in various sizes. They tend to be simpler in design and a less expensive alternative. Good value for the price.

Aurora Mini/Max Softbox
Aurora makes extra-small softboxes which attach directly to the Speedlight using the easy "Lock & Loop Mounting System" strap (included). While they are intended for on-camera usage, they are especially applicable for placement in small, confined spaces off-camera.

Ribbon Grid Softbox Attachment

This fabric grid attachment for your softbox gives great control of light diffusion. It is often referred to as "egg crate" grid because it resembles one. It directs the light source while keeping the even and soft lighting effect from the softbox. It permits excellent control over light dispersion and is good for tight spaces while keeping extraneous light from striking unwanted areas.

Plume Wafer lightbanks (plumeltd.com)
The Plume softbox has exceptionally even and soft qualities. It comes with three sailcloths, a Wafer diffuser, baffles and interior ellipse. Because of the attention to detail it has a shallower profile than its counterparts which makes it ideal for use in tight quarters.

LightWare FourSquare™ (lightwaredirect.com)
LightWare, better known for its equipment cases, has entered the market with a unique softbox. Its anodized aluminum mount can hold up to four Speedlights and will adapt to a vast range of lightbox sizes. Raw power is the reason for this arrangement. If you need smaller apertures or faster recycling times this is the product you need.

Grid Spot

If you just want to put some light on a small area in your composition, you have to reduce its tendency to spread. Grid spots are placed in front of a flash head to concentrate light and create a spot or circle of light. Any sort of honeycomb-like or egg crate-type assemblage will channel the light down to a smaller shape. The denser the grid, the narrower the effect.

Different companies make them from metal, plastic, cardboard, or foam. Ones made from metal and plastic are more durable and expensive. Plastic and cardboard ones are cheaper and disposable. It can be cumbersome to make them fit all sizes of Speedlights and still able to exchange grid sizes. A few solutions have been clever, but it varies widely from model to model.

The tighter the grid the more light you lose because it reduces the amount of usable light passing through.

Saxon PC (saxonpc.com)
These clever little grids are pleasantly simple. Made of lightweight grid material surrounded by foam they just slip over the Speedlight. No additional parts are needed. You must order the correct size that fits your individual flash but they are very cheap, almost disposable.

Rogue (expoimaging.com)
Rogue has a patent pending for their design of a stackable grid spot system. It contains three honeycomb grids that will funnel the light tighter as you place one on top of the other.

HONL (honlphoto.com)
HONL offers two grids with different spreads. Even though they are rectangular, they cast circular light. The grids can be used with colored filters for effect.

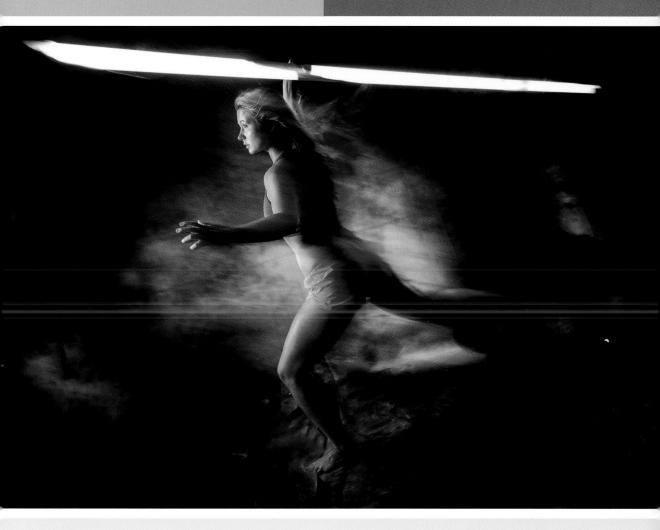

JAVELIN

I have photographed several Olympics Games in the past. This image was an homage. Since there were so many moving parts, I tried to anticipate all the complexities beforehand. The illuminated javelin was a fluorescent tube fabricated with wires and ballast able to be hidden.

Since the fluorescent light was the essential prop but an unwanted light source, I had to reduce its influence. So I used a FourSquare™ softbox with four Speedlights so I could stop down for a small aperture. We used CineFoil® to gobo the incandescent work light in order to create the warm spotlight on the painted background.

Shutter priority was set to one second to allow me to move the handheld camera during exposure. This and the fan gave the image a sense of movement.

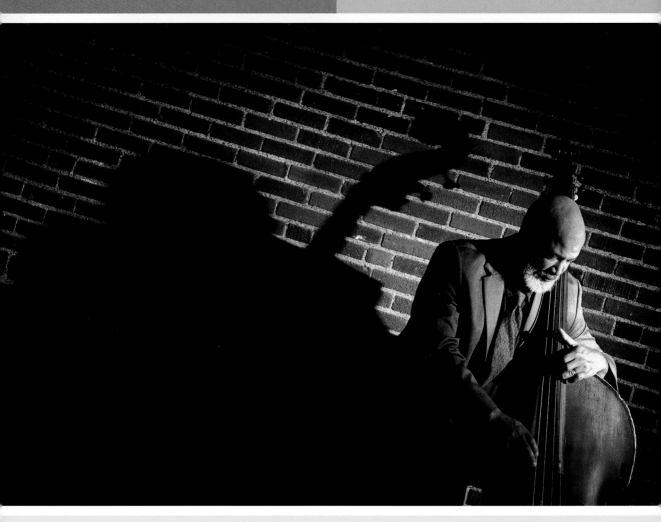

BASS

My friend was releasing his second music CD. I had shot the pictures for his first album so when he returned to my area for a gig, I had him come into the studio for more pictures. We spent all afternoon shooting different versions. He obligingly changed clothes between each set-up. For the last shot of the day, I used the brick wall in my studio to simulate the back wall of a crowded jazz club. I aimed a single spot grid and maneuvered it to produce the distinctive shadow. I would normally not use such hard light, but it seemed appropriate in order to imitate stage lights.

Snoot

A snoot is any kind of tube that fits around a light to control the direction and radius of the light beam. They can be conical, cylindrical, or irregular. They can be hard or soft. They are another way of narrowing the spread of light. Snoots are ideal for controlling light spill (see Snoots in *DIY = Do It Yourself* on page 133).

Aurora Mini/Max Stealth Snoot
The Stealth Snoot is a light shaping mount for Speedlights. When rolled into a cylinder it concentrates the flash output into a spotlight. Then it can be stored, folding flat. It has straps to attach the unit to the Speedlight.

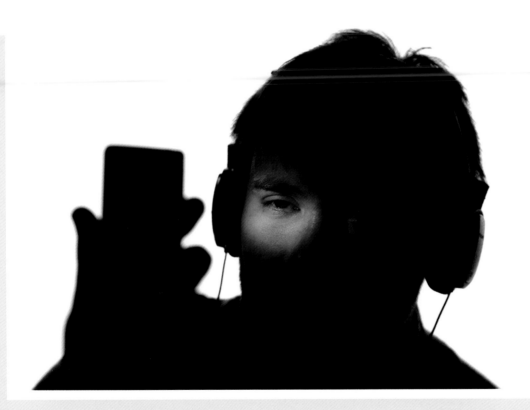

CELL PHONE
This image was to accompany an article about cell phones but everything had to be generic. The identity of the user also needed to be anonymous. A tall order. Therefore there were only two working lights—one on the background to light the white seamless and the other with a tight spot grid and green gel to light just the model's eye. (See *Gels/Filters* on page 133.) The silhouette carried the message. After coming up with the concept, the execution was fairly simple. The model was an intern working with us for the summer.

-White Seamless Paper
-SB-900
-SB-900
-Spot Grid
-Green Gel
-Model
-Cell Phone
-Nikon D700 as Master
-105mm f 2.8
-ISO 200, 1/60 Sec, f/5.0

Beauty Dish

A beauty dish is a metal or plastic reflector designed to use its parabolic shape to focus the light. It is a different kind of light modification because its objective is not to diffuse light. It is an alternative to a softbox.

In most beauty dishes, the flash hits a flat, circular plate and bounces back into the shallow bowl which spreads the light evenly toward the subject. It is a sharper, more direct light used to add drama. The bowl can be either silver or white. Just like the softbox, the larger the dish, the softer the light. It comes in a variety of sizes, typically 18 to 22 inches, but is not as portable as a softbox and is found mostly in the studio set-up.

Dot Line Corp (dotlinecorp.net)
This all-metal 20-inch beauty dish is substantially crafted for Speedlights. It has several attachments and requires some assembly.

Interfit (interfitphotographic.com)
Interfit offers a Speedlight bracket that fits all Interfit studio strobe light modifiers, including two beauty dishes and grids.

Flag/Reflector

A flag is just about any object placed between a light and the set or the camera. Its purpose is to prevent extraneous light from spilling onto a certain part of the set. It can also shield flare from entering a camera lens or block light from striking the background.

Most anything available can be pressed into service, but a number of manufacturers have fabricated very versatile products. Some of the flags made for use with Speedlights come with black on one side and white on the other so they can easily be used as reflectors for on-camera flash.

Aurora
Aurora's QBF-B Bounce Card is a small, flexible reflector that attaches directly to the flash head and can be bent into any configuration. Thin wire rods permit it to hold its shape for directing more of the light where you want it or to gobo light where you do not want it.

Rogue (expoimaging.com)
The Flash Bender can be use to as a reflector, as a flag, or as a small snoot. The design incorporates two rods that bend and allow it to be molded into all sorts of shapes.

Gary Fong Lightsphere (garyfongestore.com)
The "Fong Dome" is a well-known Speedlight diffuser that mounted to on-camera flash. The latest manifestation is called the Lightsphere, which is now collapsible. Since the light is dispersed in every direction, the Lightsphere is most efficient where walls and/or ceiling reflect the dispersed light toward the subject.

HONL (honlphoto.com)
HONL has a product similar to the Rogue, usable as a bounce card, flag, or snoot.

Chapter 6 | Accessories

Interesting, complex, and dramatic lighting is no longer just for experienced professionals. TTL allows dedicated "newbies" to perform amazing feats of legerdemain with their digital flashes.

To make the new equipment more effective, a number of manufacturers are forging new avenues with peripheral accessories and other gadgets.

Photographers love gadgets. And in an effort to capitalize on this insatiable appetite, new products are being introduced all the time. Magazines and conventions are filled with companies hawking their wares. The Internet flourishes with websites whose sole purpose is trade. Everyone feels they can "build a better mousetrap."

It is unfortunate but far too many people reduce taking pictures to the quality and quantity of equipment and paraphernalia. Whereas the right tool can solve a myriad of problems, a little commonsense is necessary to discover just those accessories that will substantially contribute to making better images. Some are tools you need to succeed and some are merely toys. Personal style dictates what kind of equipment we need, that and may be our pocketbooks.

After gathering together the basic equipment to take pictures, generations of great photographers have proven that little else is needed to make brilliant photographs. While we wish for the proverbial compass to point toward true north, a magic carpet to raise us high above it and a "perpetual motion machine" to power it all, "Necessity is the Mother of Invention."

The best photographers in the field display amazing *MacGyver*[12] instincts whereby they enlist one tool to do the work of another and make complicated devices out of ordinary objects. That gift sometimes can prove counterproductive because too many of us try to reinvent the wheel when we could better spend time incorporating someone else's invention to do the job. However, getting equipment to do double duty is important.

While you don't need the latest gadget, this chapter is intended to highlight a few things that may help and a few things that show how others have already "paved the way."

Aftermarket Speedlights

A lot has happened since we published the first edition of *Speedlights & Speedlites: Creative Flash Photography at Lightspeed* (2009). There has been a tremendous upsurge in the use of Speedlights. What was a timely, welcome anomaly to photography and lighting has since been embraced by masters, innovators, and beginners alike.

When we wrote the first book only Canon and Nikon made true integrated TTL flashes (see *TTL Electronic Flash: Definition* on page 2). With a burgeoning marketplace, a number of independent manufacturers have weighed in with genuine Speedlights that can be integrated into any system and will perform ALL the functions flawlessly.

All things being equal the newcomers are less expensive and we feel worthy of inclusion in the exclusive discussion. At the same time others have attached the title "Speedlight" to their flashes and claim some amount of TTL but only a few actually do everything explained in this book.

Table 6.1 contains the ones that we have tested and found to fulfill most of the criteria necessary to be fully compatible.

Yongnuo YN 565 ex (hkyongnuo.com)
Made in China, this flash most resembles the Canon 580EX II. It seems well made with quality plastics and a finish similar to Canon's. It works with both Nikon and Canon, but lacks Master mode and only acts as a slave. It does not have high speed sync, but does work as an optical slave. It is very inexpensive and would be an excellent alternative to the pricey name brand lights. Each new generation from Yongnuo improves on both build and available features.

Nissin Di866 II/Di622 II (nissindigital.com)
These flashes, also made in China, are capable of being inexpensive substitutes for the whole lighting system. The Nissin Di866 II works as a master/slave and the Di622 II acts only as a slave. The Di866 was the first flash to feature a full color LCD screen and comes with a full range of available modes similar to 580EX II/SB-910. The color LCD and clear icon based menu system give it an advantage in navigation over its more expensive competitors.

[12] Angus MacGyver was an American TV character known for his inventive use of common household items to improvise complex devices in order to extricate himself from life-or-death situations.

TABLE 6.1 SPEEDLIGHT CHARACTERISTICS

Model	Canon TTL	Nikon TTL	High Speed Synch	Rear Curtian	Stroboscopic Mode	Optical Trigger	External Battery Port
Canon 580 exII	Slave/Master	No	Yes	Yes	Yes	No	Yes
Canon 430 exII	Slave	No	Yes	Yes	No	No	No
Canon 600 ex RT	Slave/Master/RT	No	Yes	Yes	Yes	No	Yes
Nikon SB 910	No	Slave/Master	Yes	Yes	Yes	Yes	Yes
Nikon SB 900	No	Slave/Master	Yes	Yes	Yes	Yes	Yes
Nikon SB 800	No	Slave/Master	Yes	Yes	Yes	Yes	Yes
Nikon SB 700	No	Slave/Master	Yes	Yes	No	Yes	No
Sigma EF 610 DG Super	Slave/Master*	Slave/Master*	Yes	Yes	Yes	Yes	No
Sigma EF-530 DG Super	Slave/Master*	Slave/Master*	Yes	Yes	Yes	Yes	No
Nissin Di622 II	Slave	Slave	No	Yes	No		No
Nissin Di866 II	Slave/Master	Slave/Master	Yes	Yes	Yes		Yes
Yongnuo YN 565 ex	Slave	Slave	No	Yes	Yes	Yes	Yes
Metz 58 AF-2 digital	Slave/Master	Slave/Master	Yes	Yes	Yes	Yes	Yes

Sigma EF 610 DG Super/EF 530 DG Super
(sigmaphoto.com)
This venerable company has been making excellent aftermarket lenses and products for years. The EF 610 DG Super continues this trend. Capable of full master/slave wireless triggering and available in models for Canon and Nikon this flash is packed with professional features. The advanced features of the EF 610 DG Super include modeling flash function, multi-pulse flash, FP flash, rear-curtain Synch, and a powerful guide number of 61.

Metz 58 AF-2 digital (metz.de)
The AF-2 is the flagship Pro model Flash of the German based company Metz. This model stands a step below the Canon/Nikon equivalent in durability, but a step above the third-party models coming out of China. It works with Nikon/Canon TTL systems in both Master and Slave/Remote modes. Additional features include High guide number and a unique second flash reflector for fill flash.

Remote Triggers

The question of remote triggers has been controversial since the introduction of Speedlights. As the complexity of each generation of flash increased, the job of the triggering mechanism became more involved. There are a number of ways to sync more than one flash and the decision as to which to use has to do with simplicity, cost, weight, etc., which are fundamental to Speedlight design.

Hardwiring

The simplest, most reliable triggering mechanism is hardwiring, i.e. a physical connection between light and camera. On-camera flash is fired by the physical connection of the flash with the hot shoe. If you are using the proprietary manufacturers system you have all the features available to you. With the dedicated flash extension sync cords your flash is "hardwired" to the camera and you also retain all the features.

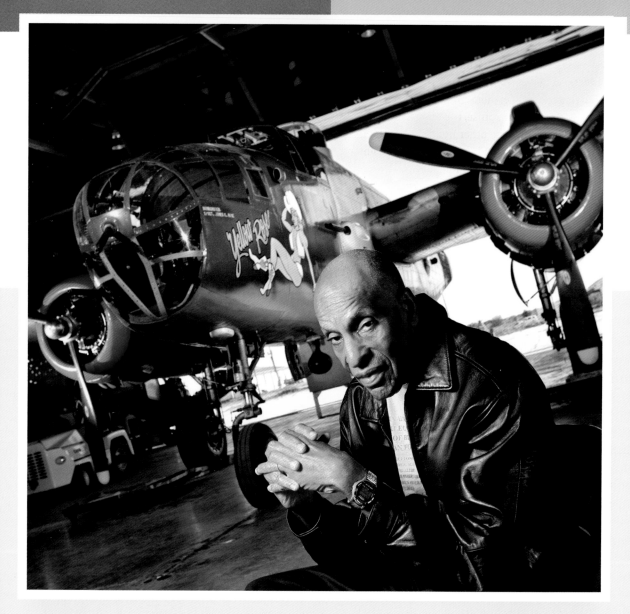

AIRPLANE

We had to contact a number of historical air museums to find a B25 bomber. The gentleman in the photograph was part of the famous Tuskegee Airmen squadron and he flew an identical plane during World War II. After a long drive to transport him to the airport, we had the custodians move the airplane to just the spot we wanted.

We did a few different set-ups to satisfy the art director. Since the model was quite elderly, I had him sit so that we could take our time "building" the lighting around him.

We opened the back door of the hanger to add light to the enormous dark room. That light cast a wonderful sidelight onto the airplane but was inadequate for the majority of the plane. We needed more light on the front. My assistant erected three Speedlights on tall stands to illuminate both propellers and the nose of the antique B25. A medium softbox lit the Tuskegee airman and I spent most of my time prodding him to assume a pose that was flattering.

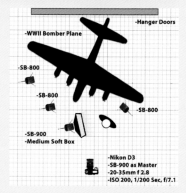

-Hanger Doors
-WWII Bomber Plane
-SB-800
-SB-800
-SB-800
-SB-900
-Medium Soft Box
-Nikon D3
-SB-900 as Master
-20-35mm f 2.8
-ISO 200, 1/200 Sec, f/7.1

Optical

Several generations ago flash makers made great advances by putting optical triggers into professional strobes. The camera ignited the main light and the instantaneous impulse, traveling at the speed of light, triggered all the other lights. This eliminated a lot of the hardwiring between auxiliary lights. It worked very well over fairly long distances and was sensitive enough to work in all but bright sunlight. All adjustments were manual and each unit had to be controlled individually.

Infrared

The traditional method for triggering Speedlights is the built-in infrared triggers. Whether you use the Nikon Commander, the Canon Transmitter, or the internal transmitter in the Speedlight, infrared signals are contained in pre-flashes (see *Wireless* on page 55). All functions are maintained. And you can control all functions from the Master/Commander.

Infrared triggers are simple and very reliable. However, a drawback to infrared control is that each supplemental Speedlight has to be line-of-sight, i.e. the Remote/Slave's receiver sensor has to visibly "see" the pre-flash from the Master. This can be inconvenient or impossible in some lighting schemes.

Radio

Before TTL, several innovators realized the problems of optical and infrared triggers. The range and ambient conditions made them inefficient in some situations. So they introduced ancillary radio triggers which enhanced functionality. The range was increased and physical obstructions did not block the signal, so you could place light around corners, in other rooms and, more importantly, all light modifiers, like softboxes and umbrellas, could not interrupt the triggering signal. Radio triggers worked so well that many studio strobes have them built into their electronics. But they circumvented the TTL systems of Speedlights. And you had to manually change all power and recycling functions of your lights.

Radio signals and infrared are incompatible. Besides not synchronizing with TTL, radio has in-ternational restrictions because different countries designate different frequencies to them and you cannot interchange models bought or rented across certain borders.

Also since they are not built-in, they are an additional expense, bulky and you need a separate one for each light you add to your shot.

Canon 600 EX-RT

All of the above has changed with Canon's introduction of the 600EX-RT. This new Speedlite revolutionizes and solves a lot of the difficulties with Speedlites. Canon has converted to radio triggering built in to the flash. (See Wireless TTL Transmitters: Master on page 58.)

FIGURE 6.1

PocketWizards® (pocketwizard.com)

PocketWizard® Radio Remote Triggers
PocketWizard® products allow for untethered radio triggering between all your lights and cameras, even when flashes and strobes are hidden behind objects or far away. Infrared and radio features in the newest Speedlight models combined with radio triggers create flexible opportunities in portable lighting. Trigger your Nikon/Canon TTL flashes with PocketWizard's ControlTL® system (MiniTT1/FlexTT5) or combine them with their Plus IIs and Plus IIIs for new photographic possibilities.

PocketWizard® MiniTT1/FlexTT5 Transmitter/Transceiver Radio Slave TTL II System

The PocketWizard® MiniTT1 and FlexTT5 is a Radio control system for flashes extending both Canon's E-TTL and Nikon's CLS/i-TTL wireless systems. It simply attaches directly to the camera's hot shoe. The FlexTT5 is a "Transceiver" that acts as a transmitter when placed in the camera's hot shoe or as a receiver when attached directly to a flash. The MiniTT1 is a transmitter-only unit. With the ControlTL® system you can control the camera, on-camera flash, or flash commander controller.

PocketWizard® Plus II Transceiver/Radio Slave

The Plus II is an Auto-Sensing radio triggering system that automatically switches to transmit or receive as needed up to 1,600 feet away. It does not need line of sight and can hide flashes behind objects. It has four 16-bit channels to use for selective triggering of lights or cameras. Photos can be taken at up to 12 frames-per-second and the fast microprocessors have top sync speeds of 1/500th for leaf shutters and 1/250th per second for focal-plane shutters.

PocketWizard® Plus III Transceiver

Remote flash and camera triggering system has 32 channels. It has a quad-zone feature that allows you to selectively trigger either the flashes or cameras in a group or individually. It has a long range, especially with the (LR) Long Range Mode, as well as the ability to extend the range with Repeater Mode (RP) being able to overcome interfering radios in between your transmitting and receiving radios. The Auto-Sensing Transceiver automatically switches to transmit or receive as needed. The Two-Stage Trigger lets you wake, focus, and meter a remote camera before triggering much like a shutter release.

Flash Brackets

Horizontal pictures, with the flash mounted on the hot shoe, have almost no shadows. The center of the flash is above the center of the lens. When the camera is vertical with the flash on the shoe, the light comes from the side and produces asymmetric shadows. Holding the camera with the flash on the left, or on the right, can change the direction of the shadow, but not eliminate it.

Red eye is flash reflecting off blood vessels in the back of the eye. Flash close to the lens axis causes red eye. Telephoto lens pictures are more prone to show red eye due to the narrow angle of reflection as a result of the increased flash-to-subject distance.

A professional flash bracket can alleviate these problems. Flash brackets that position the flash above the lens for both horizontal and vertical compositions maintain shadowless lighting. A professional flash bracket increases the distance between the flash and the lens. This creates light that is directional and reduces red eye.

Flash brackets come in two designs: flash-rotating or camera-rotating. The flash-rotating bracket matches the orientation of the rectangular flash with the rectangular format of the camera. The camera-rotating bracket keeps the flash horizontal regardless of camera orientation. A camera-rotating bracket may result in flash pictures that are dark on the top and bottom unless the wide panel is used on the flash.

A proprietary TTL Cord is required to maintain communication between the camera and the flash when using a flash bracket.

FIGURE 6.2 FLASH DIRECTION WITH VERTICAL CAMERA SHOTS

With the flash on the hot shoe, vertical composition creates side light with strong side shadows. Holding the camera with flash on right or left changes the direction of light provided by the TTL flash.

FIGURE 6.3 FLASH-ROTATING BRACKETS

Flash-rotating brackets maintain the orientation of the TTL flash and the camera for even flash coverage. Keeping the flash centered over the lens eliminates side shadows. Increased lens-to-flash distance reduces "red eye."

FIGURE 6.4 CAMERA-ROTATING BRACKETS

Camera-rotating brackets turn the camera vertical while the flash remains oriented for horizontal coverage. The tops and bottoms of the flash pictures may be dark. Use the Built-In Wide Panel/Built-in Wide Flash Adapter to widen the angle of illumination from the TTL Flash.

FIGURE 6.7 RED EYE REDUCTION WITH FLASH BRACKET

Flash separated from the lens, such as on a flash bracket, changes the angle of reflection. "Red Eye" is reduced or eliminated.

FIGURE 6.8 RED EYE WITH LONG LENS

Using a long lens increases the flash-to-subject distance, changing the angle of reflection. "Red Eye" increases, even with a flash bracket.

FIGURE 6.5 TIPPING THE FLASH HEAD DOWN WHEN USING BRACKETS

Tip the flash head down to evenly illuminate subjects that are close to the camera, especially when using a flash bracket.

What Causes Red Eye?

FIGURE 6.6 RED EYE

Flash used close to the lens reflects from the back of the eye into the lens.

Stands

A mini stand is provided with each flash. The mini stand will hold a Remote/Slave flash upright on any flat surface. The mini-stand has a standard $\frac{1}{4} \times 20$ screw thread on the bottom to mount on various light stand adapters and tripod heads. A "swivel adapter" or small ball head on the top of a light stand allows the flash to be aimed in different directions and angles.

A variety of light to medium duty light stands sufficient to hold a TTL Remote/Slave flash and a diffusion device are available at reasonable prices. Most come in 6-foot, 8-foot and 12-foot heights.

> If, for durability, a metal flash shoe is preferred, use a flash shoe that has a plastic insert or a cut-out space. Avoid metal flash shoes that make contact with the pins on the bottom of the TTL flash. This may cause the pins to short and the flash may not fire properly.

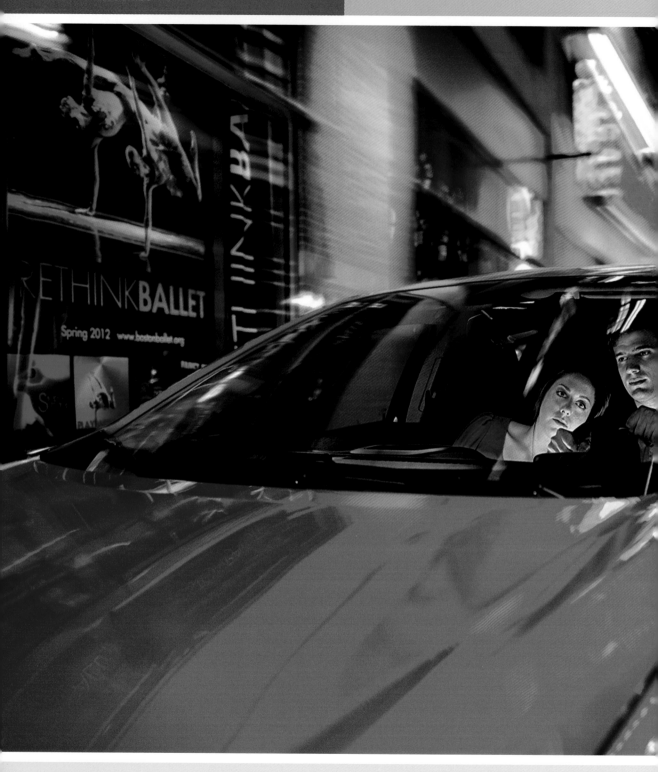

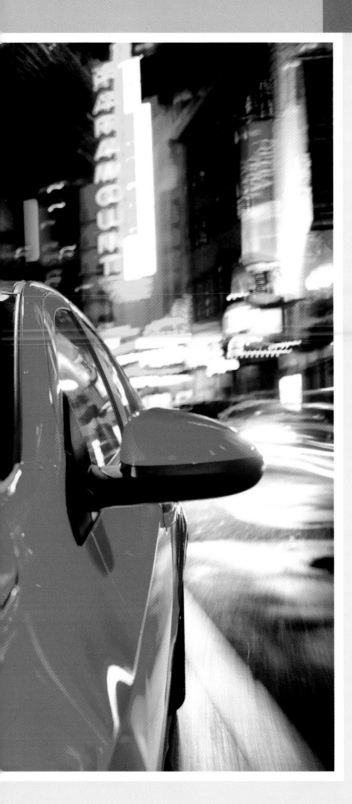

CAR

Much of photography is access. To be able to photograph in the downtown area, my studio manager had to spend days on the phone with city managers, police, and fire departments. Permission also required costly permits and insurance bonds.

Regardless of the bureaucracy, car shoots are some of the most difficult commercial photography. Besides the models, we had to have three separate crews: first, a team to rig the camera which was hanging from a boom attached to the top of the car and also to prep the car by cleaning the windows and metal; second, able-bodied people to push the car during exposures; third, a couple of people for security, who kept an eye on equipment and made sure pedestrians avoided the shooting area.

It is obvious as to why the location was selected. I wanted big city lights, neon signage, and a place large enough to put a car next to traffic. And there are only a few logical places where all those elements can be found.

Speedlights provided the only apparent lighting. To simulate interior lights, we taped a white plastic garbage bag (see *Glad Bags* on page 131) around the steering wheel. It was lit by a Speedlight with a cooling gel that was placed on the floor behind. Because line-of-sight was impossible, we used PocketWizards® for the "dashboard" light as well as triggering all the other lights for the hood and left side of the car. We cut down on glare on the windshield by using a Polarizing filter on the lens.

Two helpers moved the car from behind during the long exposure. Each frame was highly choreographed in order to create the feeling of movement.

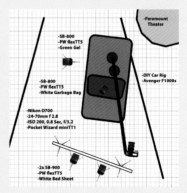

JOBY GorillaPod (joby.com)

Designed to hold small cameras but it has many other uses for the Speedlight user. The manufacturers term it a flexible tripod whereas the three legs are articulated and can act as a regular tripod. More importantly, the legs can bend and fold around all sorts of irregular shapes. A Speedlight can be mounted suspended from all sorts of supports. GorillaPods come in several sizes and strengths.

Manfrotto (manfrotto.us)

Manfrotto's large catalogue of light stands includes the Air Cushioned Light Stand 3-Pack (211cm, 237cm, 273cm, 366cm). Made from aluminum with a black anodized finish, these light stands fold flat and cling together, making them a good option if looking to reduce the cumbersomeness of traveling with many stands.

FIGURE 6.9

TTL Cords

A TTL Cord allows tethered use of TTL flash removed from the camera hot shoe. The TTL Cord maintains the flash-to-camera TTL flash connections and all TTL flash features. The TTL cord allows the flash to be handheld or attached to a light stand or secured on a flash bracket. The extra distance of the flash from the camera permits more options and a more directional light. TTL cords are available from the original camera manufacturers and from several independent brand names.[13]

It takes a little practice to aim the flash accurately when holding it with one hand and the camera with the other. Point the center of the flash at the subject. Holding the flash with the flash head horizontal or vertical will match the shape of the Speedlight to the subject. The zoom head can also be adjusted manually to alter the light. Review your images on the LCD monitor to ensure satisfactory direction and coverage. Review the histogram for satisfactory flash exposure.

Canon: Canon OC-E3 off Camera Shoe Cord 3 maintains all on-camera flash functions up to two feet from the camera.

Nikon: Various TTL cords are available from Nikon. SC-17 is a simple TTL cord. SC-29 has an auxiliary Wide Area AF Assist Illuminator and is for use with a professional flash bracket.

DIY = Do It Yourself

In the last few years, a whole industry making and supplying products for use with Speedlights has emerged. It is a burgeoning new field. You can buy a device to do almost anything you want, implements that will assist in your quest for lighting superiority. But more often than not, throwing money at the real problem is impractical and inappropriate.

In tandem, people making their own products have created ingenious solutions. Rather than retrofitting a generic item to your system, you can customize something to your style of working. Do It Yourself has proliferated and the Internet has enabled the inventors to disseminate their solutions to us all.[14]

The following are many solutions to some universal situations photographers and Speedlight users find themselves facing.

Typing Paper

You may have to use almost anything to get the shot when on location, traveling fast and light. The most mundane household items may be pressed into service. Ordinary 8 1/2" × 11" white typing paper makes a great reflector, diffuser, or gobo. But if you tape two

[13] Paramount Cords (www.paramountcord.com) custom-manufactures Nikon TTL cords in any length, and can provide Nikon TTL cords for consumer modification. Michael Bass (www.michaelbassdesigns.com)

[14] DIYphotography.net.

sheets together along three edges you create a versatile mini diffuser. Slide the Speedlight between the two sheets on the open side and you have a handy backlight. If you put it between the subject and the background, and point it straight up, it lights both with soft light and falls off around the edges quickly.

Ask the closest secretary if they have a couple of sheets and some tape. You can also make more durable versions with plastic or other diffusion materials. Works wonders.

Diffusion Sleeve

4 sheets 8½ × 11 typing paper
3 sides taped together,
bottom open

Speedlight tilted straight up

FIGURE 6.10 SPEEDLIGHT DIFFUSION SLEEVE

A Clamps

To survive in photography you have to be resourceful. Often custom or makeshift methods are just as good or better. Manufacturers have built devices to marry Speedlights to stands, umbrellas, softboxes, etc. with limited success. The mechanisms for attaching Speedlights to these products are rarely universal. They only do one job. Often they utilize the hot shoe attachment on the bottom of the Speedlight which is a very flimsy connection. It is susceptible to cracking or breaking when any weight or leverage is applied to the structure.

A Clamps are a hardware store tool that has been integrated into the world of photography. They have many uses. A Clamps come in three basic sizes, 1", 2", 3". With a lot of ridicule I started using large A Clamps a long time ago, to good effect. A Speedlight fits between the jaws of a 3" A Clamp perfectly and the two handles serve as outriggers which can be

clamped, taped, or tied to almost anything. I use another 2" A Clamp to attach the assemblage to softboxes. It is secure and solid. It may look cumbersome, but it works.

In lieu of the little stands that come with each Speedlight, you can always use an A Clamp to stand it up on a table or shelf. The small stands hold the lights well, but as soon you add any type of accessory (i.e. softbox, snoot, etc.) they tip over. The A Clamp has enough ballast to support most attachments. The 1" clamp will hold gels and flags to any three-dimensional surface.

FIGURE 6.11

Glad Bags

There are all kinds of diffusers. Many projects demand custom-made applications. Years ago I discovered one of the most versatile, ubiquitous and inexpensive materials—**Glad**® trash bags—the white ones. In a pinch I have used a couple of the "off

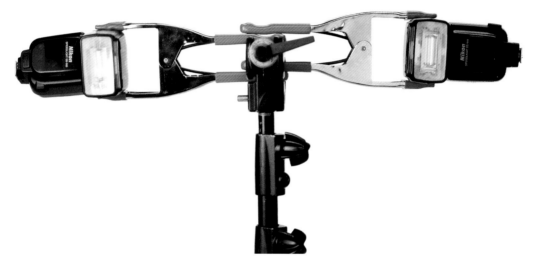

FIGURE 6.12

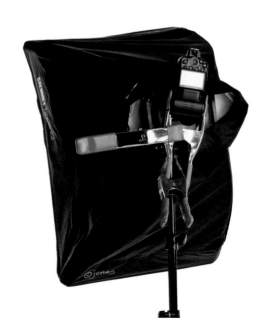

FIGURE 6.13 **FIGURE 6.14**

brands" and they worked fine, but I stick with the same brand because I know their physical characteristics. I always carry a box with any lighting kit. They are color balanced (even cut out excess UV from flash) and can be cut to any shape. To substitute for the real thing, I have jerry-rigged quick light boxes by taping the bags to walls and under computers, even stretching them across picture frames. You can cut them along a seam and double the size in single ply, or keep them uncut as two ply. I have even used Glad bags as the actual background for backlit subjects. Use them and throw them away.

Gels/Filters

A cheap trick that professionals have been using for years is to get the free sample books of gel from Lee® or Roscoe®. You can send away for the booklets or pick them up as "swag" at tradeshows or conventions. The gel sizes are small, but they are perfectly shaped to attach to the front of a Speedlight. The variety of colors can enrich your photography immensely. The companies have caught on to this "misuse" of the giveaway packages, so cherish them when you find them.

Grid Spot

One of the cleverest DIY accessories is a grid spot for Speedlights. I found the original prototype online. The grid spot is made from a corrugated lightweight plastic called Coroplast®. Buy it in black. For the SB-800 Speedlight cut the pieces according to the table below and assemble with gaffer tape. For other

Speedlights, make minor adjustments to the widths depending on the size of the Speedlight head.

You can also try various lengths to vary the effect.

Snoots

A paper towel tube, rolled black seamless paper, or Cinefoil® can be used as a snoot to limit the spread of the flash or create special effects. (See definition of a *Snoot* on page 119.)

POWER

As useful as Speedlights have become to our industry, they are hotly debated on many fronts. Photographers relinquish their traditions with great difficulty. Old habits die hard because they work.

However the caveat that crops up most often with Speedlights is power. How can they possibly be as strong as larger, AC powered units? But raw power is not all it is cracked up to be.

First of all, the top-of-the-line Speedlights generate an incredible amount of light. Modern batteries are far better than just a few years ago. Second, we do not require such severely small apertures for most photography. With larger format cameras, depth of field was a major consideration, but with small dSLRs, f/5.6 is often plenty.

All things being equal, you achieve smaller apertures by increasing the amount of light. You can certainly add more Speedlights for extra power and to maintain recycling rates. But barring that, a selective, shallower depth of field can produce more dynamic results. To get the most from the power you have, another solution is to increase ISO. With improved technology, the digital media used to

Coroplast Grid Spot for SB-800

	W (inches)	L (inches)	Quantity
Top	2.5	5.5	1
Bottom	2.5	4.5	1
Sides	1.5	4.5	2
Center	2.5	3	8

FIGURE 6.15 COROPLAST GRID SPOT PIECES

Coroplast Grid Spot

FIGURE 6.16 COROPLAST GRID SPOT, ASSEMBLED

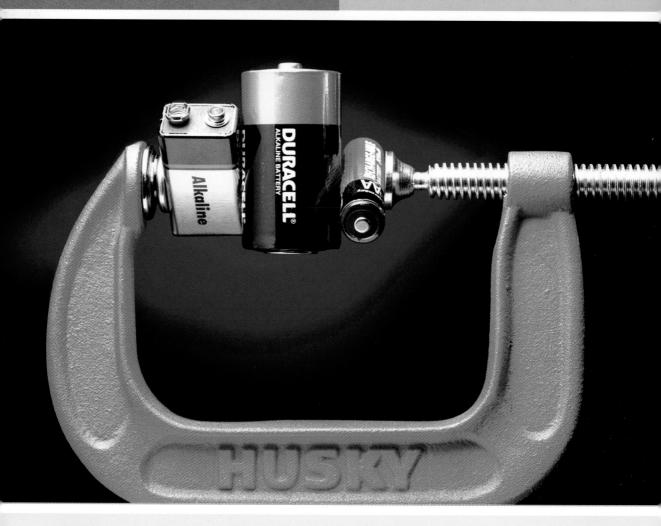

BATTERIES

I needed to illustrate a story on battery technology. I got in over my head. I ended up going to two hardware stores to find the right generic batteries and another one to get the perfect, red C-clamp.

Crazy Glue held the props together. And although the main light was from a small softbox directly over the set, the reflector card directly below bounced necessary light back into the reflective surfaces.

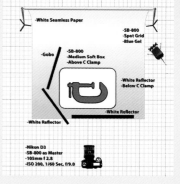

record our imagery is so refined that we need not be fearful of reduced quality when we "push the film" to higher sensitivities.

So besides juggling apertures and shutter speeds, the casual practitioner can alternate between different ISOs to achieve the desired result for specific photographs and resolution becomes an additional creative tool.

Batteries: Powering the Flash

Speedlights are a marvel of efficiency. Small and compact, they emit an amazing amount of light. This is mostly due to their small sources of power— batteries. These newest advances in technology are "bottled lightning."

Built around ubiquitous AAs as a constant power supply, Speedlights have a voracious appetite for energy. If you use supplemental lighting a lot, it is hard to justify anything but rechargeables because regular AAs have too short a lifespan and that adds expense.

In practice, most problems that arise in normal usage are because of batteries. They are the weakest link in the system. And troubleshooting their failure can be frustrating. Depleted, overheating, defective, they result in erratic behavior and inconsistent exposures.

To overcome this we have to maintain an ample supply. You have to build in redundancy to ensure reliable performance. It is necessary to carry duplicates and more. At the first sign of difficulty, switch out all of the recalcitrant set, rather than sorting out the single culprit.

Another issue when using rechargeable batteries is you have to carry chargers to "repower" before, during, and after a shoot. The more Speedlights you carry, the more batteries you have to recharge. The more batteries, the more chargers. The more chargers, the more power cords. Ad infinitum.

It is a good idea to spend some serious time acquiring a knowledge of batteries, i.e. which ones work best, which ones enhance your style of shooting and your methods of care and storage. Different types of batteries have different personalities. Learn yours.

Tenets of Batteries

Batteries are energy storage devices and the heart of the flash. Proper battery maintenance is essential to satisfactory flash operation. Attention to batteries is important.

1. Can't have too many batteries.
2. Don't mix and match.
 Use only fresh batteries of the same brand and purchased at the same time.
3. Don't just change one or two, change them all.
 Even partially exhausted batteries drastically slow recycling times and may not recharge fast enough to provide a full charge. If the recycle time exceeds 10 to 12 seconds, immediately change to fresh ones. *Flash recycling times are dependent upon the flash power required for each picture, type of batteries used and their condition.*
4. Don't overheat more than necessary. Don't overwork.
 Unsuitable or exhausted batteries can overheat and damage a TTL electronic flash. Old or damaged batteries can leak corrosive chemicals, ruining the flash.
5. Charge as slowly as possible
6. Regularly inspect your batteries for contact condition, case damage, and leakage.

Do not leave batteries in the flash for extended storage. If the flash will not be used for several weeks, remove them. Even with the flash turned off, the batteries are making a connection with metal contacts causing battery drain. Over time they can become exhausted and leak if left in a device.

Do not use carbon-zinc batteries in the electronic flash, even if they are labeled "heavy duty." Carbon zinc batteries do not satisfy the power requirements of the TTL flash, and will damage it.

Do not carry AA batteries loose. Loose batteries can short out and discharge against one another and are prone to leakage.

Make bundles of four (or five) AA batteries with rubber bands and place each bundle in separate plastic bags or use commercially available battery cases or battery boxes.

Avoid touching battery contacts with your fingers, as body acids and oils can damage the contacts.

Battery contacts can be cleaned and polished with a pencil eraser. Corrosion can be removed with a swab moistened with rubbing alcohol.

Battery Types: Power Decisions

Alkaline batteries are readily available, reasonable in price, provide good performance in TTL flash units and can only be used once. Alkaline batteries may lose power quickly in temperatures below freezing.

Lithium batteries are readily available, more expensive, provide more flashes than alkalines and can only be used once. Lithium batteries are excellent back-up batteries. They have extended shelf-life and can hold full power for up to three years of storage. Lithium batteries may provide better cold weather performance.

When flying, new rules limit how many spare lithium (rechargeable) batteries you can take on an airplane. No lithium battery spares are allowed in your checked baggage. Up to two spares are allowed in carry-on bags. Batteries that are installed in their devices are not spares and are not affected by the new rule.

Nickel-Cadmium (Ni-cad) batteries are rechargeable and reasonable in price. Ni-cads require a compatible charging device, hold charge over extended storage and can be used for up to 200+ charging cycles. Some Ni-cad batteries are prone to "memory" problems, where continued partial discharge/full charging cycles can lead to a dramatic reduction in capacity. Fully discharge Ni-cads before charging to avoid decreased performance. This is called *refreshing* the battery. Ni-cads will provide faster recycling but fewer flashes than alkaline batteries. Ni-cads are rarely available anymore, since they hold only about one-third the power of NiMH batteries.

Nickel Metal Hydride (NiMH) batteries are rechargeable, readily available, and reasonable in price. NiMH batteries require a compatible charging device, and may provide up to 1,000 charging cycles. Quick-chargers may decrease battery life due to heat damage. These batteries gradually lose power with storage. "Top off" the charge immediately before use. They occasionally should be *refreshed*, fully discharged before charging to maintain battery performance. They can provide faster recycling and more flashes than alkaline, lithium, or Ni-cad. The higher the current rating, in milli-amp hours (mAh), the greater the number of flashes. Look for NiMH batteries of 2000mAh or higher. They also provide good cold weather performance.

External battery packs can provide extremely fast recycling and high numbers of flashes for extended shooting sessions. These may use multiple expendable batteries or feature high-voltage rechargeable battery cells. External battery packs are available from a wide variety of manufacturers. They are a staple for professional shooters.

Canon: the Compact Battery Pack CP-E3 takes eight AA alkaline, lithium, or Ni-MH batteries. The 600EX-RT, 580EX and 580EX MkII can be set, through the flash Custom Function menu, to be powered by a combination of internal and external batteries or by the external power supply only.

Nikon: the SD-9 battery pack for the SB-900 and SB-910 flashes takes eight AA Alkaline, Lithium, or Ni-MH batteries, but can operate on four.

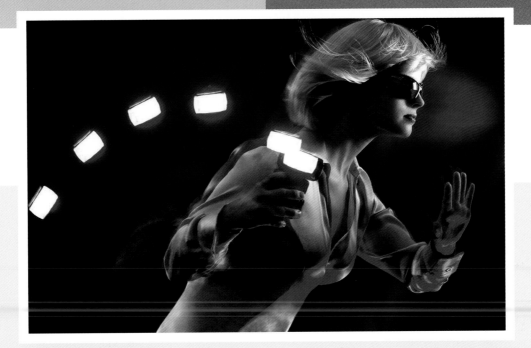

TRAVELING AT LIGHTSPEED

By accident I struck upon featuring the Speedlight in the photograph. I also wanted to incorporate a number of the techniques that we talk about in this book. But like everything, it all comes down to money. There was a budget. We searched a lot of models' portfolios to find the perfect subject. In the end I pressed my studio manager into service.

I wanted to imply movement. We handled this in a couple of ways: the photograph was shot on a slant so the woman's hair hung at an angle. We used a fan to add to the illusion. A tungsten light was placed behind the model to create some blur.

Four Speedlights, in three groups, doing separate jobs: lighting her face and hair with daylight; adding the comet-like background light; emphasizing the blue color but keeping it off her face. The trick was timing when to have Leah initiate the stroboscopic Speedlight in her hand each time we made an exposure.

We used lots of gobos to keep each light from "contaminating" the others. So there was a great deal of fine-tuning. But the whole shot was done in about 20 exposures which is a testament to the methods we have at our fingertips today.

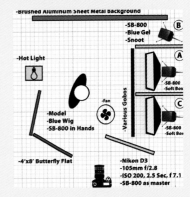

Index